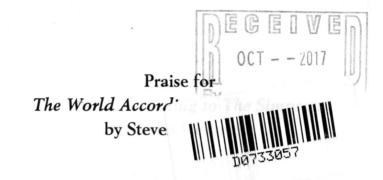

Praise for
The World According to The Simpsons
by Steven Keslowitz

"Steven Keslowitz knows mc ___ ___ *The Simpsons* than I do, and I've been working there for twenty-six years."

— Mike Reiss, Emmy-winning
writer/producer, *The Simpsons*

"As a twenty-year veteran designer at *The Simpsons*, it never ceases to amaze me how much our little yellow family has crept into the cultural lexicon in impactful ways. Steven Keslowitz's book masterfully studies and describes the parallels drawn between the cartoon world of Springfield and the often challenging reality we face every day as their generally more human-looking counterparts."

—Charles Ragins, two-time Emmy-winning
designer on *The Simpsons*

"I love this book. In order to write for *The Simpsons*, you have to think like *The Simpsons*. And each character has his own distinct voice. Over the years, *The Simpsons*' wit, irreverence, and wisdom have been the most honest funhouse mirror ever held up for us to gaze into. It's always amazing to hear echoes from the animated cast speaking through real people walking the streets, sleeping at work, and sitting in restaurants all around us. These characters transcend traditional kiddie fare yet remain accessible to adults who should know better. Nearly three decades of being our most beloved extended family members is no accident. Springfield is real; and, for the most part, we

all live there. Steven Keslowitz's *The World According to The Simpsons* is the proof. Get ready to nod your head in agreement and be happier than Comic Book Guy on Free Taco Tuesday. Thoughtful, poignant, philosophical…in all the right places. I hereby endorse this event or product."

— Chris Yambar, writer for "Bart Simpson Comics,"
"Tree House of Horror," "Radioactive Man," and more

The World According to The Simpsons takes on the big topics with a tone that's alternately serious and slapstick… Keslowitz fixes a serious eye on America's favorite dysfunctional cartoon crew, looking for deeper meaning in the antics of Krusty the Clown, Chief Wiggum, and the rest of the twisted townsfolk. He actually finds some, too."

—Larry McShane, Associated Press

The World According to The Simpsons is a collection of entertaining scholarly essays; it's an accomplished work with many insights to share. The book is useful for fans and scholars alike, as the essays, are, at turns, fun and academically enlightening. Keslowitz's analysis is right on target: there is a lot more to *The Simpsons* than initially meets the eye. And Keslowitz provides keen insight into the ways in which *The Simpsons* reflects and influences American culture. *The World According to The Simpsons* is a must-read for Simpsons fans and fans of American popular culture."

—Duncan Dobbelmann, PhD

"…His book of D'oh is a big hit."

—*New York Daily News*

Why
You Better Call
Saul

What Our Favorite TV Lawyer Says About
Life, Love, and Scheming Your Way to
Acquittal and a Large Cash Payout

Steven Keslowitz

Author of
THE WORLD ACCORDING TO THE SIMPSONS
and
THE TAO OF JACK BAUER

Published by QuillPop Books
2030 East Speedway Boulevard, Suite 106
Tucson, Arizona 85719 USA

ISBN: 978-0-9988951-1-6 (hardcover)
ISBN: 978-0-9988951-0-9 (paperback)
ISBN: 978-0-9988951-2-3 (ebook)
LCCN: 2017938886

For my wonderful wife, Lital (who introduced me to Breaking Bad *and her favorite character, Saul Goodman), and our incredible daughters, Layla and Eliana. I love you all so much.*

Justice, justice, shalt thou pursue.
> ~ Deuteronomy 16:20

The trouble with law is lawyers.
> ~ Clarence Darrow

You don't want a criminal lawyer…you want a CRIMINAL lawyer.
> ~ Jesse Pinkman, advocating for retaining Saul Goodman
> as legal counsel

I'm always chasing rainbows
Watching clouds drifting by
My schemes are just like all my dreams
Ending in the sky
> ~ Joseph McCarthy, "I'm Always Chasing Rainbows"

The only person you are destined to become is the person you decide to be.
~ Ralph Waldo Emerson

It's showtime, folks!
~ Jimmy McGill

Contents

An Introduction to Mr. Goodman (from the Perspective of a Practicing Attorney)

"*This* is who he hires?" an incredulous Walter White grumbles as he and his partner-in-meth-peddling Jesse Pinkman first pull up in front of Saul Goodman's office—which, quite appropriately, is located in a strip mall. Walt, the high school chemistry teacher turned drug lord, is less than enamored with their associate Badger's choice of legal counsel. "How about we get him a *real* attorney?"[1]

Walt takes in the surroundings: A cheap, inflatable Statue of Liberty prop sits atop the office and a brightly

lit neon OPEN hangs in the window. The waiting room[2] includes screaming babies, a receptionist seated behind bulletproof glass, and venetian blinds intended to prevent searching eyes from seeing inside.[3] Walt and Jesse will eventually meet Saul Goodman's "associates," who consist of said receptionist, a henchman named Kuby, and a massive, imposing bodyguard—of almost inhuman size—named Huell.[4] The attorney has a "World's Greatest Lawyer" mug on his desk. The scales of justice are also sitting nearby. A large replica of the United States Constitution covers the walls. Cell phones (presumably intended for disposal after one-time use by Saul's criminal clients), a gun, whiteout, and Xanax fill Saul's desk drawer.

In most scenes, Mr. Goodman dresses in sharp and colorful attire.[5] A gold lapel pin of the scales of justice is part of the Goodman costume. Saul's choice of sharp colors for his suits, ties, and shirts (and his ironic scales-of-justice pin) speaks volumes about the man: he is a *showman*, just as much as he is a lawyer.[6] In Saul's world, showman and lawyer are one and the same—and perhaps, among lawyers, he is not entirely alone in that regard. Saul's choice of attire is deliberate—and important to business:[7] before Saul Goodman existed, his prior persona Jimmy McGill, when trying to attract elderly clients, ensured that the bland suits he purchased matched those worn by Ben Matlock from the television series *Matlock*. In one episode of *Breaking Bad*, Saul acknowledges that "the minimalist thing never blew my hair back."[8]

This is not the office or attire of a white-shoe lawyer;[9] these are the tools of a different type of attorney: the shrewd headset-wearing type who declares that "the law can be slippery" and uses a slimy fish to illustrate the point; the ambulance-chasing type who drives a white Cadillac with the license plate "LWYR UP"; the criminal type who

encourages (and educates his clients on how to engage in) money-laundering; the fast-talking shyster type who shows no respect for the law. Based on his office setting and choice of attire, it is easy to dismiss this Saul Goodman character as a gimmick—a "two-bit, bus-bench lawyer,"[10] in the estimation of Walter White.[11] But as we will see, there is much more depth to the character of Saul Goodman than Walt has surmised. From his origins as Slippin' Jimmy to his eventual landing spot as an employee named Gene in a Cinnabon, Saul has lived an adventurous life, one that I believe merits serious academic attention and reflection. As we will see, Saul's journey is ripe for scholarly consumption and critique.

⚖️

Better Call Saul is the immensely popular prequel to the award-winning[12] (and also immensely popular) *Breaking Bad*. Both shows are dramas that contain deftly embedded comedic moments. More significantly, each series endeavors to crack through existing narrative norms for television, and successfully fosters copious academic dialogue about the themes expressed therein. While television is a medium through which serious issues are frequently examined, there is arguably no contemporary series that does so as broadly or as powerfully as *Breaking Bad* or *Better Call Saul*. An exploration of the underlying characteristics and components of each show is required in order to fully appreciate the scholarly value embedded within. This book aims to present this analysis from the perspective of a practicing attorney and popular-culture scholar.

The *Better Call Saul* series is set six years prior to the beginning of *Breaking Bad*. While *Breaking Bad* focused on the twists and turns in the life of Walter White—a chem-

istry teacher turned drug lord—*Better Call Saul* focuses on the intriguing backstory and character development of Saul Goodman, the attorney who represents Walter White and his partner, Jesse Pinkman. Both shows are quite poignant, each episode crafted as an artistic portrait showcasing characters dealing with incredible circumstances emanating from a combination of their own respective actions and environments. Each show is renowned for its unique narrative technique and keen attention to detail, not only in terms of maintaining internal consistency within and between the two shows, but also with respect to painting a realistic portrait of the actions and events displayed on the screen. One quick example: Bob Odenkirk was required to learn how to make a Cinnabon classic roll so that it looked just right on camera. And "squat cobblers" and "Chicago sunroofs" aside, both shows are beautifully designed, well directed by world-class directors,[13] wonderfully written,[14] and carefully acted with a desire to tell a story from the perspective of characters with deep and intriguing backstories.[15] While speaking with cocreators Vince Gilligan and Peter Gould, members of the writing team, and most of the actors and actresses on the show (including Bob Odenkirk, who portrays Saul Goodman; Rhea Seehorn, who portrays Kim Wexler; Patrick Fabian, who portrays Howard Hamlin; Michael McKean, who portrays Chuck McGill; and Brandon K. Hampton, who portrays Ernesto), I was struck by their sheer intelligence, as well as their insights and attention to detail regarding the series. The *Better Call Saul* team appears to be proud that many fans view the series as a fine work of art.

In addition to its intrinsic artistic value, *Better Call Saul* also merits, and even demands, serious review and attention from a number of empirical perspectives. A close study of the series is required in order to analyze the deep politi-

cal, cultural, philosophical, legal, and social significance and underpinnings of the show. This book tackles these broad conceptual themes by analyzing specific events in Jimmy McGill's life journey and transformation into Saul Goodman. This book also analyzes popular song lyrics for the purpose of understanding the ways in which such lyrics relate to the story of Jimmy McGill.

A deep dive into *Better Call Saul's* underlying structure enables the scholar to fully embrace the unique and creative narrative techniques employed by the writing team. This book meticulously examines such techniques and argues that the series achieves certain academic objectives because it relies heavily on the realistic portrayal and development of complex, multifaceted characters. These characters are equipped with moral compasses that are calibrated incorrectly. An analysis of other lawyers in popular culture (chapter 7) demonstrates the ways in which the portrayal of Saul Goodman merits renewed academic focus on lawyers on television and their influence in contemporary society. Using the damaged relationship between Jimmy and his brother, Chuck, as a case study (chapter 2), we learn a great deal about the deleterious effects that an unhealthy familial dispute can have in terms of identity and lifestyle. By watching Jimmy throughout the various stages of his life, we learn about identity politics in contemporary society (chapter 1). We can also analyze whether Jimmy and/or Saul are heroic in some sense, or if the character ultimately fails us because of poor decisions and a flawed, corruptible moral center (chapter 6). Perhaps most significantly, the series addresses legal, ethical, and philosophical issues in advertising (chapter 4), and more generally within the legal profession (chapter 5). This book teases out the messages embedded within this complex drama.

A core theme of both *Breaking Bad* and *Better Call Saul*

is that the world around us can have a profound impact on what type of person we become. As noted by Ed Power of *The Telegraph*, the two shows "each chillingly enumerate the ways in which the exigencies of everyday life can corrode human decency."[16] Internalizing the notion that one's environment—perhaps combined with certain flawed elements of one's character—may lead to a person's downfall can be both enlightening and frightening to viewers. The intersections between environmental factors and the characters' true natures is cleverly examined on both shows and permits differing yet valid interpretations of how heavily they weigh on the characters' actions and lives. We watch Walter White, consumed by his massive ego and greed, "break bad" as he goes down a dark, dangerous path. Similarly, we see Saul knowingly slip into a moral abyss—something that he had fought, at least for a period, to avoid.[17] Each character marches down a slippery slope, justifying each action as necessary for survival or success until he or she no longer feels such justification is necessary. They simply become the bad guys—in Walt's case "the one who knocks,"[18] and in Saul's case a criminal who also happens to be a lawyer (hence, Jesse's description of him as a CRIMINAL lawyer).

We could envision parallel worlds in which both Walter and Saul seize certain opportunities and refrain from going down the paths that they ultimately choose. (We could even add the former cop-turned-henchman Mike Ehrmantraut to the mix, as he laments that his actions "broke his boy" and turns even darker as a result).[19] Walter White's description of chemistry in the first episode of *Breaking Bad* serves as an appropriate analogy for the life journeys of all of these main characters. Walt describes chemistry as "the study of change," poignantly noting that change is "all of life" and that "it's the constant, just over and over and

over. It is growth, then decay, then transformation! It's fascinating really."[20] We watch these characters switch course over time, forge new identities, and operate under evolving circumstances. And while we may not experience the same drastic shifts in our own lives, we can relate to living life under different conditions as time goes by.

As we will discuss later, the deep backstory of Saul Goodman reads much like a Shakespearean tragedy.[21] *Better Call Saul* is a fascinating portrait of a man who is on the cusp of finding his way in the world—his rightful place—and then loses it all. Because *Better Call Saul* is a prequel, the end result of Jimmy's journey (at least up until the conclusion of *Breaking Bad*) has been predetermined.[22] The core of the drama focuses on *how* Jimmy transforms into Saul.[23] Various points in the series highlight and symbolically foretell this central underlying theme. In a trailer preceding season 2,[24] for example, we see Jimmy driving a car through a desert. He comes to a crossroads. He sees both a clear path and a stormy path ahead. He ignores both, and instead bursts through a traffic sign, deep into the unknown. Jimmy is going to have some dark adventures into the abyss and we will be watching all along the way.

Based on his role on *Breaking Bad*, Saul Goodman seemed to be an intriguing character, and the idea of a prequel dramedy series focusing on his life greatly excited fans. *Better Call Saul* shattered the cable record for a new series premiere as an unprecedented 6.9 million viewers tuned in for the first episode.[25] Critics have given *Better Call Saul* rave reviews, with the consensus on the review site Rotten Tomatoes declaring that "*Better Call Saul* is a quirky, dark character study that manages to stand on its own without being overshadowed by the series that spawned it."[26] From a scholarly perspective, each series generates its own uniquely profound discourse. As Michael Mando, the

actor who portrays drug dealer Nacho Varga on *Better Call Saul,* poignantly and quite poetically notes with respect to the relationship between the two shows:

> It's like [creator] Vince Gilligan bought this really beautiful corner plot of land. On one side of it, he built this fantastic piece of art of a building called *Breaking Bad.* Then he decided on that other piece of land, he would build another work of art called *Better Call Saul.* Everybody who was a big fan of the first building said, 'You're going to ruin the first building by building a second one next to it.' They ended up making another building that not only stands on its own, but complements the first. There are a lot of tunnels and shared rooms, some connected underground parking. What I envision, in the next few years, are these two pieces of art standing next to each other, and you're going to be able to get lost in either one of them.[27]

Most legal dramas attempt to attract viewers by having exciting cases; *Better Call Saul* attracts viewers because of the interest in the lawyer himself.[28] We have seen Saul Goodman's corruption on *Breaking Bad,* and we are eager to learn about how this character develops into the attorney we see on that series. It turns out that a series of interesting turns leads to the creation and development of the Saul Goodman persona,[29] and it is this backstory that has—and continues to—entice viewers. The *Better Call Saul* writers have imbued this character with immense depth—a noble feat for a character who was previously depicted as largely soulless. The series has proven to be a compelling explanation of this transformation and is quite addictive. This

book examines such transformation and the legal, ethical, philosophical, political, and social issues that Mr. Goodman encounters throughout his journey. The series invites us to be active viewers and to examine the series through a myriad of critical lenses.

When I told Peter Gould (the creator of the Saul Goodman character) about my book, he asked what aspects of the series I was writing about. I responded by noting that my initial plan was to exclusively focus on the legal issues presented on the show. But as the show moved forward, I explained to Mr. Gould that the richness of the story, characters, and philosophical issues demanded attention as well. Based on Mr. Gould's question, it seemed abundantly clear that he understood that the show should be looked at from many diverse angles and perspectives. I was happy to hear Peter and many of the other writers and actors say that they were excited about this book.

As a practicing attorney, I view Saul Goodman as the antithesis of everything I strive to be: he is dishonest and scheming and has no respect for the law. Because he lies so frequently, many clients will not trust him, and it is a generally accepted notion in the legal profession that earning a client's trust is essential to establishing yourself as a successful lawyer. And yet I am forced to acknowledge that he has a knack for skillfully negotiating deals and works tirelessly on behalf of his clients.

Watching an episode of *Better Call Saul* is, for me, akin to "issue spotting" on a law school exam. Many law school exams consist of one or two lengthy hypothetical situations with many legal issues interspersed throughout. It is the student's task to spot as many legal issues as possible; analyze the merits of potential claims, defenses, and strategies; and disregard nonissues intentionally incorporated into the hypotheti-

cal as red herrings. This type of exam, and the process used
by the student when answering the question, is intended to
prepare the student for the real-life situation of a poten-
tial client walking into a newly minted attorney's office and
stating an account replete with facts, opinions, conjecture,
speculation, truths, and lies. Some of the legal issues pre-
sented on *Better Call Saul* are intriguing (if not riveting) in
nature, and it is impressive that a television series can serve
as a forum through which to examine tricky issues, such as
client conflicts, confidentiality, attorney sanctions, privacy,
ethical billing practices, and many others. This book will
use *Better Call Saul* as a springboard from which to begin an
examination of these issues from a legal perspective. It has
been enjoyable to spot as many of these issues as possible
and to take careful notes on the red herrings. I note that
my decision to rewatch each episode multiple times (for
both academic and entertainment purposes) was essential
to spotting many of these issues. *Better Call Saul* rewards
repeat consumption due to the depth of its content,[30] the
quality of its writing,[31] and its unique emphasis on, and
attention to, detail.[32]

I must concede that I love watching Saul Goodman—
and Jimmy McGill—operate: it may sound strange, but his
lack of principles and unscrupulous nature is almost endear-
ing.[33] Jimmy is more likeable than Saul because Jimmy is still
dealing with the internal struggle of what kind of lawyer
and person he wants to be. Saul is a lost cause. Jimmy is the
perfect amalgamation of imperfect qualities, and looking at
Jimmy is like looking into a carnival funhouse mirror. I would
surmise—based on my own experiences and speaking with
fellow attorneys—that lawyers generally feel some degree
of imperfection and insecurity, and if those imperfections
were distorted and exaggerated in a funhouse mirror, we
might recognize ourselves in it. That is a very scary notion,

especially because many lawyers are presented with some of the ethical quandaries that Jimmy will eventually face—albeit not typically at the Walter White level. Those of us with principles and a sense of justice try to advocate on behalf of our clients without violating any ethical rules. We seek to operate within both the letter and spirit of the law. And that is why watching Jimmy/Saul is so much fun: he can—and does—engage in such extreme action that, at times, it seems almost embarrassing to admit that Jimmy/Saul and I are members of the same profession. Lawyers are generally viewed by the public with much disdain, and Jimmy/Saul only helps to perpetuate the misperception that all, or at least most, lawyers are crooked. His character is so exaggerated that we must laugh—and we cannot wait to see what he does next.

I will argue in this book that Saul Goodman—or Jimmy McGill—is a complicated character with many dimensions. Despite the extreme actions that he takes, he appears to have at least *some* boundaries (more so as Jimmy McGill) and his next action is therefore even *more* unpredictable. Two of my previous writings focused on other fictional characters with many dimensions: Homer Simpson from *The Simpsons* and Jack Bauer from 24. Like *Better Call Saul* (and *Breaking Bad*), both *The Simpsons* and 24 teach us much about the world: all four shows tackle important issues, and we can learn a lot by analyzing the actions of the protagonist in each series. I have always chosen to write about characters and shows that I both enjoy watching and have an influence in our world. I believe that, like Homer Simpson and Jack Bauer, Saul Goodman fits this mold.

I look forward to taking this journey with you through the outskirts of Albuquerque, New Mexico, where we will become acquainted with a seasoned attorney looking to eke out a living—and doing (almost) anything necessary in

order to achieve that goal. By the end, the best advice that you may glean from this book is that if and when you are in need of an attorney or any general advice about life, you'd better call Saul.

Notes

1. *Breaking Bad*, season 2 ("Better Call Saul," 2009). Walt is referring to Badger's choice of legal counsel after Badger is arrested earlier in the episode by an undercover cop for selling methamphetamine. This episode—the eighth of the second season—marks Saul's first appearance on *Breaking Bad*.

2. Saul Goodman's waiting room evokes images of a medical clinic. Saul views people's legal issues as similar to medical afflictions that can be solved by a "professional's" expertise and guidance.

3. See the office description in David Stubbs, *Better Call Saul: The World According to Saul Goodman* (New York: Harper Design, 2015), 11.

4. Huell's first onscreen appearance occurs during the premiere episode of the fourth season of *Breaking Bad* (2011).

5. In *Breaking Bad*'s season 5 episode "Buyout," (2012), a DEA agent named Hank Schrader (Walt's brother-in-law) disdainfully remarks, "Where did you get your law degree, Goodman? The same clown college you got that suit?" Saul has not always dressed this way. As noted above, as Jimmy McGill, he dresses quite conservatively in order to attract a different type of clientele, namely elderly people. In promotional images preceding season 2 of *Better Call Saul*, he is pictured in a suit closet choosing between conservative garb and Saul-type colorful suits. This depiction is intended to foretell his character transformation.

6. Saul's wardrobe is so important to him—and tied to his persona—that it is one of the first things he gives up when he realizes he can no longer be Saul Goodman as *Breaking Bad* draws to a close. During the final time we see him in that series, he is wearing only a white shirt and notes that he will become "Mr. Low Profile—just another douchebag with a job and three

pairs of Dockers." See *Better Call Saul: The World According to Saul Goodman*, 30. Commenting on this turn of events, the authors state that "The suits, the shirts, and the ties weren't just the outward signs of a sweet-talking, two-bit lawyer; they were also the expression of a boundlessly optimistic, opportunistic, problem-solving personality."

7. Lawyers' attire is viewed as important by some clients. This point is examined on an episode of *Curb Your Enthusiasm*. In the season 2 episode "The Acupuncturist" (2001), a character played by guest star Ed Asner is angered upon seeing his trusts and estates lawyer wearing jeans instead of a business suit on casual Friday. The attorney pleads with Asner not to fire him, arguing that even though the attorney's attire is casual, his work will be focused and anything but casual. Asner ignores the pleas and proceeds to fire the attorney.

8. Interestingly, the reference to hair being blown back can be symbolically tied to the free-flowing hair of the inflatable tube man that originally inspired the Saul Goodman costume in "Inflatable."

9. Jimmy McGill's first office is much less flashy. He works out of a small closet in a nail salon. The sign on the closet door is a simple 8x11 sheet of paper that reads "James M. McGill, Esq., a law corporation."

10. *Breaking Bad*, season 5 ("Live Free or Die," 2012).

11. It is noteworthy that, despite Walt's denouncement of Saul, Walt and Jesse continue to employ Saul's services, calling on Saul to use his Rolodex and cunning to help the pair out of numerous sticky situations. As we will discuss later in more depth, Saul is actually quite a good lawyer—for a certain type of clientele. Also, in the third-season episode of *Breaking Bad* "I See You" (2010), Walt acknowledges that although Saul Goodman "comes across as a clown, he actually knows what he's doing."

12. *Breaking Bad* has won, among many other awards, two Prime-time Emmy Awards for Outstanding Drama, a Golden Globe Award for Best Television Series, and three Writers Guild of America Awards for Television Dramas. *Better Call Saul* was nominated for seven Emmy awards (among other awards), including Best Drama Series, following each of its first two seasons. *Forbes* magazine deemed it the best new series of

the 2015 season. See Allen St. John, "The Top 10 Television Shows of 2015: No. 1 'Better Call Saul,'" *Forbes*, December 22, 2015, http://www.forbes.com/sites/allenstjohn/2015/12/22/best-of-2015-top-10-shows-on-television-1-better-call-saul-breaking-badder/.

13. The list of directors who have contributed to at least some portion of the first two seasons of *Better Call Saul* is as follows: Colin Bucksey, Peter Gould, Adam Bernstein, Vince Gilligan, Michelle MacLaren, Michael Slovis, Thomas Schnauz, Larysa Kondracki, John Shiban, Scott Winant, Nicole Kassell, and Terry McDonough. Vince Gilligan and Peter Gould are the cocreators of the series and have also written some episodes. See "Better Call Saul, Full Cast & Crew," IMDb, http://www.imdb.com/title/tt3032476/fullcredits/.

14. Members of the *Better Call Saul* writing team have indicated that the show is not mapped out from start to finish. As writer Gordon Smith noted, "We didn't map out a plan for these characters." ("Inside the Writers Room with Better Call Saul," *The Writers Guild Foundation*, May 26, 2016, https://www.wgfoundation.org/screenwriting-events/inside-writers-room-better-call-saul/.) During the same panel discussion, executive producer Peter Gould indicated that Jimmy "surprises" the writers. The list of writers who have contributed to at least some portion of the first two seasons of *Better Call Saul* is as follows: Vince Gilligan, Peter Gould, Gordon Smith, Ann Cherkis, Gennifer Hutchison, Thomas Schnauz, Bradley Paul, Jonathan Glatzer, and Heather Marion. "Better Call Saul, Full Cast & Crew."

On the panel, writer Jonathan Glatzer stated that "limitations" in the writing process "can be liberating." While the show may not be mapped out from start to finish, the limitations that Glatzer refers to is the major elephant in the room: namely, the fact that the *Breaking Bad* world exists, and in order to retain a sense of consistency, *Better Call Saul* must stay true to that world. The writers mentioned that they sometimes reject great ideas because they would be inconsistent with events depicted on *Breaking Bad*. Glatzer indicated that he enjoys such limitations because, perhaps somewhat paradoxically, they give him the freedom to focus on creative ways to arrive at what he *knows* must ultimately come next. (Note that at a separate

panel event held at the Vulture Festival in New York City [*Breaking Better Call Saul*, May 21, 2016], Peter Gould stated that he sometimes hears far-out pitches intended to eliminate such limitations and to essentially pretend that *Breaking Bad* does not exist, or that it exists as part of someone's imagination, or that it is a parallel universe that is unaffected by the separate, earlier *Better Call Saul* world).

15. Ruminating on the series' depth during the *Breaking Better Call Saul* panel at the Vulture Festival in New York City (May 21, 2016), actress Rhea Seehorn noted that elements such as costume design are considered extremely carefully: the goal, for example, is to portray Kim as a working-class attorney who shops at Marshall's and Nordstrom Rack, not at Bloomingdale's.

16. Ed Power, "Better Call Saul: Marco, episode 10, review: 'a dark conclusion'," *The Telegraph*, April 7, 2015, http://www.telegraph.co.uk/culture/tvandradio/tv-and-radio-reviews/11517977/Better-Call-Saul-Marco-episode-10-review-a-dark-conclusion.html.

17. One point of distinction between Saul Goodman and Walter White is that Walt's descent is less gradual than Jimmy's transformation into Saul. Walt quickly deviates from his initial mission (i.e., saving enough money to support his family upon his death) and decides that it is important to build a drug empire. He is possessed by power, ego, and greed. While he initially struggles with the moral depravity of his actions (including killing Krazy-8 during season 1 in "Krazy-8"), he soon has little trouble performing abominable actions (such as poisoning a young, innocent child [Brock]; declining to intervene when Jesse's girlfriend, Jane, overdoses on meth; and whistling carelessly soon after Todd shoots a young child in cold blood). Even at his worst, Saul appears to draw the line against killing children. Furthermore, Saul's descent is more gradual, as we watch the very real moral struggles that Jimmy faces prior to the transformation. Because of what we know about Jimmy, perhaps Saul is a bit more likeable than Walt, given Walt's wicked depravity and lack of humanity. While neither character exhibits moral clarity, Walt seems to be a more defective character as he often appears to lack the type of emotions that other human beings feel. Regarding likeability, while both characters are unmistak-

ably dark, Saul's humor is a distinguishing attribute that enamors him to fans and serves to lighten the mood in tense situations.

In some ways, Saul is the inverse of Walt. While both characters ultimately are sucked down a black hole, Walt's admitted goal is to become a powerful, dark figure, while Saul struggles with keeping his demons at bay. While neither character's actions are justifiable, Walt's desire to become a powerful drug kingpin is less relatable (and arguably more unforgivable) than Saul's desire to find his identity in a world that has not been particularly kind to him.

At an event held by the Hudson Union Society in New York City on October 10, 2016, Bryan Cranston argued that he was the first character on a television series who changed so significantly over the course of its run. While other, perhaps less notable television characters have changed over the years, one can argue that *Breaking Bad* helped transform television through a central figure who changed in such a fundamental way from start to end. (Of course, it may be argued that perhaps Walt did not change so much, but rather that circumstances allowed him to act in accordance with his true, underlying nature once he was able to move past certain societal norms and mores.) Invoking Archie Bunker, Cranston argued that one of the comforts of many television shows is that they include main characters that do not change. (I would also add Homer Simpson and Jack Bauer as prime examples). Cranston's point is well-taken: *Breaking Bad* and *Better Call Saul* function as transformative television in that the characters themselves transform so significantly, a characteristic that is relatively uncommon in most shows.

18. *Breaking Bad*, season 4 ("Cornered," 2011).

19. Both Walt and Mike are initially motivated to engage in morally abhorrent actions in order to fulfill a desire to provide for their respective families. Walt's ego later takes over and causes him to keep falling further.

20. *Breaking Bad*, season 1 ("Pilot," 2008). Walt, Jimmy, and Mike experience varying degrees of "growth" during their respective careers. Jimmy experiences such growth by transforming from Slippin' Jimmy to a member of the New Mexico Bar, and both Walt and Mike hone their respective crafts over years of experience in their respective fields. Each character decays—we see

Mike break down over the death of his son, while Walt's loss of a substantial business opportunity earlier in his life fuels his ambition to build his own empire. And Jimmy is constantly berated by his older brother, Chuck, ultimately leading to his decay. Each character transforms because of their circumstances—and likely something innate that, combined with such circumstances, creates an unstoppable reaction.

21. In an interview preceding the beginning of season 3 of *Better Call Saul*, *Breaking Bad* creator and *Better Call Saul* cocreator Vince Gilligan expanded on the notion of the tragedy of becoming Saul Goodman, observing that:

> It took us a while to realize this, but there's a real tragedy at the heart of *Better Call Saul*. It's a tragedy that this man, Jimmy McGill, will eventually become Saul Goodman. I have to say that we didn't realize that from the start... But as we've worked on *Better Call Saul* for going on three years, we've come to realize it's sort of a Pagliacci feeling we have for him now: the idea of a clown that cried... It's not a good thing to be Saul Goodman—it took us a long time to realize that.

> Courtney Hocking, "It's Showtime, Folks: Inside the 'Better Call Saul' Writers' Room with Vince Gilligan," September 23, 2016, *Junkee*, http://www.junkee.com/showtime-folks-inside-better-call-saul-writers-room-vince-gilligan/85973.

Other commentators have argued that the story of Jimmy McGill includes characteristics of other tragedies. Professor Donna Bowman, for example, argues that the structure of Jimmy's story is reminiscent of Martin Luther's journey from pious monk to church reformer. Bowman explains:

> Luther experienced an epiphany because he was not able to erase the consciousness of guilt through religious devotion. He became convinced that he could stand before God *simul justus et peccator*—simultaneously justified and a sinner. Jimmy's epiphany, however, takes place in the same godless, punishing desert that will later produce Walter White. Realizing he is a sinner by nature, unable to save himself with

good works, the only option he perceives is to accept that he's damned.

The series also, in a large way, captures the essence of a traditional Greek tragedy. A Greek tragedy is defined as "a drama which…depicts the downfall of a basically good person through some fatal error or misjudgment, producing suffering and insight on the part of the protagonist and arousing pity and fear on the part of the audience." *The Elements of Greek Tragedy*, http://amundsenhs.org/ourpages/.../The%20Elements%20of%20Greek%20Tragedy%20PP.ppt.

As we learn about Jimmy, we soon realize that he is a "basically good person" who commits certain "errors" throughout his journey, leading to "suffering and insight." He is a character that arouses both "pity and fear." See Donna Bowman, "The Lutheran Tragedy of Better Call Saul," March 15, 2015, *Think Christian*, https://thinkchristian.reframemedia.com/the-lutheran-tragedy-of-better-call-saul.

22. While the end-result of Jimmy's *professional* journey has been predetermined, questions regarding Saul's personal life are left unanswered at the conclusion of *Breaking Bad*. While some may assume that Saul is largely alone in the world, it is possible that Saul's personal life is hidden from the cameras. Some observers have surmised that "Saul is a man alone in this world" because he is not shown interacting with "friends or loved ones," and because there do not appear to be any "painful conversations or tearful goodbyes when it comes time for him to disappear." (See David Stubbs, *Better Call Saul: The World According to Saul Goodman* (New York: Harper Design, 2015, 121.) Still, *Breaking Bad* does not necessarily foreclose the possibility that Saul does have a personal life that is not referenced or examined. See Dustin Rowles, "Kim Wexler's Connection to Omaha is Now Even Stronger, And Other Details You May Have Missed From 'Better Call Saul,'" *Uproxx*, March 30, 2016, http://uproxx.com/tv/better-call-saul-kim-wexler-omaha/. In fact, some fans have theorized that his move to Omaha, Nebraska, has some relation to Kim Wexler's possible connection to the area—even though Saul's new identity and location are apparently chosen for him by the mysterious "Ed." Season 2 of *Better Call Saul* offers some insights into Kim's childhood,

and it is clear that she has some connection to an area that is at least relatively close to Omaha. The Hinky Dinky supermarket chain that she references was started in Omaha. She is also seen wearing a Kansas City Royals baseball T-shirt—it is notable that the team's Triple A affiliate is located in Omaha.

23. *Better Call Saul* also provides insights into how the events of other characters' lives (such as Mike, Nacho, Tuco, and Hector) lead to the ways in which such characters are depicted in the future on *Breaking Bad.*

24. Megan Friedman, "Exclusive: Saul Goodman Takes the Road Less Traveled in New *Better Call Saul* Teaser," *Esquire,* January 21, 2016, http://esquire.com/entertinament/tv/news/a41378/better-call-saul-season-two-teaser/.

25. Zach Seemayer, "'Better Call Saul' Series Debut Breaks Cable Ratings Records," *Entertainment Tonight,* February 9, 2015, http://www.etonline.com/tv/159488_better_call_saul_series_debut_breaks_cable_ratings_records/.

26. See *Rotten Tomatoes,* "*Better Call Saul: Critics Consensus*". http://www.rottentomatoes.com/tv/better-call-saul/s01/.

27. Chris Jancelewicz, "'Better Call Saul' Season 2 Finale: Michael Mando on what's to come," *Global News,* April 18, 2016, http://globalnews.ca/news/2644553/better-call-saul-season-2-finale-michael-mando-on-whats-to-come/.

28. In fact, as will be discussed in greater depth later on, many of the legal issues addressed on the show focus on the mundane—overcharging elderly people for toilet paper to confidentiality issues to banking regulations. The banality of the legal issues addressed on the show is a topic that the *Better Call Saul* writing team and actors spoke about during the Breaking Better Call Saul (May 21, 2016, Vulture Festival, NYC) and Inside the Better Call Saul Writers' Room events that I attended (May 26, 2016, the Writers Guild, Beverly Hills, California). Ruminating on the difference between "character-driven" and "plot-driven" legal dramas, legal scholar Charles B. Rosenberg observes that:

> In TV terms, a character-driven drama focuses as much time and energy delving into the personalities of its characters as it does on developing a detailed legal plot. A plot-driven show, by contrast, reverses the time focus and time allotment. That is because, to

tell their stories, plot-driven dramas don't necessarily need "big" characters with what writers call changing "arcs" to their lives—loves lost, diseases endured, promotions denied. So plot-driven dramas can dispense with such things in order to lavish more time on the plot. (Charles B. Rosenberg, "27 Years as a Television Legal Adviser and Counting...," in *Lawyers in Your Living Room!: Law on Television*, ed. Michael Asimow (Chicago: American Bar Association, 2009).

I would argue that *Better Call Saul* is the ultimate "character-driven" legal drama. The legal issues and dilemmas examined on the show are interesting and merit consideration, but the depth and quality of the series stems from its artistic development of the show's fascinating protagonist and the characters in his life.

29. Saul appears to have a significantly harsher, colder personality than Jimmy. It is not just the nature of Saul's actions that has changed; it is also his general demeanor. Saul's personality seems to have hardened significantly.

30. Much like its predecessor, *Breaking Bad*, *Better Call Saul* is embedded with a great deal of depth. Portraying a dark character—such as Walter White or Saul Goodman—can take a toll on the actor as well. At an event held by the Hudson Union Society in New York City on October 10, 2016, Bryan Cranston (the actor who portrayed Walter White) described the deep emotion that he felt when his character was required to allow Jesse Pinkman's girlfriend Jane to die in "Phoenix" (2009). He recalled that he had seen his own daughter's face in place of the actress portraying Jane (Krysten Ritter) while filming the scene. He was visibly shaken by the experience and sobbed in the arms of Anna Gunn. Bryan Cranston describes this experience in detail in his memoir, *A Life in Parts* (New York: Simon & Schuster, 2016), 1–4.

31. The quality of *Better Call Saul's* writing is evidenced, in part, by its ability to develop dark yet likeable characters. Some viewers take the characters on the show, as well as the characters on its predecessor, quite seriously—perhaps too seriously. At the Hudson Union Society event, Bryan Cranston explained that Vince Gilligan brilliantly used fish-baiting style techniques to

make Walt a somewhat understandable character, with the writers perhaps even playing mind games with the audience as the series progressed. Initially, the audience is sympathetic to Walt's circumstances (i.e., a dying man who wanted to leave money for his family), even if we do not agree with his method of earning the money. But because Walt's initial character baits the audience, many people find themselves pulling for Walt as he builds his drug empire. Though we continue to defend Walt, measured reflection would reveal that his initial motivation is no longer relevant. Walt has transformed into a ruthless criminal. It would be a difficult endeavor to attempt to defend Walt's actions, even though he won our sympathy on an emotional level early on in the series.

This fish-baiting phenomena was manifested in fan reaction to Walt as his actions move from bad to worse as the series continues. While most audience members do not agree with or condone Walt's actions, some fans do not want anyone—including his wife, Skyler, to stand in his way. Internet attacks against Anna Gunn (the actress who portrayed Skyler White) became personal, prompting her to pen an op-ed in *The New York Times* to address the backlash. As recounted by both Ms. Gunn and by Bryan Cranston during the Hudson Union Society event, some fans wanted Walter White to succeed in his mission and viewed Skyler as an obstacle in his path. More alarmingly for Ms. Gunn, however, was the fact that some fans, inexplicably, blame *her*—the real-life Anna Gunn—for some of these issues and their frustrations. While any reasonable observer would maintain that this is unquestionably a horrible and unwarranted reaction to fictional events on a television series, it demonstrates, to a great degree, the strength of the series and the dark character development contained therein. See Erik Hayden, "'*Breaking Bad's*' Anna Gun Writes NY Times Column in Response to Fan Hate," *The Hollywood Reporter*, August 24, 2013, http://www.hollywoodreporter.com/live-feed/breaking-bads-anna-gunn-writes-613913. The article referenced *The New York Times* op-ed by Anna Gunn, "I Have a Character Issue," *The New York Times*, August 23, 2013, http://www.nytimes.com/2013/08/24/opinion/i-have-a-character-issue.html?_r=0

It is noteworthy that *Better Call Saul* is setting up the

audience in a similar manner. While we know that Saul Goodman will disappoint us with his moral bankruptcy, we initially sympathize with the Jimmy McGill character—a man who often has decent intentions and is treated poorly by his brother.

The detailed storylines within the show are also largely organically generated, with the writers not necessarily knowing what specific upcoming plot sequences and twists the series will have. The episodes have notably few rewrites (per Rhea Seehorn; see Clarence Moye, "Rhea Seehorn's Quiet, Emmy-worthy Strength in 'Saul'," *Awards Daily*, May 14, 2016, http://www.awardsdaily.com/tv/interview-rhea-seehorn/). Actors Patrick Fabian and Brandon K. Hampton confirmed to me that the actors truly have no idea what is coming next on the show, including what their individual roles may be.

32. *Better Call Saul* incorporates many so-called Easter eggs into the series. Such Easter eggs are tiny references to scenes and characters that appear on *Breaking Bad* or previous episodes of *Better Call Saul* itself. Examples include dissecting the potential hidden meaning of, or references embedded within, the type of wine bottle that a character might hold; the significance of the painting on the wall in Jimmy's office at Davis & Main; showcasing a story on *Better Call Saul* that Saul tells during *Breaking Bad* (e.g., relating his Kevin Costner impersonation deception); and the introduction of a character who has passed through *Breaking Bad* (such as "Ken," who appears in "Switch" on *Better Call Saul* and previously during the first season of *Breaking Bad*. This character is punished by both Walt and Jimmy, respectively, for his arrogance and obnoxiousness). (I also note that the first letters of the names that Jimmy and Kim use when talking to Ken are "V" (for Viktor) and "G" (for Gizelle)—or "VG," for series creator Vince Gilligan. (Interestingly, on *Breaking Bad*, the person watching over Walt in the lab is named Victor and Walt's lab assistant is named Gail [and then there is Gus, of course] [VG, once again.]) There is copious discussion of such minutiae on social media. *Better Call Saul* fan groups serve as forums for discussion of these details, and often the conversation turns quite analytical.

Part of the brilliance of *Better Call Saul* is its uncanny ability to embed obscure references into the show without

alienating viewers who may not pick up on such references. For example, some fans have speculated on the reason for the use of the Harry Lime Theme song (from the 1949 movie *The Third Man*) when Jimmy hands out Jell-O cups in the senior citizen home. Both Harry Lime and Jimmy McGill are con artists, and Nicole Hyland points out that the theme is used in the opening sequence of a *prequel* television series voiced by the actor (Orson Welles) who had portrayed Harry Lime in the film. See Nicole Hyland, "Episode 5 (Alpine Shepherd Boy)—Part 2," The Legal Ethics of Better Call Saul, http://ethicsofbettercallsaul.tumblr.com/post/113992765906/episode-5-alpine-shepherd-boy-part-two.

Furthermore, the level of detail embedded within the show (hearkening back to *Breaking Bad*) is quite impressive and has spawned fan theories as to why certain references are included and, ultimately, why events line up the way they do. For example, in the flashback scene in the "Inflatable" episode, the camera shows a 1973 *Time* magazine displayed on a rack in Mr. McGill's store. That particular issue includes a feature on the Watergate scandal. When Jimmy confesses to Chuck in "Klick," Jimmy brags that the cover-up "would have made Nixon proud." Chuck records Jimmy's confession, and some fans speculate that the 1973 *Time* issue may well foreshadow the way in which Chuck uses the tape (blackmail à la the Watergate scandal). See Donald M. Reif's Facebook post from April 21, 2016, on the *Better Call Saul* fan group page. Even the episode names are clues to a puzzle: during the second season, the first letter of each episode name forms the phrase "Fring's back," foreshadowing the imminent arrival of *Breaking Bad's* kingpin Gus Fring.

Symbolism is also sprinkled liberally throughout *Better Call Saul.* For example, in "Amarillo," when Cliff calls Jimmy to scold him about airing the TV commercial without receiving permission, Kim and Jimmy are watching a movie scene with men drowning, as Jimmy soon will (metaphorically speaking).

33. Apparently, I am not alone in liking Jimmy McGill. In an interview, *Better Call Saul* writer, director, and executive producer Tom Schnauz stated that:

> We knew people would hopefully like the character.

I don't think any of us were prepared in the writers' room for how much people would actually love this character, given that they know who he is in the future as Saul Goodman, but we're very pleased…He's a real underdog, and you root for him. And it wasn't even intentional. We didn't decide in the beginning, "Let's make this character an underdog." He's trying his best. He's genuinely trying to be a good person and keep the promise that he makes to his brother. The flashback we saw in episode three where he says, "Just tell me what to do, and I'll do it." He does. He gets his crap together, and he becomes a very good lawyer.

Kimberly Potts, "'Better Call Saul' Postmortem: Writer Tom Schnauz Talks Jimmy's Heartbreak, Mike's New Job, and the Easter Egg Title," *Yahoo! TV*, March 31, 2015, https://www.yahoo.com/tv/better-call-saul-pimento-postmortem-115128743980.html.

The Many Faces of Our Favorite TV Lawyer

We know where he is now: a middle-aged man—current alias, Gene—working in a Cinnabon, staring nervously, and eyeing a customer who might be a threat.[1] But how did he end up here? Customers of that Cinnabon in Omaha, Nebraska, would be surprised to learn that the middle-aged man at the counter traded in his law degree—and his life of adventure—for a deep fryer.

Getting to Know Slippin' Jimmy/Jimmy McGill

We know that man—let's call him Jimmy McGill for now—from another life. We know that he grew up as "Slippin' Jimmy," a slick, scheming con man looking to make a quick buck off unsuspecting victims. He was

(and still is) a criminal, as he was jailed for committing a "Chicago sunroof"[2]—defecating through the open sunroof of a parked car belonging to a man named Chet (who had been sleeping with Jimmy's wife at the time)—an act which involved assault and property damage and carried with it the risk of being labeled a sex offender (since Chet's children, unbeknownst to Jimmy beforehand, were sitting in the car). But we have seen many sides of that criminal con man, and we find ourselves rooting for him to succeed. We have seen him fight against the perception that he is just a con man, even declaring to his brother, Chuck, that he is no longer the Slippin' Jimmy that Chuck grew up with. But fighting perception and fighting one's true nature are two distinct things. As we watch Jimmy pull off his schemes—staging fake car-hitting-skateboarders accidents, forging documents, or fooling the mass media and general public into believing that he saved a man dangling from a billboard—we realize that Slippin' Jimmy is a part of Jimmy McGill: a thorn in McGill's side, perhaps, but unquestionably still a part of him. As we will see, Jimmy, fueled by several factors, makes the conscious decision to embrace the Slippin' Jimmy side of his persona.

But so what? Slippin' Jimmy is, perhaps, at first glance, a simple small-time scam artist. He was admired and revered as a legend by his peers. Jimmy describes his former persona in the *Better Call Saul* episode "Uno" with a sense of pride and nostalgia:

> [Slippin' Jimmy] was the man. I mean, when he strolled down the street, all the corner boys would give him the high five. All the hottest babes would smile at him—and hope that he would smile back. They called him Slippin' Jimmy, and everybody wanted to be his friend.

But Slippin' Jimmy, as we also know, becomes an attorney. And that profession carries with it a great deal of responsibility—to society, to fellow lawyers, and, most importantly, to clients. It is not sufficient to show interest or passion in the law, or in the results that can be achieved from it. We learn that Jimmy has a passion for the law from a young age.[3] In "Nacho," when Chuck visits Jimmy in jail in a flashback moment, Jimmy excitedly implores Chuck to "work his magic" with "legal loopholes," a "bag of tricks," and "reasonable-doubt-type stuff." Knowledge of those loopholes is important for a lawyer's proficiency when serving clients. The bar, however, as gatekeepers of the profession, only grants licenses to those individuals that it believes are of sound character to practice law and thereby employ such loopholes in a responsible, professional manner. Honesty and integrity are essential attributes of members of the legal profession. In order to become a lawyer, one must not only pass the bar exam, but also a character and fitness test. The character and fitness requirement in New York, for example, provides that "Applicants for admission to the bar must show that they possess the personal qualities required to practice law and have the necessary character to justify the trust and confidence that clients, the public and the legal system will place in them."[4] The character of an attorney is considered so important that lawyers must adhere to a strict, ever-evolving landscape of ethical rules, and face stern rebuke and possible penalties (including, depending on the nature and severity of the violation, disbarment, or removal from the legal profession) for violations. One of America's most distinguished judges, Justice Benjamin N. Cardozo, stated that "Membership in the bar is a privilege burdened with conditions...a fair private and professional character is one of them...compliance with that condition is essential at the moment of admission; but is equally essential afterwards."[5]

We know that Saul Goodman would not have passed the character and fitness requirements in the state where he practices law (New Mexico). Jimmy McGill might stand a chance at passing, although one would suspect that Slippin' Jimmy played a role in helping to trick the examining board into believing that he was fit to serve as an attorney. Despite some positive traits, we constantly see Saul's character inside of Jimmy (as actor Bob Odenkirk noted during an interview conducted at the Ninety-Second Street YMCA before the series began).[6] Any reasonable observer would agree that an applicant as dishonest and corrupt as Goodman should not have been admitted to the bar. For all of Jimmy McGill's flaws, on the other hand, we do see some admirable qualities that serve him well as a lawyer: he works tirelessly on behalf of his clients; he digs through a garbage dumpster and attempts to pull an all-nighter to piece together evidence shredded by a corrupt senior center; he skillfully negotiates with Tuco—a crazed drug dealer—over how many body parts of McGill's associates to break; and he returns a significant "retainer" (also known as a bribe in this context) received from his corrupt clients, the Kettlemans. McGill demonstrates, in these instances, a penchant to work hard on behalf of his clients, selflessness, a unique set of negotiating skills, and distaste for accepting bribes. McGill is far from perfect, but he undeniably possesses certain human qualities that we can relate to—and, in some instances, even aspire to emulate. He has not yet descended into the darkness that is Saul Goodman, and we find him at least mildly praiseworthy until he ultimately embarks on his wayward journey off the deep end.

Jimmy's negotiation with Tuco in the season 1 episode "Mijo," for example, is nothing short of heroic, a topic to which we will turn again later in this book. After negotiating for his own release from a sadistic drug dealer who ini-

tially wanted to kill him, Jimmy goes back to negotiate for the release of two lackeys that Jimmy had become associated with shortly before the Tuco incident. Tuco expresses a strong desire to kill the boys, but eventually is persuaded by McGill to break just one of each of their legs. Jimmy saves their lives, rushes them to the hospital, and even pays their medical bills. He cares about the lives of two boys he just met, and puts himself at risk of physical harm when he negotiates on their behalf.

Jimmy's negotiation with Tuco is also significant because it allows us to see Jimmy at work, skillfully employing negotiating tactics. He successfully appeals to Tuco's love of his own family, just as a lawyer in a courtroom may try to pull at the heartstrings of jurors in order to sway them. Jimmy implores Tuco to make the "punishment fit the crime" (and nothing further) so that Tuco will come across as not only tough, but also "fair" and "just." Jimmy attempts to humanize the situation by pointing out that the two lackeys also have a hardworking mother who would be distraught if her sons were killed. Jimmy clearly gets through to Tuco: after Tuco breaks each lackey's leg, Tuco exclaims, "You say you're sorry to your mama, bitch!"

The Birth of Slippin' Jimmy: Of Wolves and Sheep

> "We look at the world once, in childhood. The rest is memory." ~ Louise Gluck

In the Showtime series *Dexter* (2006–2013), we watch protagonist Dexter Morgan engage in flashbacks to the moment when, as a young child, he witnessed the gruesome death of his mother. He was covered in her blood, and emerged from the awful scene as a different person. Throughout the series, Dexter returns to that

precise moment as the one that has shaped the rest of his life, declaring that he was "born in blood." Sensing the effect that the carnage had on young Dexter's psyche, his stepfather tells Dexter that it will be impossible for him to ever overcome that moment and become a normal person. Like Jimmy McGill, Dexter struggles with finding and accepting his identity throughout his entire life. Dexter becomes a serial killer and refers to himself as a "monster." *Dexter* shows us that a specific moment in one's life—especially when such a moment occurs at a young age—can alter that person's life in a significant way. *Better Call Saul* picks up on this theme, as we can trace the development of Jimmy McGill by returning to an identifiable moment from his childhood.

In the season 2 episode "Rebecca," Chuck tells Kim Wexler the story of the boys' father. Noting that Mr. McGill was honest to a fault, Chuck informs Kim that Jimmy stole $14,000 from the cash register of Mr. McGill's store, forcing Mr. McGill to sell the store and ultimately die six months later. While groups on the Internet continue to debate the veracity of Chuck's story, we see some evidence of the account during the season 2 episode "Inflatable." In a flashback, we meet a young Jimmy McGill. Jimmy is working in his father's grocery store and deviates from his task of sweeping the floors in the back of the shop to covertly read a *Playboy* magazine. Young Jimmy soon witnesses an exchange between his father and a man who walks into the store. The man seeks financial assistance from the elder McGill, claiming that his car broke down and he needs to rush to get medicine home to his sick child. Jimmy motions to his father and whispers that the man is pulling a scam—like others have apparently done in the past. Mr. McGill rejects Jimmy's warning and gives the man money. When Mr. McGill walks to the back of the store to find more

goods for which to provide assistance to the man, the man engages Jimmy in order to buy a couple of packs of cigarettes. Jimmy is visibly angered by the request, and it hurts him that the man has duped his father. But the man offers Jimmy some advice, telling him, "There are wolves and sheep in this world—wolves and sheep. Figure out which one you're gonna be." Jimmy hands the man the cigarettes and puts the money in the cash register. Applying the advice of the man, Jimmy has a change of heart and removes the money from the register and pockets the proceeds. At this moment, we witness the birth of Slippin' Jimmy.[7]

The wolf/sheep dichotomy will follow Jimmy throughout the rest of his life. While Bob Odenkirk has pinpointed Jimmy McGill's transformation into Saul Goodman as the precise moment in which the character's "innocence gets torn away,"[8] one could effectively argue that young Jimmy's innocence began to disintegrate following his encounter with the con man. As we watch Jimmy interact with others, it becomes clear that he feels an obligation to stray from his father's relentless honesty. For example, Jimmy expresses regret that he acted more like a sheep when he returned the Kettlemans' money, telling Mike that he will never again allow his conscience to get in the way of taking advantage of opportunities.

An analogy similar to the wolf/sheep dichotomy is also used in the 2014 biographical war film *American Sniper*. In the film, Navy SEAL sniper Chris Kyle receives some advice from his father, who notes that there are three types of people in the world: "wolves, sheep, and sheepdogs." (When I mentioned this reference in one of my conversations with *Better Call Saul* writer and executive producer Thomas Schnauz, he noted that he also recently saw the wolf/sheep reference in the movie *Training Day*).[9]

This particular analogy has found a home in the military

community and also with gun rights advocates.[10] The analogy, for example, was invoked by shock jock Howard Stern on his radio show following the June 2016 shooting massacre at the Pulse nightclub in Orlando, Florida. Stern compared most of the general public to sheep, while referring to the terrorists as wolves. He argued that the sheep are "sitting ducks," and that the idea of taking away their guns ("the ability of the sheep to protect themselves from the wolves") makes little sense.[11]

The original wolf/sheep/sheepdog description has its origins in "On Sheep, Wolves and Sheepdogs," an essay by Lieutenant Colonel Dave Grossman from the 2004 book *On Combat.* Grossman provides a description of each of the three types of people:

> If you have no capacity for violence then you are a healthy productive citizen: a sheep. If you have a capacity for violence and no empathy for your fellow citizens, then you have defined an aggressive sociopath—a wolf. But what if you have a capacity for violence, and a deep love for your fellow citizens? Then you are a sheepdog, a warrior, someone who is walking the hero's path.[12]

In the case of Jimmy, "violence" should be replaced with "causing harm." He is not a sheep, as he has the capacity for destruction and is willing to harm innocents by employing scams. Some may argue that he embodies the characteristics of a wolf, as his character is replete with destructive tendencies, some of which he cannot and will not control. He displays some empathy, though: he cares deeply about his female companion Kim Wexler;[13] he cares about, and takes on responsibility for, the well-being of his brother, Chuck, and he often exhibits devotion to his clients and

serves their needs. As he moves toward his transformation into Saul Goodman, we see the tendencies of an aggressive sociopath, but it is debatable whether he ever truly embodies the wolf.

At his finest, perhaps Jimmy can be best characterized as a sheepdog. Like a warrior, he is savvy and possesses uncanny street smarts. Jimmy is not going to be ripped off by others. If it comes down to a war, he will usually be the victor because of his ability to let loose and act ruthlessly. But Jimmy does sometimes let his guard down, especially when faced with his personal kryptonite,[14] Chuck. Chuck brings Jimmy to his knees when, in "Klick," Jimmy admits his forgery to Chuck and Chuck, in turn, records the entire confession.

Jimmy struggles with keeping himself on somewhat of a leash—a delicate balancing act that he maintains until he becomes unhinged and fully transforms into Saul Goodman. Jimmy is undoubtedly capable of causing destruction, but because he demonstrates that he also cares about his fellow citizens, one could argue that he possesses some heroic traits (a topic that will be discussed in great depth later on).

Jimmy's father is at least partially responsible for young Jimmy's desire to avoid becoming a sheep. Mr. McGill is simply too much of a pushover.[15] Having trust and faith in others can be considered a virtue when practiced in balance. When one becomes too trusting, it is inevitable that others will seek to take advantage. When presented with the stark choice of becoming like his father or the con artist in the store, Jimmy chooses the con artist. Jimmy views this as a matter of survival. He learns by watching his father and the con artist that there is no happy medium—one must become one type of person or the other. And if he wants to have some financial success in life and not be tricked by others, he must develop thick skin, toughen up, and seek to take

advantage of others (like the wolf) when possible. It is unfortunate for Jimmy that his father, as his main role model, does not exhibit a sense of balance in his economic dealings with others. And it is similarly unfortunate that Jimmy, at such a young age, receives the oversimplified (if not entirely misguided) advice about wolves and sheep. Jimmy never finds the happy medium that most people develop naturally when interacting with others. When confronted with morally challenging issues, most people will reflect on the situation and either act in accordance with a moral code or attempt to justify not acting in accordance with said moral code. When Jimmy acts in a morally questionable way, it is likely that he uses the wolf/sheep dichotomy and believes that acting in a morally questionable way is not only justified but required in order to maintain a reasonably successful life. Had Jimmy not seen his father taken advantage of so many times, perhaps he would have developed some form of a happy medium and not simply relied on a stranger's advice when confronted with ethical issues. And, as we know, he ultimately embraces a dark side that may ultimately have stemmed, in part, if not in full, from these moments that he experienced during his childhood. From Chuck's perspective, the stern lesson for Kim to learn from the account of Mr. McGill (and the associated wolf/sheep flashback scene and analogy) is that, like a wolf or a sheepdog, Jimmy, in Chuck's words (as he tells Kim during the "Rebecca" episode) "is not a bad person. He has a good heart. It's just—he can't help himself. And everyone is left picking up the pieces."

Jimmy's Dishonesty

> "If you're committed enough, you can make any story work. I once told a woman I was Kevin Costner, and it worked because I believed it." ~ Saul Goodman, *Breaking Bad*, season 3 ("Abiquiu," 2010)[16]

There are many instances of Jimmy McGill acting dishonestly in order to achieve a particular goal. He dupes potential clients into believing that he has a secretary and that his law office is under construction. In "Inflatable," he lies to the district attorney about Tuco not owning a gun. Sometimes (such as, in one elaborate scam employed during his Slippin' Jimmy days, effectively selling a fake Rolex for a significant sum), Jimmy is completely selfish and his actions entirely indefensible. Most of the time, he acts dishonestly in order to achieve the goals of his clients (such as "accidentally" spilling coffee on a detective so that his client, Mike Ehrmantraut, can steal the detective's notebook and lie about finding it in the parking lot; concocting apocryphal and colorful stories about "squat cobblers"; or, later on as Saul Goodman, offering tips to Walter White and Jesse Pinkman on money-laundering schemes). While it is fair to question whether McGill acts in such a dishonest manner in order to (selfishly) build up his own reputation as a go-to lawyer for criminals or because he firmly believes in the philosophical importance of strong advocacy—bordering on (and sometimes crossing the line of) breaking the law—on behalf of those accused of wrongdoing, it is clear that, at times, Jimmy has a moral compass even if many of his actions fly in the face of any notion of morality. That is not to imply, of course, that Jimmy's moral compass does not go awry at times or that it is not squashed and superseded by other factors—such as his desire to help Kim win back her client, Mesa Verde, by sabotaging both Chuck and Mesa Verde itself.

Some observers have pointed out that it is the ethical dilemmas faced by attorneys on television that make them seem more relatable to the average person. Legal scholar Carrie Menkel-Meadow, for example, observes that "An ethical dilemma (whether to turn over an incriminating

piece of evidence, whether to discredit a truthful witness, whether to sleep with the judge or juror or opposing counsel) forces the characters to make hard choices and makes professionals seem more like regular human beings."[17] We appreciate that Jimmy often pauses or hesitates before acting in an unfortunate manner or performing a misdeed. It is this contemplation that makes Jimmy (as opposed to Saul Goodman) a relatable character. Furthermore, Jimmy McGill at least demonstrates that he is not oblivious to— and sometimes even shows sympathy toward—the human condition.[18]

Jimmy's Moral Compass

Let's at least give Jimmy some credit: we see Jimmy's love and compassion for his family and friends.[19] He takes great care of Chuck (who believes he has a medical condition known as electromagnetic hypersensitivity) and, as a favor to Kim Wexler, Jimmy also exerts significant energy to convince the Kettlemans to return to Kim for legal representation.

Jimmy demonstrates a moral compass in other areas, too. We see him operate in ways that are far from reprehensible and perhaps even praiseworthy. In exchange for his will-writing services, for example, he charges a reasonable price to an elderly woman living on a fixed income and then further reduces it when she lacks the means to pay. He negotiates on behalf of the skateboarding lackeys, accepting the personal risk of harm to life and limb. He warns the Kettlemans about a threat (Nacho's) against them, again risking his own safety. When tempted by Nacho to rip off the corrupt Kettleman couple, he tells Nacho that "I'm a lawyer, not a criminal." When dealing with the Kettlemans later on, McGill tries to convince them to return the money that they stole. He also, at least initially, tells the Kettle-

man couple that he is a lawyer and therefore cannot accept their bribe—even though he ultimately accepts it (temporarily) as a "retainer," which he later returns to the pot of stolen money (noting, with a sense of disappointment, that he is "doing the right thing"). A major turning point in Jimmy's transformation into Saul occurs when he reflects back to this scene, as he questions the value of having a moral compass. At the conclusion of season 1 of *Better Call Saul* (in "Marco"), Jimmy engages in the following conversation with Mike, with whom he worked when returning the stolen money:

> Jimmy: What stopped us [from splitting the stolen money]?
> Mike: I remember you saying something about "doing the right thing."
> Jimmy: I know what stopped me. And you know what? It's never stopping me again.

It is Jimmy's conscience, or moral compass, that stopped him. His renewed desire to intentionally buck morality denotes an important change in his character, and is a fitting conclusion to the first season of *Better Call Saul.* The question of what led to the disintegration of Jimmy's moral compass—why he *chose* to transform into Saul Goodman—is the cornerstone of the series and merits examination.

Inflatable Man

In the season 2 episode "Inflatable," Jimmy seeks freedom and independence. He has had enough of his current gig/professional endeavor (i.e., working as an associate at Davis & Main). He will soon admit that he is simply a square peg that does not fit in with the firm's culture or environment, despite the significant opportunities afforded to him

by the firm. Jimmy realizes that in order to leave the firm
but retain the bonus he received, he must act obnoxiously
at work. He drives by a flailing inflatable figure on top of
a storefront. Smiling and moving effortlessly and carelessly
through the wind, the man represents adventure. Perhaps
more significantly for Jimmy's purposes, the inflatable man
also represents freedom and the opportunity to be a free-
wheeler while moving about relatively freely. Like the
inflatable man (who is tied down to the storefront), Jimmy
is tied down by certain immutable rules (including those
related to his profession). But both Jimmy and the inflat-
able man do have some power: Jimmy has the power to
not adhere to certain societal norms if he so chooses, while
the inflatable man can move his head as freely as the wind
permits.[20] The freedom to choose to dress like the inflat-
able man is important for Jimmy's psyche and mental well-
being.

Despite being tied to the top of the storefront, the
inflatable man is unleashed in a more symbolic way: he is
dressed in sharp, Saul Goodman-like attire—a yellow tie
with polka dots, a bright red suit, and a green shirt to boot.
Jimmy stares at the inflatable man and smiles. As we know,
Jimmy will adopt the colorful garb of the figure, and with
it, take a big step toward his transformation. And, in a nod
toward the inflatable man, he later acknowledges to Kim
that he will run his own law practice in a "colorful" manner.

Jimmy's introduction of the colorful attire takes on sig-
nificance because of what inspired him to dress in this way.
Sure, he needed to act oddly at work in order to lose his
job. But like the inflatable man, it is clear that Jimmy wants
to pave his own path, and dressing in a free manner with
no apparent restrictions is an overt statement to that effect.
It represents Jimmy's purest expression of his creativity,
independence, and rebelliousness. Clearly rebelling against

bland authority figures, Jimmy's garb reflects a deep desire to stand out and do things his own way. As Bob Odenkirk stated, "The tube man reminds [Jimmy] that maybe a part of him likes to be flashy and stick out."[21]

A Square Peg in a Round Hole

When Jimmy first decides to accept the position at Davis & Main, it is clear that he does so in order to please Kim. (He later explicitly acknowledges this: in "Inflatable," he tells Kim that he's "been trying to be the person someone else wants me to be for—I don't know how long; first it was Chuck, then it was you.") From the moment he arrives at Davis & Main, Jimmy appears to be unimpressed by his surroundings. While most associates would have been enamored of the firm,[22] it is clear from the outset that the pleasantries, perks, and seemingly endless resources do not suit Jimmy's style. Unlike most associates, he does not simply sit back and enjoy the conveniences of big firm life (while, of course, working exceedingly long hours). Case in point: he cannot even fall asleep in the new apartment that the firm bought for him, and he hates the company car because the cup holder does not properly fit his "World's 2nd Greatest Lawyer" cup). Jimmy is not sufficiently appreciative of his large, ornately designed and decorated office, his resourceful and friendly assistant (Omar), the $7,000 cocobolo[23] desk the firm purchases for him. While he is free to choose his office paintings and type of desk, Jimmy's main focus is violating the only rule that is explicitly posted in the office: a warning not to pull a switch. Jimmy is thoroughly annoyed by the fact that the firm requires a junior associate to follow his every step. He refuses to recycle, despite being directed to do so by Erin, the junior associate. He types with one finger, which sharply contrasts with the fast-paced nature of a high-profile law firm. He believes

that using the firm's particular writing style is a waste of time. He thinks that the firm, though quite successful, is not using sufficient "showmanship" to attract potential clients through television commercials. Although he does not mind working late hours, he wants to do so by his own accord and on his own terms—not because Erin wants to schedule a late-night meeting (which he unceremoniously abandons without alerting her in "Rebecca."). At every turn, Jimmy demonstrates that he does not fit within the firm's culture and is outside of his element.[24] Jimmy intentionally (and creatively, by acting like a jackass) gets himself fired so that he can retain the bonus he received from the firm: his antics include not flushing the toilet after use, wearing inappropriately colorful suits to business meetings, playing the bagpipes loudly in his office, and ruining others' clothing with the output of his noisy juicer.[25] Upon leaving the firm, he acknowledges to partner Cliff Main that he was a "square peg" and simply did not fit in with the firm's culture.

The scene in the season 2 episode "Bali Ha'i," in which Jimmy destroys the cup holder in the Davis & Main company car so that his lawyer cup fits, is perfectly equivalent to Jimmy's experience within the firm: neither he nor his cup fit. Upon Jimmy's departure from the firm, there is some evidence that his experiences there had a positive impact on him. He purchases the cocobolo desk from Davis & Main, perhaps so that he can always retain a symbolic connection to the firm. And perhaps more tellingly, he changes his mind about recording a voicemail message using the voice of a nonexistent secretary upon returning to his closet office in the nail salon. Perhaps the straitlaced culture at Davis & Main had a positive (though as we know, ultimately fleeting), influence on Jimmy.[26]

As Jimmy will come to realize, he is quite far from a prototypical white-shoe lawyer. Because he goes against the

grain so frequently, it is difficult for him to find a place where he feels at home. That is, until he transforms more completely.

What's in a Name? The Transformation of Jimmy McGill into Saul Goodman

In *Breaking Bad*'s season 1 episode "Crazy Handful of Nothin'" (2008), Walter White describes to his high school chemistry class two types of chemical reactions:

When a reaction is gradual, the change in energy is slight. I mean, you don't even notice the reaction is happening…Explosions [on the other hand] are the result of chemical reactions happening almost instantaneously. The faster reactants, i.e., explosives…the faster they undergo change, a more violent explosion.

Walt's dark descent contains elements of both the reactions described above. His initial character shift is relatively gradual, although it is clear very early on that Walt lacks a strong moral foundation. From the start, we learn that he is willing to cook meth if doing so allows him to reap significant financial rewards. The more significant change in his character occurs as he relinquishes his fear, and drops his resistance and objection to violence: once he is comfortable with the "explosions," his character "breaks bad" at a quicker, more intense pace. He is no longer afraid of who might attempt to harm him in his home. Instead, he becomes (in his own ominous words) the "one who knocks."

Jesse Pinkman picks up on the theme of acceptance. He realizes that he has started down a very dark path, and he accepts and embraces his place in the world. In *Breaking Bad*'s season 3 premiere episode, "No Mas" (2010),

Jesse states that "You either run from things or you face them…It's all about accepting who you really are. I accept who I am…I'm the bad guy." As we know, Jimmy McGill will one day accept his role in society as the "bad guy," the "criminal" lawyer, once he transforms more fully into the character of Saul Goodman.[27]

His change in persona is gradual, as we see internal elements of an identity battle within the character. It more directly mirrors the first type of chemical reaction described by Walt. As Peter Gould stated in an interview conducted at the end of season 1 of *Better Call Saul*, "Is Saul somebody who is birthed all at once, or is it an evolution? I think probably we'll find that Jimmy's progress to Saul—progress or descent, depending on how you look at it—into becoming Saul Goodman is not something that's going to happen all at once. It's like how the road to hell is paved with good intentions.[28] The road to Saul Goodman is paved with frustrations and also, oddly enough, some very positive intentions."[29] And as we watch Jimmy struggle immensely with defining his identity and forging a path in life, it is noteworthy that we witness him in various stages. We see that Jimmy possesses certain prerequisites for being a dishonest criminal, but had we not been introduced to Saul Goodman, we would not know where this character would end up. As columnist Gita Jackson notes, Saul is "blessed with a sharp tongue and a quick mind, a skill for bullshitting and sizing up the person in front of him. He's built to be a criminal, but he doesn't want to be one."[30] As a result of several life experiences, Jimmy feels that he must become someone else, and yet he need not struggle to suppress the Slippin' Jimmy side of his character. He can embrace those character traits as part of his new persona.

The specific moment in which Jimmy changes his name

to Saul represents a marked change in Jimmy's character: Jimmy has now given up on *any* prospect of becoming a respectable lawyer at a white-shoe firm. For some people, their job is not a defining characteristic of who they are— but as we will see, Jimmy's job and persona are intertwined. In fact, Jimmy's choices in his career directly mirror his descent. For example, Jimmy earlier represents elderly clients, which speaks volumes about his character at that point in time. Helping elderly clients with their legal issues, while charging them a reasonable fee for doing so, is admirable and a worthwhile contribution to society. When he transitions into the Saul Goodman character, we do not witness him representing any elderly clients. Instead, his new clientele largely consists of those individuals scheming to cheat, game, and beat the system. While there is a societal need and benefit to representing criminal defendants, the fact that Saul has chosen to leave behind his elder-law practice in lieu of representing scumbags more than hints at a transformation in his character and agenda. Worse, of course, is the fact that Saul participates in, helps to build, and often even directs his clients' criminal enterprises.

Significantly, as noted previously, the opportunity for Jimmy to work at a big law firm (with a partnership track) presents itself in the season 1 finale of *Better Call Saul.* In "Marco," Kim arranges for an interview for Jimmy with one of HHM's peer white-shoe firms, Davis & Main. As he is walking through the parking lot en route to the interview, Jimmy hesitates and stares at the pinky ring from his deceased scammer-accomplice Marco. (We learn in the season 2 premiere episode "Switch" that Jimmy goes into the firm, briefly meets the attorneys, but at this point in time walks away from the job opportunity.) He walks back into the parking lot, expresses regret (in a brief conversation with Mike) about not stealing the Kettlemans' (stolen)

money, and promises not to let any sort of moral compass stop him from engaging in similar actions in the future. The final scene in "Marco" depicts two yellow lines in the street—a prelude to season II, perhaps, or, alternatively, a metaphor for ethical lines that must not be crossed.[31]

Saul, as we know, *will* cross those ethical lines. As Bob Odenkirk notes about Jimmy's final moments in season 1, "He's going to cut loose and I feel great about it. One of the things people do in life is they overcompensate. So he may well be overcompensating by becoming Saul Goodman for his brutal and emotionally destructive desire to please his brother and gain the respect and admiration of a bunch of people who aren't going to give him it—ever. He may be overcompensating now by becoming Saul Goodman and letting all ethics fly out the window. And indulging his natural proclivities for verbosity and ethically carefree behavior."[32]

Once Jimmy does transform into Saul, we can tell that the character has changed significantly—not only in deed but in nature. In order to be a Saul Goodman type of individual, one must not only be thoroughly divorced from morals and ethics, but also be largely emotionally detached from most of the world: on *Breaking Bad*, there is no evidence that Saul has any friends or that he really cares much about anything at all. During the season 4 "Open House" episode of *Breaking Bad* (2011), Saul tells his clients Walter and Skyler White that "The number one rule is 'Don't take things personally.'" One may argue that Saul is so detached[33] and removed from the human condition that he takes nothing personally, and does not expect others to take things to heart after he inevitably betrays them at an opportune time.

The Name Game

The "Saul Goodman" name is intended to put clients at ease and instill confidence: when clients knock on Saul's office door, they can be assured that "it's all good, man." Even before we formally meet Jimmy McGill in *Better Call Saul*, we are made aware of Saul's real name and the reason behind the change: "My real name's McGill," Saul explains in "Better Call Saul," a season 2 episode of *Breaking Bad* (2009). "The Jew thing I just do for the homeboys. They all want a pipe-hitting member of the tribe, so to speak."

Saul's rationale for using a Jewish-sounding pseudonym calls to mind other instances of such intentional misdirection in popular culture. In the season 2 *All in the Family* episode "Edith the Judge" (1972), Archie Bunker, in need of legal counsel, proudly proclaims, "I'm gonna go into town and get me a good Jew lawyer." In the season 1 *All in the Family* episode "Oh, My Aching Back" (1971), Archie expresses frustration—and demands representation by the Jewish owner of the firm—when, after retaining the firm of Rabinowitz, Rabinowitz and Rabinowitz to represent him, a "token gentile" shows up at Archie's doorstep. In a season 8 episode of *Curb Your Enthusiasm* ("The Divorce," 2011), Larry David fires his divorce attorney, Andrew Berg, after finding out that Mr. Berg is not Jewish. Andrew Berg might well have been the attorney's real name, but he seems to intentionally make a number of Jewish references and have Jewish keepsakes in order to convince clients that he is Jewish. Larry replaces Berg with a Jewish attorney (Hiram Katz) and finds out the hard way that not all Jewish lawyers are great lawyers.

Saul intentionally—in a bigoted manner—chooses a Jewish name in order to attract clients. One could argue that he is committing a fraud on potential clients by inten-

tionally posing (and falsely advertising himself) as someone with a different background: not that the faith, creed, or background of one's counsel should have any bearing whatsoever on the perceived skills of said counsel. Like Andrew Berg, Saul chooses to promulgate a particular perception of himself in order to attract clients.

The Scrappy Lawyer

We know that Jimmy McGill, at one point, aspired to be a different kind of lawyer—the kind of lawyer that society respects, not the kind of lawyer, as the Kettlemans put it, that "guilty clients" retain (in direct contrast, from the perspective of the Kettlemans, to HHM). The fact that Jimmy is not viewed by potential clients as a legitimate, respectable lawyer hits him hard. He wants to work at the white-shoe firm HHM, alongside his brother Chuck. That opportunity is not in the cards for him, as the firm rejects his request for employment as a lawyer.[34] We know that Jimmy was previously employed as a mailroom clerk at HHM, and secretly took online classes at the University of American Samoa law school. Jimmy's never-give-up, hardworking nature and attitude are demonstrated by the fact that he failed the bar exam twice before passing on the third try. (As previously discussed, Chuck is strongly opposed to the idea of hiring their mailroom-clerk-turned-lawyer as a lawyer at HMM. In fact, as we learn in "Pimento," Chuck sabotages any chance Jimmy had of being hired by HHM by calling the head HHM partner and demanding that he not hire Jimmy). Had Jimmy McGill been hired by HHM, his career and persona would undoubtedly have been different—although he likely would have experienced some struggle with fitting in, as evidenced by his short tenure at Davis & Main. White-shoe-firm Jimmy McGill would probably still have had some Slippin' Jimmy in him, but

one would imagine that he would not have been the type of scrappy, underhanded, underdog lawyer that he had to become in order to survive in a world of HHMs and fierce competition for clients.

Even though Jimmy does ultimately accept a position at the white-shoe firm Davis & Main, his rebellious ways are on display from his first day at the firm, as he quickly breaks the rules by pulling a switch in his office clearly marked with the warning "Always leave ON!!! Do NOT turn OFF!" We will never know for sure whether Jimmy would have acted rebelliously at HHM had Chuck not intervened. One of the great mysteries of the series is what kind of person Jimmy would have turned out to be had Chuck shown a modicum of respect for him.

The HHMs of the world become Jimmy's enemies and he must find a way to differentiate himself from them—and one of the ways to separate himself is to operate by employing the scheming, underhanded tactics of Slippin' Jimmy. But based on his previously expressed desire to work at HHM alongside Chuck, there seems to be little question that Jimmy would have preferred to work as a white-shoe lawyer—if Chuck approved[35]—over the life of an underdog schemer, which he arguably had to live in order to compete effectively and eke out a reasonable livelihood.

What we see very early on in *Better Call Saul* is that Jimmy McGill is a complicated character, with many more dimensions than the Saul Goodman character into which he later transforms. It seems that, at a minimum, McGill takes great pride in advocating on behalf of his clients and is very grateful for the business he receives from them. He seems to take pride in preventing his clients from falling victim to the very types of fraud that he himself likely would have engaged in, such as his advocacy on behalf of

the elderly people who were being taken advantage of in an elaborate RICO scam.

Client Representation

"If there were no bad people, there would be no good lawyers." ~ Charles Dickens[36]

"Some people are immune to good advice." ~ Saul Goodman, *Breaking Bad*, season 5 ("Confessions," 2012)

Ah, to be a client of Mr. Saul Goodman! At times, Saul professes his devotion to his clients ("I live to serve!" he declares in the season 5 "Blood Money" episode of *Breaking Bad* [2012]). At other times, however, he articulates complaints about, and disdain for, his clients, exclaiming to Walt and Jesse in the season 4 episode "Face Off" (2011) that "If I ever get anal polyps, I'll know what to name them!"

Although he still works hard on behalf of clients, we will see that Jimmy McGill/Saul Goodman must act a bit more selfishly at times: he has a backstabbing brother and he knows that other lawyers—and many potential clients—do not respect him. This has hardened Jimmy, and when he transforms into Saul, he adapts by looking out for himself, even if that means the blatant betrayal of a client and violation of ethical rules, such as those relating to conflicts and zealous representation of clients.[37] In "Nailed," we see that Jimmy is willing to cost Mesa Verde time and money by sabotaging both Mesa Verde and Chuck in an effort intended to help Kim. In the season 3 "Mas" episode of *Breaking Bad* (2010), Jesse Pinkman picks up on the betrayal in the following exchange:

Jesse: What in the hell just happened? You're *my* lawyer, not his!

Saul: It's the way of the world, kid. Go with the
winner.[38]

Jimmy McGill may not have so easily betrayed a client,
and certainly would not have chosen to side with the
"winner,"[39] unless he considered the consequences of not
betraying the client to be significant. McGill—in his role as
an attorney, at least—is not nearly as opportunistic as Saul,
and would not so easily violate rules regarding advocacy and
representation. Saul and Jimmy both fight for the underdog,
but McGill is more loyal and we see no evidence that he
would drop a client to side with the winner. Saul is simply
an opportunist.

Saul, of course, is willing to engage in much worse
behavior with respect to his clients. In season 2's "Better
Call Saul" episode of *Breaking Bad* (2009), for example, he
advises Walt and Jesse to kill Saul's client (and Jesse's friend)
Badger. It does not get much worse than conspiring to kill
a client!

Jimmy's Internal Struggle

"The very nature of people is something to be overcome."
~ Steve Jobs in the film *Steve Jobs* (2015)

Despite Jimmy McGill's many flaws, we root for him to
succeed because he is a very relatable character. He admires
cunning individuals, and this admiration informs his work.
He pointedly observes that "You assume criminals are
going to be smarter than they are. Kind of breaks my heart
a little." We see him struggle to fight against creeping into
Slippin' Jimmy mode, and even though he often fails in this
struggle, we rally behind him because we see that he is at
least trying to better himself. Jimmy wants something more

out of life than simply deceiving people to earn a few bucks. In "Hero," he tells Marco (after the conclusion of one of their Rolex schemes) that the scheme is "good for making beer money. That's about all." Jimmy is acutely aware that such schemes will bring him neither prominence (at least to anyone other than Marco) nor financial security.

He works endlessly on behalf of his clients, and we wish that he had the means to move out of his closet office in the back of a nail salon and purchase the big office that he was eyeing. We sympathize with him because of the way that his brother treats him: instead of encouraging Jimmy or being proud of him, Chuck (in "Pimento") tells Jimmy that he is "not a real lawyer," and argues that Jimmy is not worthy of association with the HHM brand. As the underdog in his fight for legitimacy against HHM, we support Jimmy's attempts to win over clients with his shtick (which, as we will learn, is far from fully formed while he practices law under the name of Jimmy McGill). Jimmy works late nights, uses creativity, employs strong advocacy and negotiation skills, and appears to just want his hard work to pay off by becoming a reasonably successful—perhaps even respectable—lawyer.

Better Call Saul goes to great lengths to demonstrate to viewers that Jimmy McGill has boundaries that he will not cross or will cause him to feel guilty if he's forced to cross. In this way, we see that Jimmy has not *fully* embraced the "sheep versus wolves" dichotomy to which he was exposed as a child, and instead allows some room for measured reflection. This is one of the many reasons that Jimmy McGill is a relatable, intriguing character. We know that he will employ scams, but we also know that he will work hard on behalf of clients—even telling his buddy Marco that he needs to return to New Mexico because his clients are relying on him. He gives discounts to senior citizens,[40]

fights uphill battles against bullies, and, at times, even works for the greater good. That is not to say that Jimmy McGill is a clean, ethical lawyer constantly fighting for justice. He acknowledges his flaws, asking rhetorically in the season 2 episode "Cobbler," "Who among us is without sin?" But he does, sometimes, in his own words, try to "do the right thing." The same cannot legitimately be said about Saul Goodman, as we watch Saul cross most ethical lines.[41] As we watch Jimmy begin his remarkable and tragic descent, we see him become resigned to the fact that his Slippin' Jimmy persona is difficult to escape.

Saul's most notorious client, Walter White, flatly tells him, "You're not [the widely respected lawyer] Clarence Darrow, Saul," to which Saul exclaims, "Yeah? Well, Clarence Darrow never had a client like you!"[42] The fiery exchange hits home the point that Saul's actions and persona must be viewed in the context in which he practices law. His choice to take on the representation of society's scumbags places him in a difficult position if he wants to advocate zealously (as he may be required to do under ethical principles and rules promulgated in many states) on behalf of said clients. That is not to say, of course, that criminal defense lawyers are permitted to commit crimes if doing so aids in their representation of clients. (They are, of course, prohibited from doing so under all sets of ethical rules.) But considering Saul's client base, the influence of Slippin' Jimmy, and Saul's desire to eke out a reasonable living as an attorney, it is not altogether surprising that Saul leaps to the dark side, creating an imbalance in the scales of justice and crossing the metaphorical line between zealous advocate and criminal. Saul might not be Clarence Darrow, but he likely would have been a more respectable lawyer if he'd had the opportunity to be employed as a white-shoe lawyer at a firm like HHM—without the negativity from

Chuck that he had to deal with while employed by Davis & Main.

Chasing Rainbows

> Why have I always been a failure?
> What can the reason be?
> I wonder if the world is to blame
> I wonder if it could be me
>
> ~ Joseph McCarthy, "I'm Always Chasing Rainbows"[43]

By continuously attempting to impress Chuck and gain a solid reputation with the big players in the legal professional community (including the other partners at HHM), we see that Jimmy is, in the words of songwriter Joseph McCarthy, "chasing rainbows" that appear to be out of reach so long as he remains Jimmy McGill. Jimmy will need to find out for himself whether he is to blame for his failing legal career or whether he can resurrect his career and life by transforming into Saul Goodman. If Jimmy's previous rainbows were admiration and legitimacy, Saul's rainbow is survival. We can picture Jimmy singing McCarthy's song and internalizing the meaningful lyrics, which read, in part:

> I'm always chasing rainbows
> Watching clouds drifting by
> My schemes are just like all my dreams
> Ending in the sky
> Some fellas look and find the sunshine
> I always look and find the rain
> Some fellas make a winning sometimes
> I never even make a gain[44]

As noted earlier, the writers of *Better Call Saul* embed

a great deal of imagery and symbolism within the show. Their use of rainbows serves as a prime example. *Better Call Saul* produced a billboard image that depicts Jimmy overshadowed by dark clouds and a rainbow. The Post-it notes that we see Kim use in "Rebecca" when making phone calls seeking job offers include colors of the rainbow. And in "Inflatable," Jimmy purchases suits that include some rainbow colors. And perhaps most significantly, the common space in the Wexler and McGill[45] office includes a painting of a rainbow. In "Nailed," Kim stands next to the wall, right at the end of one side of the rainbow. By standing there, she is telling the audience that she has reached the end of the rainbow—which is symbolically known as a cause for celebration and great excitement at what adventures may lie ahead.

Many cultures and religions have placed special emphasis on rainbows. Following the flood in the biblical account of Noah's ark in the Book of Genesis,[46] for example, God made a rainbow and said:

> I have put my rainbow in the clouds, and it will be the sign of the covenant between myself and the world. When I send clouds over the earth, the rainbow will be seen in the clouds, and I will remember the covenant between myself and yourselves and all living souls, and there will never again be a flood to destroy all life. The rainbow will be in the clouds and I will see it and remember the eternal covenant between myself and all the living souls on earth.

As Rabbi Mendy Kaminker observes, "After the Flood, the Creator promised that—in spite of how man might

sin—He would never again make a flood that would destroy the world. He created the rainbow as a sign, a reminder of this covenant He made with the world."[47]

We know that as Slippin' Jimmy and Jimmy McGill, our protagonist has not always behaved appropriately when his actions are examined against existing norms and moral codes. But perhaps his choice of colorful suits can be seen as symbolic of the fact that despite his sins, he will survive. And the sight of a rainbow in his new common space depicts the potential for a brighter future ahead.

Other commentators have stated that the rainbow signifies new opportunity. Avia Venefica lists (among others) the following questions as "Potential Messages of the Rainbow":

- Is it time to take a fresh look at opportunities available to us?
- There is always another way. What other options can we see?
- Are we prepared to move into a new light, and see things with a new perspective?
- Are we ready to cross over from one phase of life to another?[48]

All of these potential messages are relevant to Jimmy's journey throughout life. It seems that the colors of the rainbow follow him wherever he goes.

Jimmy and Saul may each have a good run, but as we know, the ultimate outcome of their adventures (and misadventures) is not a rainbow but a dark rain cloud. Their schemes, in the words of McCarthy, uniformly "end in the sky" as they achieve short-term, fleeting gains at best, and never get either character very far. The closest thing to a rainbow that our favorite lawyer finds at the end of his journey are the rainbow-colored sprinkles in the Cinnabon

shop where he finds refuge after his inevitable and drastic downfall.

Cinnabon

Popular music lyrics are an ideal place to look when analyzing Jimmy McGill's life journey. In the song "Golden Slumbers" and "Carry That Weight,"[49] Paul McCartney reflects on a time during which it was possible to find one's way back to a peaceful state of mind ("home"), but laments that the burdens that one carries can adversely affect his ability to do so. Perhaps the individual longs for a past time, during which he was a different person. The individual might seek refuge in a nondescript location (consider The Beatles' reference to a place to "hide away" in the song "Yesterday."[50] And in the song "Reflection,"[51] Christina Aguilera sings about one's mirrored reflection not accurately representing one's true nature. She ponders whether the individual will be forced to conceal her true identity in perpetuity and whether the reflection that the world sees will ever serve as an accurate portrait.

Cut to that Cinnabon shop located in a mall somewhere in Omaha, Nebraska. Here we find a man who is not at peace with himself, a man who cannot find his way in life. He is also a man whose outward reflection does not reveal his underlying identity or nature. This is a broken man.

⚖️

Philosopher Marshall McLuhan observed that "The name of a man is a numbing blow from which he never recovers."[52] As we watch Jimmy struggle immensely with his identity, we know that we will witness the birth of Saul Goodman and the future transformation into Gene, the Cinnabon employee. We also know that this character

cannot escape his past or any of his former identities. We do wonder, however, whether Gene can prove McLuhan wrong and thrive in his new place in the world—as manager of a Cinnabon in Omaha, Nebraska, or perhaps in some new, yet-to-be-defined role.

The Cinnabon imagery and symbolism in *Better Call Saul* is unmistakable. We know that Gene's life is not nearly as sweet as the rolls that he prepares. "Switch" begins with a cinnamon roll swirling, arguably representing the twists and turns in Saul's life. A worker is seen brushing away some crumbs—perhaps representative of what little remains of Saul's former life. But, looking back at that Cinnabon, we know that Saul Goodman (or "Gene") has something else up his sleeve. He does not want to remain stuck in his new identity, and his desire to break free from his prisonlike trap is crystallized when we see him locked in the mall's garbage room in the opening to "Switch." Had he taken more precautions during his life (and, as Gene, ensured that the door would remain open while he took out the trash), he would not be stuck in his current position. He is both literally and figuratively trapped in a life and new identity that resembles a pile of garbage. It is also telling that the song playing in the background is Billy Walker's version of "Funny How Time Slips Away."

When Gene sees the opportunity to escape from the locked room by pulling on a lever that would alert the police, we wonder whether Gene has changed in a fundamental way. Later on in the episode, Jimmy pulls on a switch in his new office, in defiance of a sign warning him not to do so. But as Gene in the garbage room, we can speculate that perhaps he does not pull the lever out of fear of being caught by the cops and having his identity exposed. On the other hand, perhaps Gene has taken on a new persona and become an individual who no longer

seeks to bend the rules or subvert figures of authority. Or, as Thomas Schnauz posited, "When Gene is thinking 'Who would have the nerve to do what I want to do, but can't,' it was Saul Goodman."[53] Perhaps Gene simply cannot bring himself to pull the lever because he has become resigned to the fact that he has failed as Saul Goodman. But again, we have never known this character to become resigned to *anything*, except, perhaps, to the fact that he cannot continue to pursue the delicate balancing-of-morality act that defines Jimmy McGill. He is always seeking to change things—to switch things up—and we firmly believe that we have not seen the last of Saul Goodman. Gene reminds us that Saul has not completely disappeared from his psyche as he carves the words "SG was here" onto the wall of the garbage room in a poignant moment of defiance.[54]

We undoubtedly note (but ultimately disregard) the irony of the statement printed on the Cinnabon sign that Jimmy places outside of the storefront: "never had it so good." We know that Gene once had a much different life. Ask yourself whether that former life was better for himself personally or for those around him, given the profound destruction and wreckage that he caused.

We even have to acknowledge that the Cinnabon job was part of his plan if things did not go well. Predicting his own downfall after the Walter White situation went south, Saul presciently states, "If I'm lucky, in a month from now, best-case scenario, I'm managing a Cinnabon in Omaha."[55] He is a planner and a risk taker, and like any good lawyer, is known to warn his clients to have backup plans in case things do not go as planned. (When speaking to Walter White, for example, Saul asks him, "Did you not plan for this contingency? I mean, the Starship Enterprise had a self-destruct button. I'm just saying."[56]) It is difficult for us, however, to believe that Saul will simply accept his fate

as Gene, the Cinnabon employee. As our protagonist has shown us—first as Slippin' Jimmy, then as Jimmy McGill, and finally as Saul—it is indeed quite hard to keep a "Good Man" down.

<p style="text-align:center">⚖️</p>

As the rich backstory of our protagonist unfolds, we learn a great deal about two of the most influential people in Jimmy's life: his older brother, Chuck, and his friend (and fair-weather lover) Kim Wexler. These characters have also led intriguing lives, and we will take a close look at each of these individuals in turn.

Notes

1. The television audience is made aware of where Saul has ended up, but nobody in Saul's world is privy to that information. When we are first introduced to Gene, "Address Unknown" by the Ink Spots (1960) plays in the background, a throwback to the circumstances that landed Gene in this Cinnabon. He is hidden from the world, and he must not allow anyone to learn his true identity. The first scenes of the series are shot in black and white for emphasis: Gene is alone in a dreary world of his own creation.

2. When the "Chicago sunroof" is first referenced during the first season of *Better Call Saul,* the audience is simply informed that it is this action that landed Jimmy in prison. Prior to learning the definition of a Chicago sunroof in the season 1 finale, there was intense speculation on the Internet about the meaning of the term, and the phrase even appeared on urbandictionary.com.

3. In "Switch," however, Jimmy acknowledges that "I got into law for all the wrong reasons." That is not to say that Jimmy is not intrigued by the malleability of law; it's more likely an acknowledgment that had it not been for his desire to impress

his brother, he might not have worked so hard to become an attorney.

4. "Are You Fit to Be a Lawyer?" New York State Lawyer Assistance Trust, http://www.nylat.org/publications/brochures/documents/characterandfitnessbrochure09.pdf.

5. Ibid.

6. "Better Call Saul: Bob Odenkirk, Michael McKean and Jonathan Banks," February 5, 2015, http://www.92yondemand.org/better-call-saul-bob-odenkirk-michael-mckean-jonathan-banks.

7. We learn that Jimmy continued his wayward path during his youth. In "Nailed," Chuck informs Kim that Jimmy ran a thriving fake ID business during high school. Chuck compares Jimmy to Mozart because they "both started young."

8. Tim Appelo, "'Better Call Saul' Star Bob Odenkirk Teases Season 3: 'Innocence Gets Torn Away'," *The Wrap*, August 17, 2016, http://www.thewrap.com/better-call-saul-star-bob-odenkirk-teases-season-3-innocence-gets-torn-away-video/.

9. Much like other pop culture phenomena with significant depth (such as *The Simpsons*), *Better Call Saul* includes a number of both mainstream and somewhat obscure pop culture references. Both *The Simpsons* and *Better Call Saul* masterfully embed their episodes with such references without alienating those who might not catch them. Irrespective of whether one links the "sheep versus wolves" quote to popular movies, the dialogue in *Better Call Saul* more than stands on its own and merits serious critique and attention. More broadly, cocreator Peter Gould mentioned in the May 21, 2016, panel at the Vulture Festival that the writing team is influenced by movies spanning different generations (from the 1930s to much more modern films). The rich tapestry that is *Better Call Saul* stands on the shoulders of many classic influential films and aspects of popular culture. The writing team acknowledged at a panel held at the Writers Guild Theater on May 26, 2016, that many of the more dramatic scenes and sequences in *Better Call Saul* feel more like film scenes than television scenes.

10. Michael Cummings and Eric Cummings, "The Surprising History of *American Sniper's* 'Wolves, Sheep, and Sheepdogs' Speech," *Slate*, January 21, 2015, http://www.slate.com/blogs/browbeat/2015/01/21/american_sniper_s_wolves_sheep_and_sheepdogs_speech_has_a_surprising_history.html.

11. Ron Dicker, "Howard Stern Uses Sheep-and-Wolf Analogy to Denounce Gun Control," *The Huffington Post*, June 16, 2016, http://www.huffingtonpost.com/entry/howard-stern-gun-control_us_5762c1b0e4b0df4d586f6733.

12. Dave Grossman and Loren W. Christensen, *On Combat: The Psychology and Physiology of Deadly Conflict in War and in Peace* (PPCT Research Publications, 2004).

13. In the season 2 episode "Fifi," Kim is thrilled about the possibility of retaining her bank client, Mesa Verde, and smiles. Demonstrating how deeply he cares about Kim, Jimmy stares at her and warmly tells her: "I love seeing you like this." Her chance at attaining happiness makes him genuinely happy. Jimmy's actions in "Nailed" (forging documents in an effort to embarrass Chuck and convince Mesa Verde to return to Kim as a client) demonstrate that his love for Kim trumps any desire not to cause harm to innocents (e.g., Mesa Verde), or to restrain himself from seeking revenge on Chuck.

14. On *Breaking Bad*, we can identify Jesse Pinkman and Walter White's kryptonite as well. Jesse seems to draw a line in the sand when it comes to children growing up surrounded by, and even selling, drugs. Jesse repeatedly seeks revenge against those who put children in the vicinity of the drug world. And Walt displays compassion toward Jesse when he saves Jesse's life during his attempt at seeking revenge against the drug dealers who killed Tomás (an eleven-year-old boy). Walt's momentary display of humanity enrages Gus, but also demonstrates to the audience that Walt is capable of feeling compassion, at least in some capacity.

15. Perhaps the same can be said about the root causes of Nacho Vargas's decision to become a drug dealer. In the season 2 episode "Cobbler," we meet Nacho's father. Nacho's father is an extremely honest man: he directs Nacho not to upsell Mike when Mike comes to their car lot looking to purchase new seat upholstery, and even tells Mike not to invest anything because Mike's car is old. Like Jimmy, Nacho gets involved in a dark business—perhaps because he, like Jimmy, does not want to become a "sheep."

16. As previously noted, the actual Kevin Costner scene was inserted into an episode during the first season of *Better Call Saul* as an Easter egg.

17. Carrie Menkel-Meadow, "Is there an Honest Lawyer in the Box? Legal Ethics on TV," in *Lawyers in Your Living Room!: Law on Television*, ed. Michael Asimow, (Chicago: ABA Publishing, 2009).

18. The same cannot reasonably be said regarding Saul. Upon learning that Walt was expected to die soon from cancer, Saul tells Walt that it's a shame because they could have made "real money" together.

19. Jimmy's love for his family mirrors that of another complex character, namely Walter White. Despite a number of actions taken by each character that we appropriately deem reprehensible, we see a common thread of caring for those close to them.

20. It can also be said that both Jimmy and the inflatable man are filled with hot air!

21. Official AMC *Better Call Saul* website, http://www.amc.com/shows/better-call-saul/talk/page/2.

22. Working at a large firm has both advantages (including many perks, prestige, and a high salary) and disadvantages (such as long, unpredictable hours). Bill, a lawyer Jimmy speaks to in the bathroom at the courthouse, previously wanted little to do with Jimmy. But once he learns that Jimmy is working at Davis & Main, Bill expresses just how envious he is. Jimmy tries to mildly complain, but Bill is not willing to hear any of it. Perhaps this is a clear example of the grass that seems greener on the other side.

23. Cocobolo wood is a "tropical hardwood from central America known for its expressive grains and attractive colors." See, 1stdibs, Rare Cocobolo Wood desk Don Shoemaker, https://www.1stdibs.com/furniture/tables/desks-writing-tables/rare-cocobolo-wood-desk-don-shoemaker/id-f_935216/. Jimmy later refers to himself as "colorful," and it seems that he may have wanted a desk to match his clothes and personality. In "Bingo," though, he acknowledges that he is not familiar with cocobolo wood.

24. While Jimmy's aversion to his firm's culture is a bit extreme, culture is an important factor for associates to consider when choosing their firms. While on interviews at big law firms, I recall asking partners to describe the culture, and also searching for family photos on their desks to try to determine whether family life was important to them.

25. Note that Jimmy is not fired because he is incapable of practicing law at a high level. In "Cobbler," he impresses partner Cliff Main with a legal argument while working on the Sandpiper case. Jimmy is not shown to be incompetent during his stint working at Davis & Main.

26. It is also possible that, having escaped from a place where he could not be himself, Jimmy ultimately decides that he no longer wishes to pretend and goes down a different path.

27. In a flashback moment depicted in "Hero," we hear Slippin' Jimmy refer to himself as "Saul Goodman," explaining to the unsuspecting target of his schemes, "'s'all good, man."

28. One could argue that Walter White's dark path is also paved with good intentions in that his initial motivation to cook meth is to earn money to support his family after he dies from cancer. In fact, he is utterly unprepared to learn, during season 2, that his cancer is in remission. Walt takes out his frustrations on those around him, even demanding (in the season 2 episode "Over" [2009]) that his son, Walter Jr., drink hard liquor. Perhaps Walt, at least for a moment, sincerely regrets his nefarious actions: the drug money was unnecessary if he survives and is able to support his family through legal means.

 Of course, Walt's admission in the series finale of *Breaking Bad* calls into question the idea that Walt *ever* had any good intentions. In his final and powerful conversation with Skyler, he admits that his actions were, in fact, motivated by selfish reasons: "I did it for me. I liked it. And I was good at it." ("Felina," 2013.)

29. Kimberly Potts, "'Better Call Saul' Postmortem: Peter Gould Talks Where Jimmy Will Be in Season 2," *Yahoo! TV*, April 7, 2015, https://www.yahoo.com/tv/better-call-saul-producer-writer-talks-season-1-115773934500.html.

30. Gita Jackson, "*Better Call Saul* and the Fine Line Between Tragedy and Comedy," *Paste Magazine*, April 29, 2015, http://www.pastemagazine.com/articles/2015/04/better-call-saul-and-the-fine-line-between-tragedy.html.

31. Note also that the cover art for season 2 of *Better Call Saul* depicts Jimmy walking across a street, about to cross two yellow street lines. The shadow of his neck can be seen on the lines, as we know Jimmy will have his "neck on the line" in the future. A red traffic light signals impending doom, but a green

light sends mixed signals about whether to move forward. And it is likely not a coincidence that a nearby building is a locale where Jesse Pinkman once sold meth. The image is slanted, perhaps intended as a prelude to what is to come in Jimmy's life. Jimmy is walking uphill, which depicts the battle that we know he will continue to face going forward. See image in connection with the article by Proma Khosla, "'Better Call Saul' season 2 poster is full of 'Breaking Bad' goodies," Mashable, http://www.mashable.com/2016/01/05/better-call-saul-s2-poster/#aEUWxSlw48qu.

32. Aaron Couch, "'Better Call Saul': Bob Odenkirk on Finale's Saul Tease, Season Two Surprises," *The Hollywood Reporter*, April 6, 2015, http://www.hollywoodreporter.com/live-feed/better-call-saul-bob-odenkirk-786587.

33. Saul also does not take himself too seriously. He routinely mimics his own television commercials, pointing at clients and exclaiming "Better Call Saul!" just like on his ads. Note that Jimmy must be careful to avoid engaging in solicitations of nonclients so as to not violate Rule 7.3(a) of the Model Rules of Professional Conduct.

34. Soon after taking a position as an attorney with Davis & Main, Jimmy learns that he does not fit neatly into law firm culture. Arguably validating Chuck's arguments, he acknowledges, upon leaving the firm, that he is a "square peg." Query whether this acknowledgement confirms Chuck's perception, or whether the very fact that Chuck holds and expresses such beliefs has a cause-and-effect relationship to Jimmy's ultimate failure to fit in at the firm.

35. As noted previously, Jimmy declines the opportunity to be interviewed for a position with a partnership track at one of HHM's peer firms, in large part because Chuck "wouldn't like it."

36. Charles Dickens, *The Old Curiosity Shop*, Penguin Classics, 2001; originally published in 1841.

37. Such violations, of course, fly in the face of Saul's occasional proclamations of allegiance to ethical codes, such as when he declares to his clients that "There's rules to this lawyer thing!"

Note that the MRPC does not explicitly require "zealous" advocacy, as many state bar rules do. However, the comments to MRPC Rule 1.3 ("Diligence") provide that "A lawyer must

also act with commitment and dedication to the interests of the client and with zeal in advocacy upon the client's behalf." MRPC, Rule 1.3, http://www.americanbar.org/groups/professional_responsibility/publications/model_rules_of_professional_conduct/rule_1_3_diligence/comment_on_rule_1_3.html.

38. Saul also betrays Jesse's trust at other times. For example, in the season 5 episode "Blood Money," Saul calls Walt and tells him that Jesse was trying to give $5 million to Mike's family.

39. In this case, Walt is the "winner" because he had a plan in place to work alone, without Jesse, for Gus Fring.

40. In "RICO," for example, when an elderly client only has $43 cash on hand, Jimmy offers to reduce his $140 bill to $120 and allows her to mail him the remainder of the payment.

41. There appears to be some ethical lines that even Saul Goodman will not cross. While we maintain a sense of shock at some of Saul's actions on *Breaking Bad*, he does appear to condemn harming innocent children. In the season 5 premiere episode of *Breaking Bad* ("Live Free or Die," 2012), Saul proclaims his lack of knowledge about Walt's plan to intentionally poison Brock, and is dismayed by Walt's actions: "You never told me that kid would wind up in the hospital!" Ask yourself whether Saul would have found such a plan acceptable if truly necessary for his own self-preservation.

42. *Breaking Bad*, season 5 ("Live Free or Die," 2012).

43. Joseph McCarthy, "I'm Always Chasing Rainbows" (1917).

44. Ibid.

45. Note that Kim nixes the idea of sharing a law firm name with Jimmy ("Wexler McGill") because she wants them to operate independently, with Jimmy's more "colorful" practices not reflecting poorly on her. Even though they plan to operate independently, Kim seems happiest when she and Jimmy move into their shared new office space.

46. Genesis 8:21, 9:8–16 (cited by Mendy Kaminker, "What Is the Significance of a Rainbow in Judaism?" Chabad, http://www.chabad.org/library/article_cdo/aid/2770455/jewish/What-Is-the-Significance-of-a-Rainbow-in-Judaism.htm.).

47. See Mendy Kaminker, "What Is the Significance of a Rainbow in Judaism?" Chabad, http://www.chabad.org/library/article_

cdo/aid/2770455/jewish/What-Is-the-Significance-of-a-Rainbow-in-Judaism.htm.

48. Aviva Venefica, "Symbolic Meaning of Rainbows," http://www.whats-your-sign.com/symbolic-meaning-of-rainbows.html.

49. "Golden Slumbers" and "Carry That Weight" (The Beatles, *Abbey Road*, 1969).

50. "Yesterday" (The Beatles, *Help!*, 1965).

51. Single version sung by Christina Aguilera, lyrics by David Zippel (1998).

52. Marshall McLuhan and Lewis H. Lapham, *Understanding Media: The Extensions of Man* (Cambridge: The MIT Press, reprint, 1994).

53. Daniel Fienberg, "'Better Call Saul' Writer-Director on Surprise 'Breaking Bad' Return and What's Next,'" *The Hollywood Reporter*, February 15, 2016, http://www.hollywoodreporter.com/fien-print/better-call-saul-season-two-864735.

54. There is other graffiti on the wall as well. The word "Moriah" is written there. Moriah is the place where Abraham, at God's request, took his son Isaac to be sacrificed (before angels intervened to prevent the sacrifice). (See Genesis 22:2.) This reference serves as another example of the symbolism embedded within the series. We can tie the idea of sacrifice to all of the things that Saul has sacrificed in his life upon forging his new identity as Gene. He has sacrificed his law degree and his principal source of income. In the course of his transformation from Jimmy McGill to Saul Goodman, Saul sacrifices his moral compass and the relationships that he has forged. For further discussion on this point, see Reddit post, http://www.reddit.com/r/bettercallsaul/comments/4hm154/no_spoilers_this_ones_a_long_shot_but_this_shot/.

55. *Breaking Bad*, season 5 ("Granite State," 2013).

56. *Breaking Bad*, season 3 ("Sunset," 2010).

Brotherly Love and Betrayal (and a Momentous Moment with Marco)

Jimmy has a strained and very complicated relationship with his brother, Chuck. It is a relationship that Brandon K. Hampton (the actor who portrays Ernesto on the series) refers to as "the Cain and Abel story."[1] Chuck views Jimmy as a charlatan, a fraudster always seeking to hook his next fish. He believes Jimmy is the ultimate con artist—a vacuous individual with little to offer the world once the

lights and mirrors disappear, reminiscent of the not-so-wonderful wizard from *The Wizard of Oz*.² And Chuck seems to feel an obligation to save the world from his brother. As viewers, we are not sure how to feel. On the one hand, we know who Jimmy becomes and sympathize with Chuck. On the other hand, we may blame Chuck for who Jimmy is and, more significantly, who he will become. But perhaps what is most frustrating for the audience is that we may never have a full and complete picture of Jimmy. While we watch him operate as Saul, and we see him during the period set six years before the start of *Breaking Bad*, we will never know Jimmy as well as Chuck knows him. The flashback scenes in *Better Call Saul* are helpful, but since we only see out-of-context fragments, it is difficult to piece together what Jimmy's life was like before we meet him in earnest. While we attempt to piece together whatever we can about Jimmy, we also get some information about Chuck. We learn, for example, that he previously had been married to a woman named Rebecca. And we watch him suffer from a condition that confounds not only us but also those around him.

Chuck's Electromagnetic Hypersensitivity

Chuck is afflicted with a condition that generates a great deal of hardship for him and for the people in his life. Chuck refers to the condition as electromagnetic hypersensitivity, or EHS. While medical doctors repeatedly advise him that he does not have a medical condition, he insists that the symptoms are real. He refuses to live with lights, cell phones, and computers, and demands that individuals he comes into contact with do not carry phones or other electronic devices. We watch Chuck suffering—even when he is alone, thereby debunking any theory that he is faking the illness for attention. (For example, he wraps himself

in aluminum foil like a baked potato, in Jimmy's words.)
There is no scientific basis for Chuck's condition, nor is it
a recognized medical diagnosis.[3] But it is a real-world con-
dition that has been studied by the medical and scientific
communities. Some psychologists have suggested that psy-
chological mechanisms play a role in the condition. The
World Health Organization issued the following statement
regarding EHS:

> EHS is characterized by a variety of nonspecific
> symptoms that differ from individual to individual.
> The symptoms are certainly real and can vary widely
> in their severity. Whatever its cause, EHS can be a
> disabling problem for the affected individual. EHS
> has no clear diagnostic criteria and there is no scien-
> tific basis to link EHS symptoms to EMF exposure.
> Further, EHS is not a medical diagnosis, nor is it
> clear that it represents a single medical problem.[4]

The writers' deliberate choice of EHS as Chuck's con-
dition was undoubtedly intended to generate discussion
and debate. Many fans have posited that the condition is
a true physical condition that affects Chuck (although this
is belied by the frequent rejection of a medical basis for
the condition by doctors on the show); others believe the
symptoms reflect Chuck's desire to escape from the pres-
sures of life (perhaps embodied by modern technology);
and yet others believe that it results from a reaction to a
significant event in Chuck's life—perhaps Jimmy's entrance
into the world as a lawyer.

Lacking the Common Touch

Chuck is in many ways the opposite of Jimmy. He is
a person who has worked hard to achieve the respect and

accolades that he has earned, and he plays by the rules. Chuck does not take shortcuts, cut corners, or engage in tacky actions. He is a prominent and proud[5] individual, but is highly unlikeable (largely because of his stern personality, judgmental nature, and extreme, off-putting, no-nonsense attitude). He lacks a common touch with people[6] and, in the estimation of Michael McKean (the actor who portrays Chuck), is "soulless."[7] By sharp contrast, Jimmy does not play by a rule book and very much relies on his people skills, common touch, humor, and street skills to succeed in life. Summarizing his own incredulousness over people's affection toward Jimmy, Chuck flatly acknowledges that "Jimmy certainly has a way with people." ("Cobbler")[8]

Jimmy has always wanted to please and impress Chuck. In a flashback from "Nacho," Jimmy declares to Chuck (who is in the process of begrudgingly helping Jimmy with legal troubles in prison) that "It's about time I make both of us proud." In "Switch," Jimmy acknowledges to Kim that all he ever wanted to do was make Chuck happy, noting that Chuck made Jimmy come to Albuquerque, and that Jimmy (in his own words) "got into the law for all the wrong reasons." And he laments the fact that people (such as Chuck and the Kettlemans) "tell me how they see me and it's not as a lawyer." Jimmy's consistent desire (and failure) to win the approval of his brother ultimately leads to Jimmy's dark descent into the Saul Goodman character. As we continue to learn about the relationship between the brothers, it becomes evident that there is nothing Jimmy could reasonably do to impress his brother.

Before Jimmy becomes a lawyer, he is largely a manageable problem for Chuck. Even prior to Jimmy's admission to the New Mexico Bar, we see evidence of Chuck's disdain for him—although such disdain is muted when compared with his treatment of Jimmy once he becomes an attorney.

In a flashback scene during "Rebecca," Chuck tells his wife, Rebecca,[9] that Jimmy is "an acquired taste," apologies in advance of Jimmy's arrival, and even directs her to give him a signal if and when she wants Jimmy to leave. Jimmy, we learn, is staying at a motel—presumably because he is not welcome to stay at Chuck's home while searching for a permanent residence.

Once Jimmy becomes an attorney, Chuck feels an obligation to both the profession (to protect it from Jimmy's claws), and to Jimmy (to ensure that he acts properly). For example, in "Gloves Off," after Jimmy produces a television advertisement for Davis & Main that was not approved by the partners, Jimmy and Chuck engage in the following exchange:

> **Jimmy:** What did I do that was so wrong?
>
> **Chuck:** You broke the rules! You turned Kim into your accessory. You embarrassed Howard, who, God help him, inexplicably vouched for you with Cliff Main, you made Cliff and his partners look like schmucks. Shall I go on?...You're my brother and I love you. But you're like an alcoholic who refuses to admit he's got a problem. Now someone's given you the keys to a school bus, and I'm not going to allow you to drive it off a cliff.

Chuck's sense of obligation is manifested in the contempt that he both feels and expresses toward Jimmy. Even if some of Jimmy's actions do not seem to deserve a severe degree of ridicule from Chuck—the TV advertisement that Jimmy creates is perhaps a good example— the elder brother feels that it is far better to nip even the smaller issues in the bud given what he knows about the

capacity for Jimmy's behavior to manifest itself in potentially destructive ways. It is also noteworthy that, in the above exchange, Chuck is promising to actively intervene if and when necessary to stop Jimmy from causing destruction. He therefore commits to taking action, as opposed to his previously declaring that he was around simply to "bear witness" to Jimmy's antics.

Per Michael McKean: "Chuck is a man who respects and honors the law and he just doesn't think that his brother has the stuff and he doesn't think that his brother is a legitimate addition to the honor and integrity of the law."[10] Chuck's impressions of Jimmy as the Slippin' Jimmy character will not melt away, despite the responsible person that Jimmy McGill has in many ways become (or at least seemingly become). This is evidenced by the exchange that the pair have after Chuck finds out about Jimmy's publicity stunt involving a billboard. In "Alpine Shepherd Boy," Jimmy tries to downplay the billboard stunt, promising Chuck that it was a "one-time thing." Jimmy also tells Chuck the following:

> I'm a good lawyer. I just needed some razzmatazz to get the ball rolling. Showmanship. From here on out, I am going to play by the rules.

Chuck flatly responds, "As any lawyer should." Chuck does not seem to buy Jimmy's promise that Slippin' Jimmy is gone: "We'll see," Chuck says.

Chuck encourages Jimmy to find his own identity, even though Chuck never truly believes that Jimmy McGill could be or become anyone other than Slippin' Jimmy.[11] (It is noteworthy that Slippin' Jimmy's friends agree. When informed that Jimmy is going to start a new life in New Mexico, his friend Marco responds, "You're Slippin' Jimmy.

What are you gonna change?") While Chuck could not have known that such encouragement would lead to the creation of Saul Goodman, Chuck doesn't exactly encourage his brother to succeed. In "Uno," Chuck advises Jimmy to change the name on his matchbook advertisement from "James M. McGill" to something else (perhaps the Vanguard Group),[12] given that McGill is in the name of both law firms. Chuck even asks Jimmy, "Wouldn't you rather build your own identity? Why ride on someone else's coattails?" Needless to say, Jimmy *does* forge his own identity in the future, largely because of the way in which Chuck has treated him.

Jimmy works tirelessly to take care of Chuck, and is thrilled as Chuck begins to fight his illness. He tells Chuck, "I am so proud of you," after Chuck tries to build up immunity to electricity. Jimmy's joy at the prospect of his brother's improvement stands in sharp contrast to Chuck's disgruntled attitude when bailing out Jimmy for the Chicago sunroof incident. Jimmy demonstrates his desire for Chuck to succeed and achieve happiness. This is not reciprocated by Chuck, who does not want to help Jimmy.[13] Chuck is less than pleased with Jimmy's request to keep boxes of legal documents at his house when working on a case, for example. Still, Chuck maintains (in "Fifi") that if the brothers' circumstances were reversed, Chuck would similarly take care of Jimmy. Perhaps Chuck does love and care for Jimmy, and is simply mired in a state of constant anger and frustration over Jimmy's actions. Perhaps Chuck would treat Jimmy more tenderly had Jimmy been the sick one. We are not so sure. As we continue to observe the interactions between the two brothers, we and Jimmy learn more about the extent to which Chuck has it in for Jimmy.

A Chimp with a Machine Gun

In "Pimento," Jimmy learns that it is Chuck, not Howard Hamlin,[14] who has prevented Jimmy from receiving a job offer from HHM. Despite Jimmy's care and unwavering kindness toward Chuck, he has been betrayed by his brother. Producer Tom Schnauz, who wrote and directed "Pimento," summarizes Chuck's feelings toward Jimmy:

> Where Chuck has dedicated his whole life to the law and studying and being the best that he can and being really, really good at it, here comes his brother who was a screw-up...He comes along and puts together this amazing case. He's going to have an office next to Chuck's. Chuck thinks, "No, that's not going to happen...You can't do it that easily. You have to dedicate your whole life to this kind of thing and not just come waltzing in and make friends and then all of a sudden, 'Here I am, I'm your equal.'"[15]

In "Pimento," Chuck finally makes it quite clear that he does not consider his brother to be his equal. Jimmy figures out that it was Chuck who implored Howard at HHM not to hire Jimmy, and the pair has the following powerful and fiery exchange:

Jimmy: You told him not to hire me. It was always you. You didn't want me. Tell me why!

Chuck: You're not a real lawyer! University of American Samoa, for chrissake? An online course? What a joke! I worked my ass off to get where I am, and you take these shortcuts and you think suddenly you're my peer? You

do what I do because you're funny and you can make people laugh? I committed my life to this! You don't slide into it like a cheap pair of slippers and then reap all the rewards!

Jimmy (tearfully): I thought you were proud of me.

Chuck: I was. When you straightened out and got a job in the mailroom, I was very proud.

Jimmy: So that's it? Keep old Jimmy down in the mailroom, 'cause he's not good enough to be a lawyer?

Chuck: I know you! I know what you were, what you are. People don't change. You're Slippin' Jimmy. And Slippin' Jimmy I can handle just fine, but Slippin' Jimmy with a law degree is like a chimp with a machine gun. The law is sacred! If you abuse that power, people get hurt…on some level, I know you know I'm right.

In this exchange, Chuck attacks Jimmy from multiple angles. Chuck declares that Jimmy has a weak educational background unbefitting of a "real lawyer"; he states that Jimmy has very little experience; he argues that Jimmy's shortcuts have insufficiently prepared him for a career in law; he argues, by referencing Slippin' Jimmy, that Jimmy lacks morality; he declares that Jimmy-as-lawyer will hurt people, thereby displaying his lack of faith in him; and opines that Jimmy cannot handle the pressure and dynamics of the legal profession. Jimmy desperately wanted to work with Chuck on the Sandpiper case, but Chuck had other ideas. Instead of thanking Jimmy for finding the case and delivering it to Chuck on a silver platter, Chuck coldly and secretly decides to betray his brother.

This pivotal scene serves as one of the turning points in the transformation of Jimmy into Saul. During an interview

conducted during season 1, writer Tom Schnauz pointedly noted that, absent Chuck's betrayal, it is unclear whether this transformation would have ever occurred:

> What I like about the final scene that I had so much fun writing is that a lot of the stuff that Chuck says, the law is sacred, and you're Slippin' Jimmy, and you're a chimp with a machine gun... we know what the future is, we know Jimmy becomes Saul Goodman. The question is, was he always going to become Saul Goodman, or did Chuck's actions turn him into Saul Goodman? I think that's open for debate. I would never want to answer that question one way or the other, but I think, hopefully, some people in the audience will hear Chuck and say, "You know what? We know who Saul Goodman is, and Chuck might be right about this. Maybe being a lawyer is not the best thing for this guy," whereas another half of the audience are going to think, "You know, he's really trying his best, and he is a good lawyer."[16]

When interviewed again during season 2, Tom Schnauz strongly suggested that Chuck's actions played a pivotal role in Jimmy's transformation into Saul, noting that "Jimmy would be a very different person if Chuck had stood by his side more."[17]

Perhaps Jimmy should have seen Chuck's sabotage coming, as there is evidence that Chuck never saw Jimmy as an actual lawyer. In a flashback scene from "RICO," Jimmy hands Chuck a document showing that he's passed the bar exam. Chuck's initial response is stinging: "Is this a joke?" When Jimmy asks whether Chuck is proud of him, Chuck awkwardly responds, "Oh, yes. Absolutely." And finally

when Jimmy asks Chuck whether HHM would consider hiring him, Chuck responds, without intending any sarcasm, "As what? Oh, a lawyer, obviously." This scene is reminiscent of the season 2 scene in which Howard Hamlin informs Chuck that Davis & Main has hired Jimmy, with Chuck inquiring, "Doing what?"[18] The pair's exchange in "Pimento" demonstrates that Chuck's disbelief was not mere sticker shock at learning that Jimmy is now a lawyer; we learn that Chuck never comes to embrace the idea of Slippin' Jimmy as an attorney. Chuck's harsh view of Jimmy is reminiscent of another character's severe critique of another pop culture icon—America's everyman, Homer Simpson.

Frank Grimes—the "Self-Made" Man

While it is not entirely clear why Chuck has such disdain for Jimmy—even after Jimmy has taken such good care of him—it seems that at least part of the reason is jealously.[19] The series continues to provide clues about the brothers' past and the way in which jealousy and resentment have eroded their relationship. During a promotional trailer for season 2, Michael McKean pointed out that Chuck is stunned that the world cannot see Jimmy for who he truly is (at least in Chuck's eyes). McKean observed, "Everybody loves Jimmy. It baffles Chuck. Don't they see what I see? Don't they see what a dangerous mess this guy is?"[20]

McKean's observation is reminiscent of how Homer Simpson's coworker Frank Grimes perceives Homer in "Homer's Enemy,"[21] a seminal installment of *The Simpsons'* phenomenal and record-breaking run. In the season 8 episode, we are introduced to Frank Grimes, a down-on-his-luck, brilliant nuclear engineer who begins work alongside Homer Simpson at the Springfield nuclear power plant. Grimes butts heads with Homer throughout the episode and finds our favorite TV father to be utterly annoying (as

Homer eats like an animal, chews on Grimes's pencils and steals Grimes's lunch); completely lazy (as Homer provides Grimes with tips about how to avoid work); relentlessly irresponsible and endlessly reckless (as Homer would have drunk a beaker of sulfuric acid, save for Grimes's intervention); and ultimately dangerous to everyone around him (as Homer pours liquid on equipment needed to keep the power plant from melting down, nearly destroying said equipment). Grimes's rage grows after learning that Homer played with the Smashing Pumpkins, met President Gerald Ford, and went to outer space as an astronaut. Frank is clearly jealous of these amazing life experiences (and, perhaps, Chuck is similarly jealous of Jimmy).

Most importantly for Grimes, though, is his strong desire to ensure that others agree with his viewpoints about Homer, as he feels they are incontestable. In the following exchange with Homer's longtime friends and coworkers Lenny and Carl, Grimes implores them to see Homer for who he truly is:

> **Frank Grimes:** Does this whole plant have some disease where it can't see that he's an idiot? Look here. (He points to a graph on the bulletin board.) Accidents have doubled every year since he became safety inspector, and meltdowns have tripled. Has he been fired? No. Has he been disciplined? No, no.
>
> **Lenny:** Eh, everybody makes mistakes. That's why they put erasers on pencils.
>
> **Carl:** Yeah, Homer's okay. Give him a break.
>
> **Frank Grimes:** No! Homer is not okay. And I want everyone in this plant to realize it. I would die a happy man if I could prove to you that Homer Simpson has the intelligence of a six-year-old.

Chuck and Grimes are angry at the world for not admonishing Jimmy and Homer, respectively. In "Nailed," for example, Chuck pleads with Kim to "Please open your eyes here" about Jimmy's underlying nature and penchant for underhanded actions. Grimes continues to be infuriated by Homer's actions throughout "Homer's Enemy," and, in an epic meltdown that quickly leads to Grimes killing himself by touching equipment marked "high voltage," cries out that "This whole plant is insane." The coworkers remain unfazed. Homer gets the ultimate laugh, as he is seen sleeping at Grimes's funeral, drooling, and murmuring to Marge to "change the channel." Everyone laughs at Homer as Grimes's casket is lowered into the ground.

While we wait to learn the ultimate fate of Chuck, it seems that Jimmy's actions and presence may have had a similarly detrimental effect on Chuck's well-being. We suspect that Jimmy's actions are at least a contributing factor to Chuck's physical and/or mental condition. (Chuck also injures himself in "Nailed" as he frantically tries to prove that Jimmy used a copy shop to commit forgery). While we view Jimmy as Chuck's guardian, it is possible that Chuck views himself as a failure for not watching over Jimmy closely enough, thereby enabling Jimmy to wreak havoc.

In the eyes of Frank Grimes, Homer is (like Jimmy) "a chimp with a machine gun." Homer Simpson should not be safety inspector of the nuclear power plant, just as Jimmy, in the eyes of Chuck, should not be a lawyer due to the harm and destruction that he can cause if unleashed. In their respective positions, Homer and Jimmy are potentially a danger to themselves and to others. Yet both characters are able to become professionals because the world has given them a free pass. Prior to Grimes's meltdown, he lets Homer know it, just as Chuck scolds Jimmy. After observing that Homer lives in a beautiful home ("a palace," according to

Grimes), eats lobster for dinner, and has a wonderful family, Grimes provides the following sharp critique of Homer:

> **Grimes:** I'm saying you're what's wrong with America, Simpson. You coast through life, you do as little as possible, and you leech off of decent, hardworking people like me. Heh, if you lived in any other country in the world, you'd have starved to death long ago.
> **Bart:** He's got you there, dad.
> **Grimes:** You're a fraud. A total fraud.

Jimmy McGill and Homer Simpson have each received a free pass from the world. And the sharp critique from Chuck is reminiscent of Grimes's attack on Homer. Grimes and Chuck have both worked extremely hard to achieve professional success (and it is noteworthy, in the case of Grimes, that "success" is simply becoming Homer's coworker). Conversely, Homer secures his job by simply being in the right spot at the right time, and Jimmy (in a feeble attempt to emulate his brother's success and use the goodwill of the "McGill" name) attends a less-than-stellar law school (yet, in the words of Chuck, was able to slide into the profession "like a cheap pair of slippers" and "reap all of the rewards"). Like Homer and Grimes, Chuck and Jimmy are members of the same profession. And that infuriates both Grimes and Chuck. Chuck believes wholeheartedly that Jimmy, in the words of Frank Grimes, is a "fraud," or in the words of McKean, a "dangerous mess." Both Grimes and Chuck are dismayed and dumbfounded that the public has placed their trust in Homer and Jimmy, respectively. While Jimmy is not nearly as lazy as Homer, and would likely be able to survive anywhere by relying on his street skills, it can be argued that both he and Homer have taken some

shortcuts in life and received, perhaps, some undue admira-
tion from their peers. Simply put, Chuck and Frank Grimes
share a common bond: Frank Grimes does not believe
Homer should be a respected or successful person, and
Chuck holds the same belief about Jimmy. In their view,
the world is worse off because Homer is entrusted with
nuclear safety and Jimmy is trusted to represent clients of
his own.

In my discussion of "Homer's Enemy" in my book *The
World According to The Simpsons*,[22] I discussed Homer and
Frank Grimes in the context of David Brooks's notion of
two competing types of people in contemporary society.
This dichotomy serves as a useful lens through which
to examine the underlying tension between Chuck and
Jimmy. In *On Paradise Drive*,[23] David Brooks describes the
distinction between the "blondes" and the "brunettes," care-
fully emphasizing that it isn't based upon hair color. The
vapid people—the blondes—never become aware of their
shortcomings because they are promoted and treated well
by their peers. The brunettes are frustrated, as they work
hard for what they have, live a life of reflection, and are
more qualified than the blondes in relevant tasks. Homer
and Jimmy are the "blondes"; Frank and Chuck are the
"brunettes."

More Jealousy

Chuck may also be jealous of what he (incorrectly)
perceives to be Jimmy's easy ride through the legal profes-
sion, despite Chuck's keen awareness of at least some of
the day-to-day struggles that Jimmy-the-lawyer encounters.
From Chuck's perspective, any bumps and bruises were of
Jimmy's own making, and from the moment he decides to
fly right and (somewhat) get his act together, he is well-
respected and accepted by his peers. There is some validity

to this observation, at least with respect to Jimmy's peers: Jimmy likely would have been hired by HHM immediately after passing the bar had it not been for Chuck's intervention. And Kim greatly respects Jimmy's skills. However, we know, of course, that Chuck's observation is flawed in many respects. Jimmy struggles significantly to attract clients, with the Kettlemans even deadpanning that Jimmy is the type of lawyer that guilty clients hire. And the opposing counsel in the RICO case seem to have utterly no respect for Jimmy-the-lawyer.

It is not clear why Chuck doesn't admire and respect Jimmy's skills, especially since Chuck is the potential beneficiary of much of Jimmy's hard work, both in helping him negotiate a possible exit arrangement with HHM due to Chuck's medical condition and in taking care of him. Chuck has no reason to believe that a successful Jimmy McGill would supplant Chuck—there is no reason why there cannot be room for both brothers to succeed at HHM. Jimmy makes it clear that he is not looking to overtake or replace Chuck in any way at the firm, and even demonstrates his lack of greed by accepting (without negotiation) Howard's first offer of compensation for bringing in the RICO case. He simply wants a seat at the table alongside Howard and Chuck; he is not looking to immediately become a named partner at the firm.

Chuck may not be aware of how hard Jimmy works, and Chuck might believe that Jimmy is simply trying to shoot his way to the top by associating with his brother. The audience, of course, has seen Jimmy in a different light: he is a scrambler who works hard to retain and attract a small client base, and he operates out of a tiny office in the back of a nail salon. When Jimmy discusses the "413" form, and Chuck corrects him, noting that it is a "513" form,[24] we assume that Chuck feels Jimmy is not up to the task of

representing clients. But Chuck ignores the bigger picture: lawyers are capable of committing error. Notably, Chuck fails to see the possibility of a larger case when Jimmy puts together a RICO case on behalf of his elderly clients. (Jimmy, of course, downplays Chuck's miss and tells him not to worry about it.) Jimmy is certainly aware of his own limitations, and seeks direction in the RICO case from expert-lawyer Chuck, even asking Chuck to direct him as to what steps are most important to take. But Chuck views himself as a true lawyer, and Jimmy as simply a small-time con artist who has crawled through the cracks of the legal profession and will inevitably cause trouble and hurt others. Jimmy, unquestionably, feels inferior to Chuck, even while seeking his brother's approval. The powerful exchange with Chuck in "Pimento" demonstrates to Jimmy that his brother has no respect for him, and this marks a turning point in his life.

Chuck plays a major role in Jimmy's initial decision to decline the opportunity with Davis & Main, and ultimately in his transformation into Saul. A significant factor in Jimmy's last-minute choice not to pursue the job interview presented to him by Kim (before later changing his mind and accepting the position for a short period of time) is Chuck's lack of confidence in, and disapproval of, Jimmy. Jimmy idolizes Chuck, a seasoned, highly respected attorney at HHM, and sacrifices his own desires in order to please him: upon hearing of the job opportunity, Jimmy's initial reaction is that Chuck "wouldn't like it." Jimmy then questions why the firm would want to hire him. "What's the angle?" he sadly asks Kim. It is clear that Chuck has broken Jimmy's spirit. Jimmy may appear uber-confident at times, but we come to learn that such confidence is simply part of his shtick. He has been dragged through the mud by his brother, insulted in such a significant way that Jimmy

feels a strong desire to go down a different path. Chuck has caused serious damage in Jimmy's psyche. And Jimmy becomes unhinged in an epic scene at the senior center bingo hall.

B Is for Bingo

During his infamous meltdown at the bingo hall, Jimmy expresses his dismay at the way Chuck treated him during their intense exchange. Jimmy is not in the best of mental states as he stands before a large group of seniors and calls out numbers. It takes only the slightest annoyance to set him off, and it is clear that his feelings regarding the incident with Chuck are at a breaking point. He calls multiple *B* numbers in a row and becomes enraged by this slight-to-moderate statistical oddity. Referring to those *B* numbers, he declares, "*B* as in betrayal…*B* as in brother…*B* as in Belize…I would love to go there, but let's face it, that's not going to happen. None of us is ever going to leave this godforsaken wasteland!" He continues to criticize his small New Mexico town, and caps the soliloquy by describing the Chicago sunroof incident and blaming it for his life's misfortunes. "I've been paying for it ever since. That's why I'm here!" he screams.[25]

It is noteworthy that while Jimmy blames the sunroof incident on his misfortunes, it is not clear that he internalizes the notion that he deserves the punishment that was meted out. He argues that the tint in the car was illegal and that Chet was a bad guy. He also notes, for good measure, that Chet had connections in law enforcement that influenced the filing of trumped-up charges against Jimmy. While he acknowledges that the incident was not his finest moment, he largely blames the "system" for his troubles. It is this theme—the failure to accept full responsibility for one's actions and instead deflect blame onto society—

that permeates throughout *Better Call Saul* and influences the events depicted therein. If Jimmy had accepted full responsibility and understood that his poor choices would always have adverse consequences, it is quite possible that he would not have proceeded down such a wayward spiral. But by blaming everyone and everything for his misfortunes (e.g., Chet, the tinted windows, and Chuck), and fostering the belief that the world is out to get him, Jimmy forges a dark path in life. His natural reaction to events that do not go his way is to fight back, often in deeply disturbing ways.[26]

Once Jimmy has had some time to reflect on his intense conversation with Chuck, he realizes that he will never be able to please his brother and will always be stuck in the rut that is his small New Mexico town. He realizes that he will never be able to overcome the damage that the Chicago sunroof incident caused to his reputation. Just as pulling multiple consecutive *B*s in a bingo game will delay winning the game, Jimmy will keep pulling the same "numbers" in his life and continuously fail to impress his brother and develop a solid reputation. As he tells Kim earlier, "He's my brother. He thinks I'm a scumbag. There's nothing I can do to change that."

Kant versus Bentham

In "Switch," the season 2 premiere episode, Jimmy observes that "I've been doing the right thing for all of these years now, and where has it got me? Nowhere!" Recall also that in "Bingo," Jimmy (nearly in tears) kicks the walls of his prospective office upon realizing that returning the Kettlemans' money to the proper authorities means that he cannot afford the rent of said office. Chuck never sees this particular side of Jimmy—the side that struggles with identity and ultimately acts in a responsible manner (albeit

in the context of a situation where he is already playing outside of the rules).

We see that Jimmy no longer believes (if part of him ever did) that being a morally responsible person is a good in and of itself. And this places Jimmy in square opposition to the philosophical writings of Immanuel Kant, who, as a deontological moral philosopher, set forth and defined the "categorical imperative":[27] that universal moral law includes absolute, unconditional requirements to act or not act, without any regard to the consequences of any such action or inaction. Jimmy typically employs a different calculus when deciding whether or not to act, nearly always taking into account the potential adverse consequences and benefits before moving or shifting in a particular direction. Jimmy is clearly desirous of reaping a reward (in the form of recognition from, and admiration by, Chuck and others) for the sacrifices he has made trying to "do the right thing."[28] And if such a reward is unavailable, as he realizes upon further reflection, all bets are off.

That is not to imply that Jimmy's calculus is entirely reflective of Jeremy Bentham's conception of utilitarianism, as defined in his book *An Introduction to the Principles of Morals and Legislation.*[29] Utilitarianism requires an actor to take into consideration the consequences of an action in their entirety and engage in the action that creates the overall "greater good." From Jimmy's perspective, the greater good is typically limited to himself (with some notable exceptions, such as where Kim is concerned). Immanuel Kant would have praised Jimmy's original proclamation to Mike that he wanted to "do the right thing" with respect to the Kettlemans' money. Jeremy Bentham would have similarly praised the statement, but for a different reason: Bentham would have required him to take into account

not only his own desires but the overall consequences of his actions. In this context, the conclusion would be the same: returning the money results in a larger societal benefit than Jimmy keeping the money for himself. The difference between the two philosophies, however, is that Bentham would be willing to stray from honesty if doing so led to a greater overall benefit, while Kant would never look to consequences as a factor in his analysis.

Although Jimmy continues to struggle with whether he should continue on his current path, he has become resigned to his current place in the world—that is, unless and until he decides to take his life in a *completely* different direction and forge another reality for himself. He cannot simply remain Jimmy McGill and achieve personal satisfaction with his life and career. So perhaps instead of attempting to achieve redemption by desperately trying (in vain) to please Chuck, and representing needy seniors at discounted rates, he should choose to take a path in which he survives by his base instincts and is not motivated by the desire to please others or achieve any semblance of justice. As we know, he will ultimately decide not to fight his Slippin' Jimmy instincts; rather, he will embrace and nurture the scheming, morally inept side of his persona.

And as the series moves forward, we continue to see the impact of Chuck's words and actions on Jimmy and his agenda. In season 2's "Cobbler," for example, Chuck (to the surprise and bewilderment of Jimmy) attends a meeting at HHM about the Sandpiper case, walking into the conference room while Jimmy is presenting to the other members of the legal team. This flusters Jimmy, but Kim rubs his leg with her hand and Jimmy continues on. Afterward, Jimmy approaches Chuck and asks him why he attended. Chuck coldly responds that he was there "to bear witness," pre-

sumably to the failure Chuck anticipates will be forthcoming. Jimmy then receives a timely phone call from Mike:

> **Mike:** You still morally flexible? If so, I may have a job for you.
> **Jimmy:** Where and when?

We watch Jimmy as the realization that he cannot please Chuck continues to sink in. And Jimmy's knee-jerk response to that realization is to revert to the Slippin' Jimmy persona.

Jimmy's Offer

After Jimmy becomes convinced that Chuck is responsible for Kim Wexler's banishment to the HHM basement to conduct lowly document review duties ("Gloves Off"), Jimmy makes a high-stakes offer to Chuck: Jimmy will agree to leave the legal profession in exchange for Kim's reinstatement to her previous role as a premier litigator. Jimmy begs Chuck to accept this offer, reminding Chuck of his "chimp with a machine gun" comments. (The fact that Jimmy quotes Chuck demonstrates the obvious and severe impact that these words had on Jimmy's psyche). Chuck would undoubtedly be pleased were Jimmy to leave the practice of law, and Chuck seems to at least very briefly entertain Jimmy's offer. But Chuck, in sharp contrast to Jimmy, is a process-oriented individual, and he does not approve of the means suggested by Jimmy to achieve this end. Chuck retorts, "You want me to commit a felony?[30] Because that's what *you'd* do, right?" Jimmy is nonetheless persistent, pleading with Chuck to "do it," to "roll around in the dirt with me! All your dreams will come true!" While we witness the famous Jimmy charm come to life in this

scene, the straitlaced Chuck ultimately resists Jimmy's pleas, as Chuck is not the type to engage in such explicit law-breaking (despite Chuck's occasional violation of certain ethical rules, as will be discussed later on).

Even though Chuck declines Jimmy's offer, Chuck in no way encourages Jimmy to continue practicing law. Conversely, he tells Jimmy that he does not need any help "tanking" his own career. But, as we will soon see, Chuck pulls the ultimate con on Jimmy at the end of season 2, potentially giving Chuck significant leverage in his ongoing war with Jimmy.

The Ultimate Con

> "There is nothing like a crisis to help define who you are." ~ Dexter Morgan, *Dexter*

Perhaps Jimmy should have been more wary of Chuck by the end of season 2. Chuck had previously betrayed Jimmy during season 1 by secretly demanding that Howard not hire Jimmy for a position at HHM. And Chuck demonstrates a strong propensity for ruining the plans of those individuals for whom Jimmy cares deeply. In "Fifi," for example, Chuck uses all of his energy to participate in a meeting with Mesa Verde in an attempt to retain them as a client for HHM. While there was a clear business incentive for doing so, we may speculate that Chuck would not have gone to such lengths to retain a client that had no relationship to Jimmy's companion, Kim. Chuck clearly wants to beat Jimmy; hurting those close to him is one potential means of bringing him down. Jimmy could easily have seen this coming had he heeded the advice of poet and activist Maya Angelou: "When someone shows you who they are, believe them the first time."[31]

It's ironic that it is the typically straitlaced Chuck, not

the scheming Jimmy, who pulls the ultimate con at the conclusion of season 2. In "Klick," Chuck seems to have a mental breakdown, covering an entire room in his house in aluminum foil. He sends a letter of resignation to his law partner, Howard Hamlin. This prompts Jimmy to intervene. Chuck says that he is distraught over the typographical error on the documents, and that he is no longer fit to practice law. Jimmy showers praise unto Chuck in an attempt to convince him not to retire: "The law needs you," Jimmy proclaims, also telling Chuck, "I don't know what you are if you're not a lawyer." Jimmy is also willing to engage in self-deprecation in support of his cause, saying that if Chuck retires, then Jimmy will be the only person using the family name in the practice of law, and we "can't have that!" When these arguments fail to convince Chuck to rescind his retirement plans, Jimmy confesses to the forgery and compliments Chuck on the uncanny way in which he figured out all of the details of Jimmy's plot. Chuck advises Jimmy of the magnitude of the confession, and the pair engages in the following exchange:

> **Chuck:** You do realize you just confessed to a felony?
> **Jimmy:** I guess. But you feel better, right?

Jimmy lets down his guard and is not ruthless in this interaction with Chuck. He tells Chuck that he committed the forgery in order to help Kim, not to hurt Chuck—and he expresses his surprise that the action had such an adverse impact on Chuck. Jimmy is willing to admit his actions just so Chuck "feels better," despite the many times that Chuck has made Jimmy feel horrible about himself. The fact that Jimmy praises Chuck demonstrates that he respects him greatly, and the fact that he denigrates himself shows that he

does not believe that he is Chuck's equal. And Jimmy clearly feels bad that he has led Chuck to question himself and retire from practicing law. Jimmy feels so guilty for causing this chain of events that he is willing to admit his actions to the brother that treats him so poorly. Jimmy raises Chuck up, while Chuck constantly brings Jimmy down.

Quickly after Jimmy confesses, he leaves and we watch Chuck press the stop button on a tape recorder that he hid in the room. It is now clear to the audience that Chuck never intended to retire from HHM, and that the elaborate use of aluminum foil to cover the room was part of the ruse. He clearly exaggerated the extent of his medical condition. Chuck made a bet that Jimmy would sympathize with him, and he was right. This demonstrates that Chuck meant what he said when he told Kim that Jimmy had a "good heart." Jimmy falls for the ultimate con. Chuck now holds all of the power over Jimmy.

Although Chuck's treatment of Jimmy is a substantial factor in his transformation, there are other factors at play as well—including his relationship with a character named Marco.

It's Not All About Chuck—Marco Works His Magic

Although we first see him earlier in the season—lying on the ground, feigning serious injury, and then laughing with Jimmy at the conclusion of their Rolex scheme—we are formally introduced to Marco in the season 1 finale, an episode which bears his name. We learn in a flashback that Marco has been Jimmy's go-to accomplice for his low-level schemes. Marco pleads with Jimmy to stay in Chicago, likening Jimmy's decision to give up his scheming ways to "watching Miles Davis give up the trumpet. It's just a waste, that's all I'm saying." (Marco's declaration calls to mind Billy

Joel's "Billy the Kid," where he sings of a legendary figure who had committed crimes.)[32] Jimmy resists Marco's plea and moves to New Mexico to be closer to Chuck and begin a new life as a mailroom clerk at HHM.

When Jimmy returns to Chicago ("Marco"), he sees Marco at the bar, and the pair engage in a week of elaborate (and successful) schemes—just like in the good ol' days. Eventually, after listening to voicemails left by his clients, Jimmy feels beholden to them and explains to Marco that he must return to New Mexico to continue to serve as their legal counsel. When Jimmy reveals that he is trying to eke out a living and is by no means wealthy, Marco tells Jimmy, "You're a lawyer! If you're not making bank, you're doing something wrong!" These words foreshadow what the audience knows will ultimately happen: Jimmy will more easily be able to "make bank" once he crosses ethical lines and transforms into Saul Goodman.

Later on, Marco has a heart attack in the middle of the Rolex scheme. Lying on the concrete right before death, he tells Jimmy that the past week has been the best week of Marco's life. This seems to strike a chord in Jimmy: note that Jimmy looks at Marco's pinky ring at the very moment that he considers whether or not to ditch the law firm interview.[33] And after quitting the law at the beginning of season 2 in "Switch," Jimmy tells Kim, "I think my talents are better spent elsewhere... The stuff I like about [the law]—selling people, convincing people—I don't have to be a lawyer to do that." Jimmy and Kim then proceed to scam Ken at the hotel bar—a fitting tribute to Marco. It seems that Jimmy's exchanges with Marco have a profound effect on Jimmy's ultimate transformation into Saul Goodman.

⚖️

Another person of significant influence in Jimmy's life is his friend and sometimes-lover Kim Wexler. In order to fully understand Jimmy's character and transformation, we must take a careful look at Ms. Wexler and her impact on Jimmy.

Notes

1. The Book of Genesis provides that Cain and Abel were sons of Adam and Eve. Cain killed his brother Abel because of envy and wrath. Brandon also refers to the pair as "Caesar and Brutus." The differences between Julius Caesar and Brutus ultimately led Brutus to murder Caesar.
2. The Wizard of Oz (1939).
3. "Electromagnetic fields and public health: Electromagnetic hypersensitivity," World Health Organization, December 2005, http://www.who.int/peh-emf/publications/facts/fs296/en/.
4. Ibid.
5. "Cobbler" begins with Chuck struggling to play the piano, as he makes a number of mistakes. When Howard Hamlin stops by and asks what the music was, Chuck denies that he has been playing. We can speculate that this denial was out of fear that Howard would think less of Chuck because of the imperfections.
6. In "Nailed," we see Chuck forcefully arguing with and denigrating his client at the banking hearing, telling her that she is "muddying the waters."
7. Vulture Festival, *Breaking Better Call Saul* panel, New York City, May 21, 2016.
8. In "Fifi," Chuck refers to Jimmy as "Svengali" upon hearing that Jimmy is teaming up with Kim to form Wexler and McGill. Svengali is a fictional character from George du Maurier's 1895 novel, *Trilby*. In the novel, Svengali seduces and exploits a young English girl. See George Du Maurier. *Trilby*. New York: Oxford University Press, 2009; Originally published in 1895.
9. Jimmy shows Chuck respect by wiping his shoes on the doormat before entering Chuck's home. At dinner, Jimmy tells

lawyer jokes, but adds, "I have nothing but the utmost respect for your profession." Rebecca loves the jokes, and even tells one of her own at the table. Later that night, Rebecca tells Chuck that Jimmy is "great." Chuck tells Rebecca a funny lawyer joke that falls flat because of his lack of comedic timing and common touch.

10. Karen Butler, "UPI Spotlight: From 'Laverne & Shirley' to 'Better Call Saul,' Michael McKean 'never had a plan,'" *UPI*, April 7, 2016, http://www.upi.com/Entertainment_News/TV/2016/04/07/UPI-Spotlight-From-Laverne-Shirley-to-Better-Call-Saul-Michael-McKean-never-had-a-plan/9051459954569/.

11. Perhaps Chuck is simply sick and tired of Jimmy asking for Chuck's advice. When Jimmy is in jail, he tells Chuck, out of a sense of desperation, "Tell me what to do and I'll do it." One would think that Chuck would have welcomed and responded favorably to such a request, but perhaps Chuck wants Jimmy to find his own way, without help from Chuck. Note that many years later, Jimmy repeats this line when working with Chuck on the Sandpiper case. Jimmy desperately seeks assistance from his older brother, both in terms of personal legal troubles and work-related issues.

12. Chuck assures Jimmy that this request came from Howard Hamlin, a partner at Chuck's law firm, Hamlin, Hamlin and McGill. Based on what we will learn about Chuck's view of Jimmy, however, we can speculate that the request came from Chuck himself.

13. Chuck does, however, stay up all night piecing together shredded documents in an effort to work on Jimmy's case. Did he do so to help Jimmy or, to insert himself into the case for personal gain and acclaim?

14. Howard tells Jimmy that he had always liked him, but that Chuck is a very powerful voice at the firm. Jimmy is apparently good enough for Howard (and most likely other firms), but is not good enough for Chuck.

15. Kimberly Potts, "'Better Call Saul' Postmortem: Writer Tom Schnauz Talks Jimmy's Heartbreak, Mike's New Job, and the Easter Egg Title," March 31, 2015, *Yahoo! TV*, https://www.yahoo.com/tv/better-call-saul-pimento-postmortem-115128743980.html.

16. Kimberly Potts, "'Better Call Saul' Postmortem: Writer Tom Schnauz Talks Jimmy's Heartbreak, Mike's New Job, and the Easter Egg Title," *Yahoo! TV*, March 31, 2015, https://www.yahoo.com/tv/better-call-saul-pimento-postmortem-115128743980.html.

 Schnauz also stated:

 > We as viewers, having seen *Breaking Bad*, know Chuck might be right about this. Even though what he's done is really, really horrible, we know who Saul Goodman is. People in the future die and get hurt because of his actions. If not for *Breaking Bad*, I think this scene would have another feeling to it. I think half the audience is going to listen to Chuck and say "what a jerk." I think some people will listen to him and think "he's not too far off. Maybe he's giving the correct advice." We don't know—would Jimmy turn into Saul Goodman if not for Chuck's horrible actions? Is it a self-fulfilling prophecy? Or was Slippin' Jimmy always going to be become Saul Goodman? We'll never know.

 See Aaron Couch, "'Better Call Saul' Producer on Jimmy's Tragic Betrayal, 'Epic' Finale," *The Hollywood Reporter*, March 30, 2015, https://www.yahoo.com/movies/better-call-saul-producer-jimmys-tragic-betrayal-epic-040000469.html

17. "Better Call Saul Q&A—Thomas Schnauz (Writer, Director and Executive Producer)," http://www.amc.com/shows/better-call-saul/talk/2016/04/better-call-saul-qa-thomas-schnauz-writer-director-executive-producer.

18. Chuck also asks Howard whether Davis & Main is aware of Jimmy's background and education. When Howard acknowledges to Chuck that he did not "stand in the way" of the hiring, Chuck flatly responds, "Nor should you," and, in a fake, awkward manner, says, "That's great" when informed about Jimmy's partnership prospects.

19. In addition to jealousy, there may be other reasons behind Chuck's disdain for Jimmy. In the season 2 episode "Rebecca," Chuck tells Kim that Jimmy stole $14,000 from a business run

by Chuck and Jimmy's father, and that their father's sadness over losing his business led to his death. It is quite possible that Chuck's resentment for Jimmy stems, at least in part, from this event. While some may question whether the story is accurate, "Inflatable" brings the audience back to a moment in which a young Jimmy stole a few dollars from the business's cash register.

20. Katia Kleyman, "Better Call Saul Season 2 Preview Unseen Footage, Vince Gilligan and Bob Odenkirk Comment," *Design and Trend*, January 20, 2016, http://www.designntrend.com/articles/68675/20160120/better-call-saul-season-2-promo-video-new-clips-vince-gilligan-bob-odenkirk-commentary.htm. It is evident that many people in Jimmy's life do not view him in this harshly negative light: Chuck's wife, Rebecca, seems enamored of Jimmy, as do Kim, mailroom clerk Ernesto, elderly people, and a host of other individuals.

21. Episode 4F19, 1997.

22. Steven Keslowitz, *The World According to The Simpsons: What Our Favorite TV Family Says About Life, Love, and the Pursuit of the Perfect Donut* (Naperville: Sourcebooks, 2006, 153–154).

23. David Brooks, *On Paradise Drive: How We Live Now (And Always Have) in the Future Tense* (New York: Simon & Schuster, 2004).

24. As will be discussed later, Jimmy's revenge against Chuck ties back to Chuck's attention to detail (i.e., the 1261 to 1216 switch in "Fifi" and "Nailed"). Fun fact: the actual real-life address of the hot dog place (Dog House Drive In) where Jimmy and Kim are seen eating in one episode is 1216 Central Avenue NW. See *"Breaking Bad* Tour" at http://www.wikitravel.org/en/Breaking_Bad_Tour. This locale was also featured on *Breaking Bad.*

Jimmy also picks up on certain small details—often when it matters. In "Nacho," for example, Jimmy notices that the daughter's doll is missing. He surmises that this means that the family left voluntarily and was not dragged out of its home. His uncanny ability to see such small details dovetails with his ability to think like a sneaky person (because he is one!).

There is also evidence to support the notion that Jimmy intentionally mixes up "413" and "513" to induce Chuck to open the file boxes and effectively team up with Jimmy. After

Jimmy makes this error, he leaves the boxes with Chuck and peers through the window, perhaps checking to ensure that his plan has worked and that Chuck is beginning to review files.

25. Note that Jimmy attempts to deflect attention from his own misdeed in the Chicago sunroof incident by arguing that the tint in Chet's car was illegal. He attempts to use the law to show that the victims of the incident (Chet and Chet's children) should not be let off the hook because Chet was also (allegedly) breaking the law. This demonstrates how Jimmy (and later Saul) views the law as a tool—a means to an end—that can be molded to fit one's circumstances. It is also an example of the larger observation that Jimmy does not respect the law or treat it with dignity (unlike Chuck, who seems to place value on the inherent nature of the law itself). Lawyers, under this view, need not have a love affair with the law. Jimmy's perspective is shared by many lawyers—even those who lack Jimmy's/Saul's sleaziness.

26. I am reminded of Donald Trump's proclamation while a nominee during the 2016 presidential campaign: "What happens is they hit me and I hit them back harder and, usually in all cases, they do it first. But they hit me and I hit them back harder and they disappear." Trent Baker, "Trump: If Someone Hits Me, I Have to Hit Them Back Harder—'That's what we want to lead,'" *Breitbart*, April 3, 2016, http://www.breitbart.com/video/2016/04/03/trump-if-someone-hits-me-i-have-to-hit-them-back-harder-thats-what-we-want-to-lead/. Just as many have accused President Trump of not striking a presidential tone, one can strongly argue that Jimmy does not strike a lawyerly tone.

27. Immanuel Kant, *Grounding for the Metaphysics of Morals: with On a Supposed Right to Lie because of Philanthropic Concerns.* Cambridge: Hackett Publishing Company, Inc. 3rd edition, 1993, originally published in 1785.

28. See "Marco" (2015). On *Breaking Bad*, we watch Walter White employ a risk-benefit analysis as well. "I am breaking the law here," he tells Jesse. "This return is too little for the risk," "Crazy Handful of Nothin'," episode 6, 2008.

29. Jeremy Bentham, *An Introduction to the Principles of Morals and Legislation.* Mineola: Dover Philosophical Classics, 2007. Originally published in 1781.

30. Consider whether Chuck's acceptance of Jimmy's offer would have broken any laws. Had Chuck made the demand, it might have constituted extortion, blackmail, and/or tortious interference with economic relations in certain jurisdictions. Because *Jimmy* makes the offer, however, it is difficult to imagine Chuck being held responsible for any of the foregoing . An interesting question arises as to whether a judge would find Chuck responsible if Chuck, as offeree, were to *enforce* or attempt to enforce the terms of the deal.

31. See Oprah's Life Class, http://www.oprah.com/oprahs-life-class/when-people-show-you-who-they-are-believe-them-video

32. Billy Joel, "The Ballad of Billy the Kid" (*Piano Man*, 1973).

33. Jimmy glances at Marco's ring several times over the course of the series, as it symbolizes his battle between playing it straight and operating as a con artist.

③

Kim Wexler: Jimmy's Fair-Weather Partner in Crime

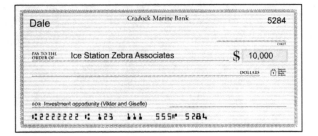

Kim Wexler is a strong, independent woman who is laser-focused on her career as an attorney. She comes from a small town on the border of Nebraska and Kansas and, as she noted on a job interview, wanted more out of life than the possibility of working at the local Hinky Dinky[1] supermarket as a cashier. She is a highly qualified lawyer and has made a strong impression on her industry peers. Case in point: Kim so impresses her adversary (Rick Schweikart of Schweikart & Cokely) during a court hearing during season 2's "Bali Ha'i" episode that he makes her a job offer. Feminists[2] have praised Kim's ambitiousness and desire to succeed in a law firm (HHM) that appears to be dominated by men. While she has aspirations to become a

partner at HHM, her relationship with Jimmy only hurts those prospects. In "Rebecca," when Jimmy proposes a potential way[3] to right the ship after his antics at Davis & Main lead to Kim's banishment to the HHM basement to do junior-associate-level document review,[4] she pushes his offer aside, sharply telling him, "You don't save me. I save me."[5] She is brave enough to open up her own law practice (while sharing the expenses with Jimmy), but sufficiently stubborn and grounded to resist Jimmy's enticing offers of partnership (during both seasons 1 and 2).

It is clear that Kim possesses a special affinity for Jimmy, and his continuous shenanigans do not appear bad enough to shake such affinity—even if she does not necessarily agree with his "colorful" approach to both life and the legal profession.[6] Kim has been described as "the unique center of the show, balancing between the flexible ethics of Jimmy McGill and her own infallible moral center—a dichotomy that may well prove the couple's end."[7] At least through the conclusion of season 2, she does not feel the need, however, to break ties with Jimmy, and, as will be discussed, does not exhibit moral inflexibility. She also declines to heed any of Chuck's warnings about the deleterious effect that Jimmy may have on her life—including his proclamation that Jimmy has already "ruined" her by way of his behavior at Davis & Main. Just as she does not need Jimmy to "save" her, she does not solicit or take Chuck's advice.

On the surface, it may appear that Jimmy and Kim are completely different people with little in common. But as we learn more about the characters, we realize that they do possess some similarities. Neither character is a native of New Mexico. Both worked in the HHM mailroom before becoming attorneys, with Jimmy following in Kim's footsteps. And perhaps most significantly, as Rhea Seehorn (the actress who portrays Kim Wexler) noted during a panel

at the Vulture Festival, both she and Jimmy are "loners."[8] Jimmy is a misfit at Davis & Main, while Kim appears to be quite lonely as she attempts to move up the ladder at the male-dominated HHM law firm. They both seem happiest putting up their own respective shingles while remaining close to one another; they appear to be in good spirits while jointly painting their new common office space.[9]

Nasa

Both Jimmy and Kim seek a release, and they let loose when they are together. They possess a physical attraction to each other and enjoy each other's company. Kim's influence on Jimmy can perhaps best be described by invoking the Hebrew word *nasa*—"to take hold of something and lift it up."[10] Kim "takes hold" of Jimmy when she convinces him to return to the practice of law and ultimately accept the Davis & Main position. She also "lifts" Jimmy up, rubs his leg when Chuck's presence in a meeting causes him to be stressed, telling Jimmy that he's a "great lawyer" ("Switch"); and advocating on his behalf to help him land the Davis & Main position. For the most part, she has a positive impact and influence on Jimmy. Seemingly because of Jimmy's decision to accept the Davis & Main position, for example, Jimmy forgoes an opportunity to con another couple that he eyes while in the hotel pool. Even though Kim, in a conversation during "Bali Ha'i," expresses regret that Jimmy accepted the position only to please her, Jimmy reassures her that her influence on him is a positive one. Jimmy, on the other hand, brings Kim down. She is at her freest when she is with Jimmy, but this inhibition is demonstrably deleterious to both her career and moral clarity.

Chuck believes that Kim is making a terrible mistake by believing in Jimmy, and that this mistake is a stain on her

judgment and ability to make decisions. In "Gloves Off," Chuck and Jimmy engage in the following exchange:

> **Chuck:** You have to admit this shows a lack of judgment on [Kim's] part [referring to her recommendation of Jimmy to the Davis & Main partners]. She knows you—she should have known better!
>
> **Jimmy:** You are such an asshole!
>
> **Chuck:** Why? For pointing out that her one mistake was believing in you?

Even though Kim did not know that Jimmy had not received approval for the TV commercial that got him (and her) in trouble, Chuck faults Kim for recommending Jimmy in the first place. And in "Rebecca," after Kim asks Chuck whether she has a future working at HHM, he responds by reflecting on the above situation, telling Kim that:

> We have a lot in common, you and I. My brother left you holding the bag. If it makes you feel any better, you're not the first person to go out on a limb for him. I made the same mistake over and over again.

Despite Kim's desire to be close to Jimmy and help him in his journey, it is clear that Kim is not yet ready to fully commit to a life with him.[11] That may be in part because of Jimmy's nature and his destructive impact on her career, but it seems equally clear that she does not exhibit a strong desire to settle down, get married, or have children with anyone at this point in her life. She is largely focused on her work, and while she enjoys many of her interactions with

Jimmy, such interactions do undoubtedly serve as a distrac-
tion (and, per Chuck's warnings, may have the potential to
derail her career and life).

A Fair-Weathered Partner in Crime

Most of the time, we see Kim Wexler as a serious,
focused and responsible attorney. Her gut instinct is often
to try to do the right thing. In the "Bali Ha'i" episode, for
example, Kim identifies and is initially uncomfortable with
the potential ethical implications of switching law firms to
work for HHM's adversary in the Sandpiper Crossing case,
Schweikart & Cokely.[12] But Kim has also demonstrated an
occasional propensity to serve as Jimmy's partner-in-crime.
And she exhibits a keen ability to match Jimmy punch for
punch as they jointly perpetuate their scams on unsuspect-
ing victims.[13] When she is with Jimmy—and if she is in
the mood for pulling a scam—she lets loose and demon-
strates her wild and adventurous side. At these times, she
serves as a replacement for Jimmy's fallen (apologies for
the pun) friend Marco. Kim relishes the thrill of Jimmy's
scams and serves as an active participant. While at a hotel
bar during the season 2 premiere episode "Switch," she flirts
with an unsuspecting businessman (Ken), lies about her
identity and finances, and presents Jimmy as her brother
in order to deceive the man into believing that Jimmy will
become a significant client and that she will sleep with him.
The purpose of the ruse is to entice the man to purchase
extremely expensive drinks for Kim and Jimmy (without
his knowing the cost of the drinks).[14] The plan works per-
fectly, and Kim ends up kissing Jimmy and sleeping with
him after they leave the bar. In another season 2 episode
("Bali Ha'i"), Kim initiates a scam: she calls Jimmy after a
man who just said goodbye to another woman buys Kim
a drink. Together, they pull off another scam—this time

convincing him to invest in their fake dot-com company. (Kim declines to cash the $10,000 check, instead keeping it as a souvenir).

One major point of distinction between Jimmy and Kim is that Kim wholeheartedly accepts the notion that she cannot live a successful life simply by employing, or participating in, scams with Jimmy. While Jimmy shows some signs of acknowledging the same (as indicated in his conversation with Marco about scamming people for "beer money," not as a way of life), we know that Jimmy ultimately forges a way forward that fully embraces the schemer lifestyle. After scamming Ken, Jimmy asks Kim, "Wouldn't it be great if we could do [scams like that one] every night?" While both acknowledge they can't,[15] it is Kim who quickly shoots down the proposal—not because it's immoral, but because it is so impractical.

At other times, Kim is much more tightly wound. She practices law in a serious, confident manner and earns the trust of large clients, such as banking client Mesa Verde. She endeavors to separate her practice of law from her more unhinged, less ethical behavior with Jimmy. While it is clear that Jimmy is a poor influence on Kim, it is noteworthy that Kim adds confusion to Jimmy's life. Kim is more than willing to run with Jimmy's shenanigans at times—arguably even providing validation for some of his actions by actively participating—but at other times she seeks a degree of separation from Jimmy and his wayward methods.

For example, in "Cobbler," when Jimmy tells Kim that he made up a (now infamous) story about a cobbler in order to deflect attention from cops about his client's illegal actions, she seems quite impressed—even eating a cobbler with Jimmy to celebrate the con. But upon learning that Jimmy directed his client, Daniel Wormald, to make a "squat cobbler" video, she is visibly disturbed and sharply

admonishes Jimmy for fabricating evidence. Kim warns Jimmy never to tell her about such fabrications or similar misdeeds.[16] In "Rebecca," she admonishes Jimmy and issues a challenge: "Prove you can go one day without breaking the rules of the New Mexico Bar Association or pissing off your boss." And in "Inflatable," Kim also draws a line in the sand when Jimmy asks her to join together as partners, Wexler McGill in the proposed Wexler McGill law firm. She asks Jimmy, "What kind of lawyer are you gonna be…Are you gonna play it straight or are you gonna be colorful?" Jimmy hems and haws, changes his answer, and acknowledges that he would be a "colorful" (code word for "unethical") lawyer because if he is not himself, the practice will fail ("I gotta go into it as me…yeah, colorful, I guess…Every time I try to do things someone else's way, it blows up in my face"). She informs him that she will not be able to become his law partner.

It is perhaps because of Kim's ability (at least during the first two seasons) to walk the line between responsible attorney and confidant to the colorful Jimmy McGill that one commentator declared her to be "a hero in a show where there aren't many."[17] Rhea Seehorn acknowledged her character's internal struggle to find direction, noting that it was fun for her (as an actress) to "grapple with what are the boundaries…between what's okay and what's immoral," noting that "there's legal versus illegal, moral versus amoral, and ethical versus unethical." She also added that "all the characters on *Better Call Saul* feel like they know how to hang on to right and wrong, and they keep finding out that it depends on your perspective."[18] Kim also seems to implicitly acknowledge the veracity of Dexter Morgan's proclamation that "We all make rules for ourselves. It's these rules that help to define who we are, so when we break those rules we risk losing ourselves and becoming something

unknown."[19] As we will see, Kim does bend some rules to benefit and protect Jimmy, and it will be interesting to watch the impact of her actions, not only on Jimmy but on herself as well. The depth of the characters on *Better Call Saul*—and the interactions among them—make it one of the most thought-provoking, astute shows on contemporary television.

The interaction between Kim and Jimmy is an intriguing aspect of *Better Call Saul.* Kim knows that Jimmy's actions have had an adverse impact on what is most important to her—her career as an attorney[20]—but she does not abandon Jimmy. It is clear that she wants to be a part of Jimmy's life, but she is still figuring out what form their relationship should take. They seem to make each other happy, but there is also some resistance on the part of Kim to go all-in when it comes to their relationship (both professional and otherwise). And from Jimmy's perspective, if Chuck is Jimmy's kryptonite,[21] then Kim is Jimmy's Achilles's heel, a source of emotional attachment that affects him dearly, for good or ill. There is little doubt that she will play a significant role in his ultimate transformation.

Kim's Powerful Defense of Jimmy

In "Nailed," Chuck declares to Kim that Jimmy has committed forgery (and perhaps fraud, breaking and entering, and falsifying evidence) in an attempt to win back Mesa Verde as a client for Kim and embarrass Chuck along the way. Kim responds with a powerful defense of Jimmy, arguing that it was much more likely that Chuck simply made a typographical error. She makes it clear where her loyalties reside in her fiery response, and places the blame for Jimmy's flaws squarely on Chuck:

I know he's not perfect. And I know he cuts corners.

But you're the one who made him this way. He idolizes you. He accepts you. He takes care of you. And all he ever wanted was your love and support. But all you've ever done is judge him. You never believed in him. You never wanted him to succeed. And you know what? I feel sorry for him. And I feel sorry for you.

This is an exchange that the audience has been waiting for. It is impossible to adequately express the deep and raw emotion contained in Kim's delivery of this speech, making it one of the most powerful moments of the entire series. We were waiting for someone to speak so bluntly and directly to Chuck, and to let Chuck know how profoundly (and negatively) his words and actions have affected Jimmy. Chuck does not interrupt Kim, nor does he respond. We do not know, at this point, whether Kim's direct talk will have any discernible impact on Chuck's behavior or posture toward Jimmy, but these were words that he needed to hear.

It is notable that Jimmy does not strongly deny Chuck's accusations. Aside from brushing them off and attempting to quickly dismiss such accusations, he does not put up much of a fight. This lack of resistance should make him seem guilty in Kim's eyes, and, in fact, we soon see evidence that Kim does believe Chuck's accusations. When Kim and Jimmy leave Chuck's house and jump into Jimmy's car, Kim punches Jimmy for what she believes he has done. And then later in the episode, she warns him to cover his tracks, because Chuck will make a tough adversary in the event that he pursues a claim against him.

Kim's defense of Jimmy is noteworthy for several reasons. There is a small chance that she initially believes that Chuck made a typo, then rules out that possibility upon further consideration. It seems more likely, however,

that she realizes that Jimmy was guilty all along, and tries to take the easy way out. Perhaps she wants to stand up for her friend, since he committed the forgery with the intention of helping her. Perhaps she does not want to deal with the ethical dilemma that Chuck presents to her: he forcefully argues that it's Kim's ethical obligation to report Jimmy's purported actions to Mesa Verde.

Interestingly, Chuck does not threaten to tell Mesa Verde himself, or to report Jimmy to the New Mexico Bar. All state bar associations *permit* an attorney to report another attorney's violation of their ethical rules, and many states even require an attorney to do so if the attorney has actual *knowledge* (as opposed to a reasonable belief) of a violation of the rules. Section 8.3(a) of the Model Rules of Professional Conduct (MRPC) ("Reporting Professional Misconduct"), and Section 16-803(A) of the New Mexico Rules of Professional Conduct[22] each state that "A lawyer who knows that another lawyer has committed a violation of the Rules of Professional Conduct that raises a substantial question as to that lawyer's honesty, trustworthiness or fitness as a lawyer in other respects, shall inform the appropriate professional authority." Because Chuck and Kim's strong suspicion of Jimmy's professional misconduct does not arise to the level of "knowledge" (at least at this point in time), both could plausibly argue that reporting is not required in this instance. It is also not immediately clear from the MRPC whether Chuck is correct that, as its attorney, Kim is required to report Jimmy's malfeasance to Mesa Verde. Perhaps competent, diligent, and zealous representation demands that she do so, but the reporting requirement itself only speaks to reporting to the applicable bar association, not to a client.

Kim clearly does not want Jimmy to receive any discipline from the New Mexico Bar Association, and the

easy fix here is to blame Chuck if he cannot produce solid
evidence of Jimmy's misdeeds.

Hear No Evil

Kim reaches a fork in the road upon realizing that
Jimmy did commit the forgery. She could have decided
that she had been stung by too many of his antics, and that
it would be best to leave him once and for all. But Kim
chooses a different route. She decides that simply punching
him and telling him that she never wants to talk about what
he did is sufficient.[23]

The cover-up is a classic tool employed by television
dramas, and silence often proves to be critical to main-
taining the cover-up. On season 4 of the television drama
24, for example, former president David Palmer rightfully
accuses the thoroughly misguided President Charles Logan
of "hearing no evil" after Logan refuses to acknowledge that
Logan's henchmen are going to murder Jack Bauer in cold
blood.[24] And during season 8, Jack Bauer similarly accuses
President Allison Taylor of refusing to acknowledge the
Russians' murderous actions so that she would be able to
proceed with a landmark peace deal.[25] Kim's decision to
remain silent about Jimmy's actions places her in the same
category as Presidents Logan and Taylor, each of whom were
judged harshly by the audience as the respective seasons
played out.

Kim's actions also reflect her desire to maintain her
relationship with Jimmy. Heeding Billy Joel's advice in
the classic song "Only the Good Die Young," she seeks to
enjoy her time with the wrongdoer and not feel the sense
of regret of the individual that instead chooses to maintain a
high moral standing. Remaining with Jimmy, his antics not-
withstanding, provides her much more personal pleasure
than she would receive if she were to report Jimmy to

Mesa Verde or to the New Mexico Bar. She would also rather reap the rewards of Jimmy's forgery—winning back Mesa Verde as a client—than telling them the truth and ultimately regretting the loss of their business. She would rather rejoice with Jimmy than feel sorrow over losing both him and her new client.

Kim's defense of Jimmy demonstrates that she is somewhat hypocritical. While she previously lectures Jimmy about "falsifying evidence" after he concocts the "squat cobbler" story, her warning to Jimmy to cover his tracks in case Chuck searches for evidence shows that she is willing to have some indirect involvement in bending the rules. Jimmy would likely not have considered returning to the copy shop to bribe the clerk were it not for Kim's warning. In this sense, she not only aids and abets Jimmy, but specifically advises him to cover up his actions. Kim therefore exhibits a degree of moral flexibility in this situation.

<div align="center">⚖</div>

Overall, despite her own internal struggles to define her moral boundaries, Kim is a positive influence on Jimmy. With some discreet and notable exceptions, she generally acts in a responsible manner and tries to keep Jimmy on the right path. She stands up for her friend against negative influences, such as Chuck. And she provides Jimmy with affection and a certain degree of love. We know that Jimmy values Kim dearly, and we also know that he desperately needs someone to provide some positive energy in his life. Kim is this vibrant source of positive energy.

Notes

1. This is a real-life supermarket chain located in the region where Kim was raised.

2. Emma Dibdin, "Why 'Better Call Saul' Is One of the Most Feminist Shows on Television," *Indiewire*, March 17, 2016, http://www.indiewire.com/2016/03/why-better-call-saul-is-one-of-the-most-feminist-shows-on-television-57980/

3. Jimmy's plan is to sue HHM for extortion, a case that he would likely lose. In addition, most law employee arrangements are on an "at-will" basis and are nonunionized. HHM need not state a cause for any demotion (or even firing) of Kim. They are free to assign her to menial tasks if they wish to do so.

4. During the Breaking Better Call Saul panel (Vulture Festival, NYC, May 21, 2016), actress Rhea Seehorn stated that many attorneys have praised the series because of its realistic portrayal of policies, hierarchy, and internal politics at large law firms: for instance, demotion to doc review, responsibility for billing a large number of hours, lack of credit for bringing in clients, lack of respect and appreciation for associates, and many late nights of work in dreary, depressing conditions. There are not many legal dramas that paint such a realistic picture of life at a large law firm. Members of the *Better Call Saul* writing team have acknowledged that they consult with real-life attorneys (often within their own families) when writing the series. Inside the Better Call Saul Writers Room, May 26, 2016, the Writers Guild Theater, Beverly Hills, CA.

5. Kim's statement is reminiscent of Ralph Waldo Emerson's observation that "Nothing can bring you peace but yourself." See Ralph Waldo Emerson. *Self-Reliance, Essays: First Series* (1841), math.dartmouth.edu/~doyle/docs/self/self.pdf.

6. Kim often declines to adhere to Jimmy's "colorful" approach. For example, in "Fifi," Jimmy advises Kim to submit her HHM resignation letter overnight and not in a face-to-face meeting with Howard Hamlin in order to give her a head start on recruiting Mesa Verde as a client for her new law practice. Kim resists Jimmy's suggestion, retorting that she wants to do

things the right way. (Kim learns her lesson, though, as Howard immediately calls Mesa Verde following his meeting with Kim, and Kim must scramble in order to try to retain this client.)

7. Clarence Moye, "Rhea Seehorn's Quiet, Emmy-worthy strength in 'Saul,'" *Awards Daily,* May 14, 2016, http://www.awards-daily.com/tv/interview-rhea-seehorn/.

8. Breaking Better Call Saul panel, Vulture Festival, New York City, May 21, 2016.

9. Kim agrees to share expenses and common space with Jimmy, but she stipulates that each attorney will operate his and her own practice independently of the other. She wants to maintain a degree of disassociation from Jimmy's "colorful" ways and antics.

10. Jeff A. Benner, *Biblical Hebrew E-Magazine,* Issue #041, February 2008, http://www.ancient-hebrew.org/emaga-zine/041.doc. *Nasa* appears in the weekly Torah portion, "Ki Tisa."

11. Kim's decision to remain noncommittal with respect to Jimmy is akin to Mike's early decisions to engage in half measures as opposed to becoming the full-blown killer for hire into which he transforms.

12. Because Kim is in possession of confidential information that would be valuable to Schweikart & Cokely due to her position at HHM and intimate involvement in the Sandpiper Crossing case, Kim immediately explains to Mr. Schweikart that it would be ethically problematic for her to work for Schwei-kart's firm. Mr. Schweikart addresses the concern by promising not to ask Kim to reveal any such information and to create a screen between her and any Schweikart lawyers working on the case. This is common practice in such situations, and an effective screen should suffice to remove any potential ethical concerns.

13. It bears mention that Kim's propensity for occasionally partici-pating in, or even perpetuating, such scams is of a far different nature (and of much lesser concern) than Saul's propensity for engaging in some of the more egregious actions that Jimmy (and ultimately Saul) undertake.

14. In fact, Kim is the one who actually orders the expensive tequila at the table with Ken.

15. Jimmy acknowledges this, but we may suspect that his mind

hearkens back to his days with Marco, when he did in fact engage in such scams all of the time.

16. There is a question as to whether Jimmy actually falsified "evidence," since his client had not yet been indicted or charged with a crime. Furthermore, the video was created privately and not shared with anyone (at least not at this point in time). Assuming Jimmy did fabricate (or conspire to fabricate) evidence and thereby violated ethical rules, Kim might have legitimately considered the ethical requirement that she file a report with the New Mexico Bar regarding Jimmy's actions. MRPC, Rule 8.3(a), states that "A lawyer who knows that another lawyer has committed a violation of the Rules of Professional Conduct that raises a substantial question as to that lawyer's honesty, trustworthiness or fitness as a lawyer in other respects, shall inform the appropriate professional authority." See "Center for Professional Responsibility," American Bar Association, Rule 8.3, http://www.americanbar.org/groups/professional_responsibility/publications/model_rules_of_professional_conduct/rule_8_3_reporting_professional_misconduct.html.

 Chapter 5 includes a discussion of Kim's behavior in this situation. It bears mention at this point that Kim's behavior is odd, and her moral compass misguided, because she seems proud of Jimmy for lying to the cops.

17. Allison Keane, "TV Performer of the Week: Rhea Seehorn, 'Better Call Saul,'" *Collider*, April 8, 2016, http://www.collider.com/rhea-seehorn-better-call-saul-tv-performer-of-the-week/.

18. Clarence Moye, "Rhea Seehorn's Quiet, Emmy-worthy Strength in 'Saul,'" *Awards Daily*, May 14, 2016, http://www.awardsdaily.com/tv/interview-rhea-seehorn/.

19. *Dexter*, season 7 ("Surprise, Motherfucker!" 2012).

20. It is clear that Howard Hamlin punishes Kim (by banishing her to do junior-level association document review in the basement) because she recommended Jimmy to Davis & Main, and his antics ultimately embarrassed both HHM and Davis & Main. While Jimmy believes that Chuck is the true force behind the punishment, it becomes relatively clear that it was in fact Howard's decision. Upon Kim's departure from HHM, Howard acknowledges that he was always harder on

her because he believed in her ability and wanted to push her even further.

21. Jimmy has the opportunity, on a couple of occasions, to have Chuck committed after EHS episodes place Chuck in the hospital. Jimmy declines to commit Chuck, even though doing so would likely either silence his suspicions about Jimmy's malfeasance in the Mesa Verde situation or make him look crazy for suggesting that Jimmy forged such an elaborate plot of sabotage. In "Klick," Jimmy chooses to become the temporary emergency guardian over Chuck, but this legal guardianship ends once he takes Chuck out of the hospital a very short time later.

22. *New Mexico Rules of Professional Conduct*, Legal Information Institute, https://www.law.cornell.edu/ethics/nm/code/NM_CODE.htm.

23. This is not the first time that Kim has protected Jimmy. For example, she declines to inform Howard Hamlin that Jimmy didn't tell her that he had not received approval for his television commercial, even after Howard interrogates her about the situation. But, per Chuck's argument, perhaps Kim still deserves some degree of punishment simply for recommending Jimmy to the Davis & Main partners.

24. 24, "Day 4, 6:00 AM—7:00 AM" (Fox television broadcast, May 23, 2005).

25. 24, "Day 8, 9:00 AM—10:00 AM" (Fox television broadcast, April 9, 2010).

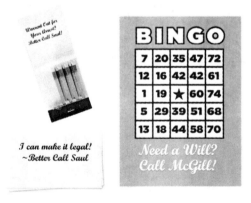

Better Call Saul and Attorney Advertising: Analyzing the Medium and the Message

For every attorney who **overreaches** through advertising, there will be thousands of others who will be *candid* and *honest* and *straightforward.* ~ *Bates v. State Bar of Arizona*, 433 U.S. 350 (1977) *(emphasis added)*

Substance abuse? Better call Saul! I'll make your afflic-
tion into a medical condition. ~ Saul Goodman adver-
tisement

Let's not fixate on the medium. Let's look at the message.
~ Jimmy McGill, "RICO"

"Candid," "honest," and "straightforward" are not the descrip-
tions that come to mind when we think of Saul Goodman.
He is part of the "overreaching" category, to put it mildly.
Saul is always scheming, seeking to break ahead of the pack
by almost any means necessary. And the shady advertise-
ments that he uses to attract potential clients are an integral
part of this strategy.

Everything about Saul Goodman is a shtick. From the
replica US Constitution plastered on his office walls to the
colorful suits, Saul is an entertainer—a tacky one. Even the
name—Saul Goodman—is a pseudonym used to create a
particular impression. The catchy tagline used on advertise-
ments—"Better Call Saul!"—could not be more contrived.
Instead of inventing a name that sounds a bit more dis-
tinguished—perhaps by using a middle initial and adding a
roman numeral (perhaps James M. McGill, III, Esquire)—
Saul intends to make a vastly different impression. Not one
of dignity or class, but one that perhaps can be more relat-
able to the clientele he wants to attract.

Saul Goodman's website[1] and the aesthetics contained
therein tell us much about the type of clientele he seeks.
Sprawled across the middle of the home page are the words
"Welcome Lawbreakers!" The website is a compendium of
Saul's self-promotion tools: tacky infomercial-type com-
mercials, testimonials from past clients, over-the-top proc-
lamations and promises about achieving particular results,
and references to allegations that Saul will defend clients
against. Saul's website is an embodiment of the character

that the audience sees on television. It is brightly-colored (like his attire), is replete with exaggeration, and makes frequent use of exclamation points in lieu of a more calm, measured tone. Saul's advertising helps to reinforce what we know about Saul—that he is a shyster who views the law as a shady business. Saul uses his quirky charm and cunning in his business and exploits the good name and honor of the legal profession.

The McLuhan Message

Jimmy McGill is the classic ambulance-chasing lawyer, soliciting clients in virtually every way imaginable. But his methods go far beyond ambulance chasing. Jimmy is desperate to survive in the cutthroat legal profession and cares neither about the forum nor the means of advertising his legal services: he simply wants to get his name out there and is willing to go to extreme lengths to do so. (Case in point: in a throwback to Lionel Hutz's preparation for trial,[2] Jimmy watches episodes of *Matlock*, draws pictures of what Matlock wears, and ultimately dresses like Matlock and hosts bingo games at a senior citizens' center in order to attract clients for his elder law business). He advertises his services on a giant billboard, on Jell-O pudding cups ("Need a will? Call McGill!"), on business cards, on matchbooks, on bingo cards,[3] on the aforementioned tacky website, and on infomercial-style television commercials using the tagline "Gimme Jimmy!" He is more than willing to plaster his face and information about his business anywhere. Because Jimmy views what he does as more of a blue-collar services business than an elite profession, he is unconcerned about how he distributes the message.[4] He disregards Marshall McLuhan's declaration that "the medium is the message,"[5] ignoring the arguably symbiotic relationship that a message has to the means by which it is distributed. While media

scholars have identified and examined this phenomenon, Jimmy sees no benefit in accepting the validity of this notion. He is a flashy messenger but does not believe that the content of his message is in any way diminished or diluted by his flamboyant style or gaudy pitches. Conversely, Jimmy may believe that while the message and medium are largely distinct, any convergence can only be beneficial to his business. Jimmy sees no reason why the methods that he employs should be regulated in any way. As we will see, however, the legal profession is quite concerned with the means of distribution of lawyers' advertisements, as well as the content contained therein.

Lawyers typically seek to create the impression that they are *serious* about their work. They prefer to exhibit qualities such as quiet dignity, methodical planning, focus, and intelligence. An unspoken tenet of many lawyers is that the law itself, as Chuck stated in "Pimento," is "sacred." Holding true to that belief impacts the way many lawyers both practice law and promote their legal services. Simply stated, most lawyers hate gimmicks—especially gimmicky ads[6] that appear degrading to the profession. But Saul is nothing without such ads. He is the ultimate performer— an attorney whose pre-courtroom performance routine consists of declaring, "It's showtime, folks," followed by a quick demonstration of jazz hands, in front of a bathroom mirror. Jimmy believes, perhaps with some merit, that putting on a good show in the courtroom is crucial to winning the battle.

Jimmy is a powerful salesman, telling the Kettlemans during one meeting, "Lawyers—we're like health insurance. Hope you never need it—but man, oh man, not having it…" This is a prime example of Jimmy's attitude toward the legal profession, and is relevant to understanding his excessive use of tacky advertisements in connection with

his work. He views legal services as a commodity, whereas highbrow lawyers such as Chuck view the profession as possessing a significantly higher degree of dignity. In Chuck's view, lawyers provide a valuable service that is based on hard work, allegiance to principles, and no shortcuts. In other words, Chuck and Jimmy are polar opposites when it comes to their perspectives on the law: Chuck views the law as something of value that deserves to be cherished in and of itself; Jimmy, conversely, views the law not as a body of rules with inherent value, but rather as a useful, malleable tool that can and must be manipulated in order to achieve a particular outcome.

Jimmy knows that the "show" begins from the moment he attempts to find clients to represent: in "Amarillo," he expresses his astonishment at the lack of creativity in an old ad released by Davis & Main, asking why the "showmanship" is missing. As part of his role as "client outreach" leader for the Sandpiper case, he produces a television advertisement. His black-and-white ad evokes much more emotion than the old Davis & Main ad, showing an elderly woman sadly sitting and shivering in a rocking chair, explaining her precarious situation to the audience. Jimmy takes great care not only in the theatrics, but also the timing of the ad—right after the first commercial break of *Murder She Wrote* (1984–1996)—a TV series that Jimmy knows is quite popular among his potential clients. Jimmy has a knack for creating powerful ads and a keen eye toward ad placement.

Branding, Fair Use, and Hamlindigo Blue

Part of Jimmy's performance consists of duping potential clients into believing that he has a secretary (by answering the phone in an accented, female-sounding voice, and declaring in a voicemail message, "You have reached the office of James M. McGill, Esquire, a lawyer you can trust")

and falsely stating that his law office is under construction. Jimmy's first purchase with the money that he accepts as a "retainer/bribe" from the Kettleman couple is a set of new, very expensive suits. He knows that clothes are integral to advertising for a lawyer, and essential for creating a certain impression.[7] He also knows that he would likely not even see the inside of a courtroom (at least as an attorney!) were it not for his scrappy (and often dishonest) ways and his wacky, tacky advertisements. Both Jimmy McGill and Saul Goodman love to advertise their legal services. And they understand the immense value and power of a well-placed, well-timed advertisement.

In "Hero," for example, Jimmy—as an act of defiance against the Kettlemans choosing HHM, HHM's poor treatment of Jimmy, and Chuck's declaration that Jimmy should forge his own identity—puts up a large billboard in which he is dressed very much like his white-shoe competitor Howard Hamlin from HHM. This billboard is intended to serve the additional purpose of stealing clients away from Hamlin. Jimmy uses the McGill name (which he shares with Chuck, a named partner at HHM), copies the HHM logo (including the font), and dresses and styles/dyes his hair like Howard Hamlin.

There is a strong argument that the billboard scheme itself constitutes a legal advertisement in that Jimmy hopes to receive publicity for his legal practice by employing this scheme. While Jimmy is permitted to make use of the McGill name on the billboard despite sharing it with a named partner of HHM, it is *how* Jimmy uses the name, combined with other elements of the billboard, that is unsettling. As a general matter, the elements of Jimmy's advertisement, when taken together, replicate HHM's advertisement in a manner that would confuse the general public. A judge (correctly) holds that Jimmy's advertisement

is both intended and likely to cause consumer confusion. Note that Jimmy might face disciplinary action from the New Mexico Bar Association if the billboard advertisement violates New Mexico Rule 16-804(C): "It is professional misconduct for a lawyer to engage in conduct involving dishonesty, fraud, deceit or misrepresentation."

The judge could have also considered whether Jimmy's actions violated unfair competition laws, and whether dressing up like Howard Hamlin violated rights of publicity or misappropriation of name or likeness laws, all of which vary by state (but which are often particularly potent when commercial interests are at stake).[8] As a general matter, the publicity and misappropriation claims are only available to individuals and not to corporations or other legal entities, while the unfair competition claims are available to all persons and entities. Note also that in certain states, rights of publicity claims are not available to noncelebrities (under the theory that the likenesses of noncelebrities do not possess any commercial value). Generally, liability for misappropriation of name or likeness claims requires a showing of use of a protected attribute for an exploitative purpose without consent of the individual. The right of publicity is tied to use of one's name and/or likeness for a commercial, exploitative purpose. At a high level, Jimmy's actions can reasonably be seen as creating potential liability for him under these claims.

We learn several salient facts during Hamlin and Jimmy's discussion with the judge. First, Hamlin, to Jimmy's disbelief, informs the judge that he (or perhaps HHM) has received a trademark registration for the color "Hamlindigo blue"[9] as part of a branding strategy. It seems that Hamlin may have invented this particular shade of blue (although it is not entirely clear), but the creation or development of a color is not a requirement for trademark registration. (A

demonstration that one has invented a color perhaps will aid in showing priority of use over others, however. And the fact that Hamlin invented the word "Hamlindigo" helps to solidify the strength of the mark). While not particularly common, a color may be the subject of a trademark or service mark registration in connection with particular goods or services if it designates the source of the goods or services.[10] A few noteworthy examples: UPS received a registration for the color brown in connection with delivery and transportation services; Owens Corning received a registration for pink in connection with fiberglass insulation; and Tiffany's received a registration for a particular shade of blue in connection with bags, boxes, and other items. Because a trademark registration is granted only in connection with a class or classes of specified goods and/or services, a third party is not prohibited from making use of that mark in connection with other goods/services if doing so will not lead to consumer confusion. Trademark rights for a word mark or color are not granted without a nexus to particular goods or services. If Jimmy used Hamlindigo blue, for example, in connection with restaurant services, Hamlin would be hard pressed to stop him from doing so, particularly if Jimmy does not refer to the color as "Hamlindigo."

Jimmy argues to the judge that his use of the JMM logo (a slight variation of HMM's name) is permitted by the "fair use" doctrine, which is an exception to trademark infringement. Trademark rights are important because they help a company establish goodwill in a brand and prevent others from infringing on those rights. Brands are built over a period of time, and the longer a consumer associates a brand with the owner, the stronger the brand—and the trademark rights associated therewith—become. HHM likely spent years developing its client base, building a solid reputation

and goodwill, and using a logo to identify the firm. Jimmy, in bad faith, attempts to piggyback off HHM's success, trying to confuse the consumer by copying nearly all of the elements of HHM's preexisting logo. The logo that Jimmy creates is substantially similar to HHM's (notwithstanding the use of the letter *J* instead of *H*). Based on Jimmy's awareness of HHM's logo and his bitter relationship with Howard Hamlin, it is clear that the copying is intentional. Howard therefore has a strong argument that Jimmy's use of the logo constitutes trademark infringement. However, his rebuttal to Jimmy's "fair use" argument is incorrect as a matter of law. Howard says that because Jimmy is "clearly profiting" from use of the logo, fair use does not apply.

Under US trademark law principles, the fair use analysis is different—although, as discussed below, the conclusion is likely the same. The law recognizes several distinct types of fair use: "classic," "nominative," "parody," and "comparative advertising."[11]

The use of a mark qualifies as classic fair use when it is "being used for its ordinary, descriptive meaning to describe a product or service."[12] The law provides that when a third party uses a word for purposes of *describing* a product or service using the *ordinary meaning* of the word, a trademark owner cannot deprive such third party of such usage—even if the third party profits from the use. By comparison, nominative use applies when a third party uses another individual's trademark "not to describe its own products or services but to refer to the actual trademark owner or identify a product or service of the trademark owner."[13]

Jimmy's use of major elements of the HHM logo likely does not qualify as classic fair use because the purpose is not necessarily to describe Jimmy's services; Jimmy clearly acts with an element of bad faith here, and he would be hard pressed to argue that the logo has an "ordinary meaning"

that he intends to legitimately exploit for his own purposes. Jimmy's use of the logo would not qualify as nominative fair use because he is not intending to expressly refer to HHM, but is rather attempting to confuse potential consumers (and perhaps piggyback off the goodwill developed by HHM). Jimmy intends to confuse consumers into either believing that he has an association with HHM, or that the ad itself is an ad for HHM. Either way, the law does not protect such bad faith usage.

After a judge decides that Jimmy's logo creates a likelihood of consumer confusion (in the trademark context) between HHM and McGill, and that he has no valid fair use defense, Jimmy stages an elaborate scheme—television cameras in sight—in which he is seen "saving" the man taking down the offending billboard. (The man was hired by Jimmy to pretend that he was falling.) Ironically, Jimmy's course of action engenders far more attention than the billboard ever could have if it had been allowed to remain. Even though Jimmy does not win with legal arguments, he most certainly wins in the court of public opinion, triumphing as a dishonest version of underdog David over the Goliathlike HHM.

As we will see in future episodes and in *Breaking Bad*, Jimmy/Saul is a master of self-promotion and the type of cunning he demonstrates in the billboard situation. He would scoff at the notion that attorney advertising should be prohibited or restricted in any way. He would find it difficult to operate within the confines of the US legal system.

Lawyer Advertising in the United States: Bates v. State Bar of Arizona

Historically in the United States, attorneys were legally prohibited from advertising. That changed as a result of the 1977 United States Supreme Court landmark case *Bates v.*

State Bar of Arizona. Chuck shows disdain for the court's decision in the course of complaining to Jimmy about the billboard fiasco. Expressing the viewpoint that attorney advertising is degrading to the legal profession, he notes that it "was not even allowed until five Supreme Court justices went completely bonkers in *Bates v. State Bar of Arizona.*"

In this case, attorneys John Bates and Van O'Steen sought to increase the volume of their caseload and decided to advertise to the public. They placed a newspaper advertisement in the *Arizona Republic* on February 22, 1976.[14] In accordance with the rules of the State Bar of Arizona, Bates and O'Steen were suspended from practicing law for a period of six months for doing so. The pair argued before the Arizona Supreme Court that the advertising ban violated their First Amendment freedom of speech rights under the United States Constitution and the Sherman Antitrust Act. The Arizona Supreme Court rejected these claims (although they agreed to reduce the length of their suspensions). Bates and O'Steen then appealed to the highest court in the land, the United States Supreme Court. Although the United States Supreme Court rejected the Sherman Antitrust Act claim (holding that lawyers are subject to the provisions of that act), it held that lawyer advertising was protected commercial speech under the First Amendment and lifted the advertising ban. The court viewed the limitation of information accessible to the public as anathema to the public policy goal of having an informed population, noting that "the consumer's concern for the free flow of commercial speech may be far keener than his concern for urgent political dialogue."[15] Despite the removal of the ban, the court permitted the Arizona State Bar to regulate advertising in order to ensure that the information presented therein was truthful.

In the *Bates* case, the Arizona State Bar made several

arguments intended to support the ban on legal advertising. It attempted to defend the prohibition by arguing that legal advertising, even in its most basic sense, would "undermine the attorney's sense of dignity and self-worth," "erode the client's trust in the attorney," and "tarnish the dignified public image of the profession." The court rejected these concerns, noting that "Bankers and engineers advertise, and yet these professions are not regarded as undignified. In fact, it has been suggested that the failure of lawyers to advertise creates public disillusionment with the profession."[16] The court argued that a more important public policy concern arose from bans on legal advertising, positing that absent sufficient information about the price of legal services, many potential litigants would be dissuaded from seeking legal representation when it would be objectively advisable for them to do so. The *Bates* case also dispensed with the elitist view of the legal profession, arguing that, in modern times, the "belief that lawyers are somehow 'above' trade has become an anachronism."[17]

The court stressed the importance of access to legal services, and viewed legal advertising as a legitimate means of creating awareness for such services. Noting that the "middle 70% of our population is not being reached or served adequately by the legal profession," the court found support for the public's need for lawyers to reach out to them. Saul Goodman would have reacted with joy at the prospect that he is filling a legitimate need in his community.

Although the flat prohibition on advertising was lifted after the *Bates* case, advertising is now typically regulated by state bar associations. The court held that individual states are permitted to prohibit "false, deceptive, or misleading" lawyer advertising, to place certain restrictions on ads, and to require disclaimers on the advertisements.

Just as there are other limits on First Amendment rights in other contexts (such as a prohibition on shouting "fire" in a crowded theater),[18] there are specific restrictions on lawyer advertising. New York print ads, for example, are only allowed to contain the address and phone number and only list specialties if the firm is licensed in that specialty.[19] The ABA has created the following legal standard for regulation of advertising: "The state may prohibit speech that is false or misleading. If the communications are truthful and non-deceptive, the state may limit [advertisements] if the state asserts a substantial government interest. The regulation under scrutiny must directly advance state interest. The regulation must be a reasonable fit narrowly tailored to achieve the desired objective."[20] Lawyers and the American Bar Association have battled over advertising that may be seen as distasteful but truthful. Often, the lawyer's First Amendment right to free speech wins the day in court. Attorneys have, however, been sanctioned for violations of advertising rules. A lawyer was suspended, for example, for sending hundreds of spam e-mail messages.[21]

Even after *Bates v. State Bar of Arizona*, many attorneys and bar associations still frown upon the idea of advertising legal services, invoking some of the arguments set forth by the Arizona State Bar in the *Bates* case. As legal scholar Dr. Kimberlianne Podlas notes, "The Bar has voiced concerns that the once-noble profession of law is becoming just another business where aggressive advertising is the norm and professionalism and ethics are subservient to profit."[22] Despite this perception, legal advertising remains a significant phenomenon in the United States. According to a recent study, in the top seventy-five television markets in the United States, approximately two thousand lawyers advertise on television, spending nearly $200 million collectively.[23] Such advertising has likely contributed to the

proliferation of voluminous individual lawsuits (including many in the personal injury category) and large class action lawsuits with multiple plaintiffs, especially in the tort industry (such as major lawsuits involving fen-phen litigation).[24] Television and Internet advertisements often invite people who may have experienced some suffering potentially related to some third-party factor to join class action suits in order to be compensated. Because of the massive influx of potential clients and the rush to develop cases quickly, there is a greater chance for error, and perhaps even fraud in some of these cases.[25] Furthermore, hearing an authoritative legal voice in an advertisement almost demanding that viewers call a toll-free number to receive representation likely influences many viewers to seek representation for what may or may not be a valid, actionable claim. There can be little doubt that Saul's facetious and aggressive advertising leads to frivolous lawsuits—even the tagline Better Call Saul is in and of itself a *demand* for viewers to call in.

One of the main reasons that many major white-shoe law firms do not advertise is that it is widely viewed in some circles as pandering—something that those in such an "elite" profession seek to avoid. Lawyers do not want to appear desperate, and, so the argument goes, law is less of a business than a craft or profession.[26] Lawyers will not sink so low as to promote their services; that would be degrading to the profession itself.

Lawyers do need to make a living, and potential clients need to have some way of learning about particular lawyers. Crass television and Internet ads have not generally been their preferred means of communication, however. We see these ads on television, and, whether fair or not, many people form a particular opinion about the lawyer or firm simply because the firm has made the conscious decision

to advertise legal services in a medium that many other lawyers avoid. The large, white-shoe firms instead tend to attract clientele by building a solid reputation and using the occasional face-to-face, highly dignified pitch. While law is undoubtedly a business, many lawyers seek to distance themselves from that fact and instead focus on the substantive nature of the work, not the business elements. For example, the Chicago Bar included the following statement in its materials: "The most worthy and effective advertisement possible…is the establishment of a well-merited reputation for professional capacity and fidelity to trust."[27]

Jimmy McGill's Davis & Main colleagues highlight the above perspective. In "Amarillo," Cliff Main becomes incensed upon learning that Jimmy created and placed an ad in a small television market without obtaining approval from the partners. In "Gloves Off," Cliff Main dismisses the fact that the ad leads to more business and attracts clients, focusing instead on the potential contents of the unseen ad: would it be tacky and give a negative impression of the firm? Does it violate ethical rules? To Cliff, maintaining the dignity of the profession (and, in particular, his law firm) is much more significant than earning a few bucks from a clever, tacky ad. "Our image, our reputation is something we've been carefully building for years," he says. "It's worth far more than any one case. Something like this could damage it."

Another partner at the firm also sharply admonishes Jimmy, noting that "We have clients who wouldn't want to be associated with this kind of… *this!*"

It turns out that the ad is relatively clean (especially by the standards that Saul later sets), and Jimmy even proudly notes that it was created "in accordance with the rules and regulations of the American Bar Association."[28] But the mere possibility of airing an ad that generates a less-than-favorable impression of the firm is enough to worry Main. And

in "Bali Ha'i," we learn that Jimmy's ad has been replaced with one that completely lacks any sense of "showmanship."

It is fascinating to watch Jimmy as he develops his ads. In "Fifi," he engages an actor (who is Jimmy's former client) to play a war veteran so he can convince actual members of the military to allow Jimmy and his film crew access to an old warplane named *Fifi* (because of his association with the "veteran"). And in "Nailed," Jimmy and his team set up a video camera in a schoolyard. When confronted by school officials who ask Jimmy to leave, he falsely claims that his associates called the superintendent's office for permission in advance, and says that he is filming a documentary about Rupert Holmes. He even begins to sing "Escape (the Pina Colada song)" in support of his lie. Jimmy lies seamlessly to anyone standing in his way. He has a common touch with people, one which ensures that they will believe him—and this is one of the sentiments that shines forth in his ads.

Saul Goodman's exaggerated and crass advertisements are prime examples of what many in the legal profession fear. The ads can be seen as degrading to the profession. The fast-paced, money-hungry image that Saul presents serves as a reflection of America's obsession with filing lawsuits. The United States is an extremely litigious country—we file more than fifteen million in state courts annually (one lawsuit every two seconds).[29] Warning labels and disclaimers adorn almost every product we use (including, as a classic example that resulted from an actual case that was satirized on an episode of *Seinfeld*,[30] coffee cups with warnings that the cups contain—you guessed it—hot coffee).

Saul's ads undoubtedly encourage frivolous lawsuits: by declaring that potential clients can sue libraries, churches, Amish elders, glassblowers, synagogues, and even "yourself," Saul attempts to stretch the law in odd and creative ways in order to achieve results for them. And while attempting

to obtain the best result for a client is a virtue, Saul's frivolous cases would cause a judge to view him as an attorney with no credibility—which, in the long run, will hurt Saul's clients more than his creative (and deceptive) approaches do to help them.

Saul might respond to the above criticism by pointing out that his ability to stretch the intent of the law at times, and to be as creative as possible, helps to keep police, government officials, and corporations on their toes. Saul might readily admit that he is a sneaky, devious lawyer. But he might also argue that these qualities help him to combat overreaching by figures of authority. He can be considered a check on such authority, just as the subversive nature of a television series like *The Simpsons* can be considered a check on authority.[31] If a coffee cup fails to include a label warning us that the contents may be hot, or if a police officer digs a bit deeper than the law allows, Saul Goodman will be there to assert the victim's rights.

Despite some admirable lawyering skills, Saul is a gimmick—and this is clearly and overtly expressed in his advertisements. Because he's a showman, advertising is a crucial part of his game. He needs a way to compete with the HHMs of the world, and crass advertising that attracts a particular type of clientele is his preferred means of contact.

Saul's Ads

Here is the advertisement (published in the *Arizona Republic*) that gave rise to *Bates v. State Bar of Arizona*:

Do you need a lawyer?
Legal services at very reasonable fees
- Divorce or legal separation—uncontested (both spouses sign papers) $175.00 plus $20.00 court filing fee

- Preparation of all court papers and instructions on how to do your own simple uncontested divorce $100.00
- Adoption—uncontested severance proceeding $225.00 plus approximately $10.00 publication cost
- Bankruptcy—non-business, no contested proceedings
 - * Individual $250.00 plus $55.00 court filing fee
 - * Wife and Husband $300.00 plus $110.00 court filing fee
- Change of Name $95.00 plus $20.00 court filing fee

Information regarding other types of cases furnished upon request

Legal Clinic of Bates & O'Steen[32]

The above advertisement is quite innocuous: it does not make promises about results, it does not tout previous settlements or victories, and it lacks the hubris that is often contained in modern legal ads. It simply lists the types of services offered along with the fees. The attorneys intended to introduce themselves to the public through the ad, but the ad is not an example of self-promotion. It would be difficult to argue that such an informational advertisement would inflict harm on the dignity or stature of the legal profession. But it should not be surprising that a lawyer would find issues with it, as we are trained to spot issues and engage in debate. In his dissenting opinion in *State Bar of Arizona*, Justice Lewis F. Powell Jr. takes issue with the attorneys' claim that their fees were "very reasonable,"

opining that "Whether a fee is 'very reasonable' is a matter of opinion, and not a matter of verifiable fact as the court suggests. One unfortunate result of today's decision is that lawyers may feel free to use a wide variety of adjectives—such as 'fair,' 'moderate,' 'low-cost,' or 'lowest in town'—to describe the bargain they offer to the public."[33]

Justice Powell is correct that "reasonableness" is a matter of opinion and a relative term. That said, because it is a relative term, one can feel comfortable in making a determination that a fee is or is not "reasonable" based on a comparison with fees charged by other lawyers performing similar services in the marketplace. In any event, Powell's prediction that lawyers may "use a wide variety of adjectives" proved true. Saul Goodman's advertisements are, in many ways, distasteful and may well inflict long-term, significant harm to the legal profession. Because Saul is a showman, his ads need to be on full display for potential clients to see.

Saul's ads do not just push the envelope—they tear the envelope wide open. They are completely undignified and lack the substance and measured tone that is displayed in the Bates and O'Steen advertisement. Saul is often pictured in the ads, alongside a backdrop of the US Constitution and a large set of law books. The ads take on the tone of a late-night infomercial. Justice, it appears from Saul's ads, is only available as part of a limited-time offer and can be purchased for a fee.

One of Saul's advertisements reads:

Allegation of Incest? "Better Call Saul!" I can make them disappear! Saul Goodman, Attorney at Law—Call Risk Free Now

First, it is noteworthy that Saul's ad adopts a gimmicky,

cheesy tone ("Call Risk Free Now")—exactly the kind that those in an "elite" profession seek to avoid. It is not informative in that it does not describe the types of legal services that will be provided (other than promising that the attorney can make the "allegation...disappear") and does not include anything about price, such as we see in the Bates and O'Steen ad. Saul's ad is targeted to alleged *criminals*; this is in sharp contrast to the typical personal injury television ads aimed at potential *victims*. From Saul's perspective, however, the alleged criminal may be more accurately characterized as a victim—of poor judgment, perhaps, but also of police overreaching and of society at large.

Saul's Clientele: Victims of Society?

In *The Simpsons* season 9 episode "Girly Edition,"[34] Lisa Simpson makes the argument that society may be partially to blame for Bart's misbehavior:

> **Lisa Simpson:** He's...well...he's your son!
> **Groundskeeper Willie:** *What?!*
> **Lisa:** Well, not literally. But, in a way...isn't he everyone's son? For you see, that little hell raiser is the spawn of every shrieking commercial, every brain-rotting soda pop, every teacher who cares less about young minds than about cashing their big, fat paychecks. No, Bart's not to blame. You can't create a monster and then whine when he stomps on a few buildings!...
> **Willie:** You're right. It's all Willie's fault! I've been a terrible father.

One could imagine Saul Goodman making the same appeal in a courtroom. Saul (in what you could consider a President Donald Trump impression) has argued, sometimes

implicitly but often explicitly, that his clients are "victims" of a legal system that is stacked against them. Therefore, the "wrongdoer-as-victim" argument warrants further discussion in the context of the American legal system. As I wrote in *The World According to The Simpsons*:

> Lisa's analysis of the inherent causes of Bart's deviant behavior broaches an ongoing debate in contemporary society. After students in Columbine shot and killed fellow students and teachers, many people found it quite difficult to place blame entirely on the murderers themselves. Many wondered whether society at large was at least partially to blame for their actions. Were these teenagers influenced by violent movies and video games? Were they neglected by their families and teachers? Were they constantly criticized and ridiculed by classmates? Did society, as Lisa poignantly noted, "create these monsters"?
>
> If Lisa is indeed correct, then we are left to consider whether or not we treat delinquents in the proper manner. Are we justified in "whining" when these "monsters stomp on a few buildings"? In an age of harmful external influences, it is often difficult to decide how to justifiably attribute blame for one's actions. Is Bart the victim of society's ills? Or is society the victim of Bart's actions?
>
> Willie's response to Lisa's comment, while humorous, serves also as a point of discussion. Certainly, Willie is not Bart's "father" in the biological sense, but in another sense, as Lisa contends, "isn't he everyone's son?" It can be argued that it is society's job to nurture Bart so as to prevent him from resorting to mischief.

Certainly, individuals are believed to possess at least a certain degree of free will, so Lisa's comment about Bart serves to pose more questions than it answers. The answers to all of these questions probably lie within a compromise between the two schools of thought: environmental theorists, who claim that Bart's actions are solely a result of the environment to which he belongs, and biological theorists, who claim that Bart's deviant tendencies are innate and inherited.

Saul would certainly side with the environmental theorists on this one. We may well see him representing Bart Simpson one day in the future, employing Lisa's arguments.

Note also that Saul's ads are directed at the type of clientele that, once again, many lawyers would seek to avoid (the ad which tries to attract those who have committed incest is a prime example). However, directing advertisements at a specific type of clientele is not a violation of ethical rules, and can even be viewed in an admirable light: it is the role of the criminal defense lawyer to take on the legal representation of those who have been accused of crimes— even heinous ones. The criminal lawyer may well be the accused individual's only friend and advocate in the world, after the accused is slammed in the media and possibly even shunned by friends and family. One of the reasons that many attorneys choose not to become criminal defense lawyers is because they do not want to represent those who may have committed violent and/or despicable crimes. But by taking on the representation of alleged criminals, Saul and other criminal defense lawyers serve the larger societal role of protecting the rights of the accused.[35] If there were no criminal defense for those accused of heinous crimes, there would be many more false and improper convictions.

It has been said that it is better for ten guilty men to walk free than for one innocent man to be convicted. By providing a competent, zealous defense of an individual accused of a crime, and by requiring the prosecution to prove beyond a reasonable doubt that the individual committed the crime of which he or she is accused, the criminal defense lawyer plays an important role in strengthening the fabric of justice in our republic. Because the burden of proof is on the prosecution in the United States, police are less likely to arrest innocent people and prosecutors are less likely to bring weak and/or frivolous cases to court. Criminal defense lawyers, of course, must advocate for their clients within the strict confines of the law and ethical guidelines. When Saul inevitably veers off course (at times helping his clients *perpetuate* crimes), he is, of course, not benefitting the public. In fact, we might view Saul's interactions with his clients as the morbid (and perhaps inevitable) extension of the role of the criminal defense attorney as friend of the lonely accused defendant. But if a criminal defense lawyer works within the parameters of the rules, society receives an important benefit—even if the end result in a specific case is a guilty man or woman walking free.[36]

Another advertisement reads: "Substance Abuse? Better Call Saul! I'll make your affliction into a medical condition." This ad demonstrates that Saul is more focused on including catchy, rhyming taglines than providing substantive information to potential clients. It is the type of ad that makes the law profession seem more like a sketchy business, replete with tricks and gimmicks, than a craft practiced by dignified professionals.

A third advertisement reads, "Looking at jail time? I know a guy who knows a guy who can fix that." This cheesy ad includes images of a police car and handcuffs.

Other ads by Saul Goodman are even less informative.

One simply features a picture of the Statue of Liberty with the accompanying text, "Liberty? Better Call Saul!" This ad does not even include the words "Advertising Material" (which is required under the ABA Model Rules of Professional Conduct [MRPC], as discussed below). Saul's goal in this ad is to evoke imagery of justice, freedom, and patriotism rather than provide any information on the types of legal services offered or rates associated therewith. As such, the ad is quite gimmicky.

Considering Filing a Frivolous Lawsuit? Better Call Saul!

Saul presents himself in his advertisements as a generalist lawyer, although the ads tend to focus on the criminal and personal injury fronts. As commentary on the spate of personal injury ads that are typically seen in American households, Saul's website includes commercials in which Saul pleads with potential clients to call him to solve legal problems that may or may not exist. A common criticism of such advertisements is that they lead to frivolous lawsuits and create the misperception that almost all tort lawsuits are frivolous. By flooding the legal market with questionable cases, the select few that include legitimate, actionable claims are viewed as suspect and can be lost in the voluminous sea of lawsuits.

For example, Saul employs classic ambulance-chasing tactics in connection with the Wayfarer 515 plane crash on *Breaking Bad*.[37] He produces a television commercial seeking out not only those who have experienced physical damage, injury, or pecuniary loss, but also those who may have *known* a victim—even as an acquaintance. This "special message to Wayfarer victims" is set against a backdrop of the American flag, bald eagle, and the US Constitution. Saul speaks in a solemn tone in this commercial, but we can

easily see through the charade. He tells us that "we are all victims" of the crash—even those of us who were merely "inconvenienced" by it—and surmises that we are all struggling with difficult questions at this time:

> Is there a God?
>> How can he let this happen?
>> Who did this to me?
>> Who can I sue?

The inclusion of the last question among the other, truly important questions serves as satirical commentary on the value that we place on lawsuits in contemporary society.

The ad continues, and implores anyone who has experienced "nausea, anxiety…survivor's guilt, restless leg syndrome, uncertainty…" to call Saul, adding that "doctors are standing by!" We see the shift from feigned sympathy for victims to Saul's overtly opportunistic declaration: "The tragedy is profound, the pain is profound, and, believe me, the settlement will be profound!"[38]

Lost in the vast number of potential "victims" that Saul's ad may attract are those who have actionable claims. (It goes without saying that "survivor's guilt" does not constitute an actionable claim!) Justice demands that true victims be compensated for their losses; it is important to avoid flooding the courts with frivolous cases so as not to overshadow those individuals who have experienced actual harm. An outpouring of frivolous cases might not only make the real victims seem less sympathetic, but also would make the legal resolution process longer.

In an attempt to deter abuses and reduce the number of frivolous lawsuits that are filed in federal court, the Federal Rules of Civil Procedure (which attorneys are required to adhere to in federal court) include a rule that permits a

court to impose sanctions on attorneys for filing them. The standard for the imposition of sanctions is relatively high, and are not awarded merely because a plaintiff's case is weak. Saul might be subjected to sanctions under Rule 11, but certain formalities would need to be followed. Generally speaking, he would need to provide a written document to the court that contains legal allegations without an adequate basis in fact, and this document must be provided for an improper purpose. In "RICO," Jimmy McGill's opposing counsel in the Sandpiper case considers sending a Rule 11 letter and having him sanctioned because he has "no good-faith basis to threaten any litigation." The attempt to invoke Rule 11 is improper in this context. Rule 11 only applies to documents filed with a court, and, according to the view of most courts, can only be triggered by a motion, not by letters sent to opposing counsel. In this instance, no court even has jurisdiction at this point and no lawsuit has been filed or commenced; it would therefore be impossible for anyone to even award damages at this point.

Has Fast Food Made You Overweight? It's All Good, Man!

As a master of advertisement and publicity, Saul uses the media to attract large numbers of clients, most of whom have claims that are questionable at best and frivolous at worst. One infomercial-style commercial on his website starts with Saul, US Constitution in the background, asking the audience:

> Are you or someone you love fifty, a hundred, or even two hundred pounds overweight? Then you better call Saul! Have fast food restaurants tricked you into an unhealthy lifestyle with their ads, their dollar menus and their colorful banners? I'm Saul

Goodman, and I have the highest dollar per pound
recovery ratio in Bernalillo county.

We have seen TV advertisements that are similar in
both style and content. In some ads, we hear loud attor-
neys bellowing at the top of their lungs, imploring us to
call for free consultations.[39] They point at us through our
television screens and demand that we call in. We see
Saul's gimmicky style employed all of the time and have
read about cases that make some of the claims that Saul
makes in the fast food ad. When customer Caesar Barber
filed a lawsuit against McDonald's, Wendy's, Burger King
and Taco Bell, for example, he argued in the press that the
fast food restaurants "never explained to me what I was
eating."[40] Barber implicitly made the same claim that Saul's
ad makes: by failing to explicitly inform consumers about
the food that they are purchasing, it is the restaurant that is
tricking consumers to lead an unhealthy lifestyle. Reason-
able observers can argue the merits of such cases, but it is
clear that cases and arguments of a similar nature are part
of the contemporary American legal landscape. They have
engendered a discourse in which we can argue whether
the corporation should be blamed for an individual's eating
habits, or, in other contexts, whether a killer can have an
excuse defense if certain actions directly or even indirectly
lead to the killer's act of taking another life.

The media has perpetuated false narratives on the
use and efficacy of certain defenses, such as the so-called
"Twinkie defense" (which the media inaccurately described
as blaming an individual's potentially criminal deeds on the
adverse effects of sugar in the individual's body at the time
the act was committed).[41]

While lawyer creativity is an important part of the
American judicial system, such cases and defenses may do

a disservice to the legal system by making it seem like a one-stop shop for figuring out what gimmicks can be used to justify certain actions or to obtain a large cash payout. And perhaps the most severe effect of such lawsuits is that legitimate claims and defenses can be swept up in the same bucket and too often dismissed by observers as frivolous (in the case of claims) or illegitimate excuses (in the case of defenses). We are left to consider whether "battered women's syndrome" (a documented phenomenon in which a woman who has been physically abused by her husband ultimately kills him)[42] is any more legitimate than any other defense arguing that certain circumstances contributed to commission of the alleged misdeed. While there appears to be more substantive, clinical evidence for battered women's syndrome than certain other excuse defenses, critics of these types of defenses argue that they have an important element in common: they all place blame for a misdeed on the defendant's previous circumstances—and remind us of the conversation between Lisa and Willie from *The Simpsons*, in which Lisa seeks to place blame on society for Bart's misbehavior. The concern with this approach, these critics argue, is that *every* potentially criminal misdeed can be seen as resulting from *some* past circumstance: the child sex abuser may have been sexually abused himself as a child, and our legal system typically rejects that kind of defense. Drawing the line between what defenses are viewed as legitimate excuses (if not justifications) for actions versus those that should be dismissed has become more difficult because of the expanded universe of arguments employed in contemporary courtrooms.

As other observers have noted, the fast-food lawsuits and certain excuse defenses are just a small part of the large number of quirky, sometimes gimmicky claims and defenses employed by creative lawyers.[43] One of Saul's main

strategies is to blame others for the failings and misdeeds of his clients: blaming the fast food industry for an individual's conscious decision to consume too much fast food is a classic example of this strategy in action. (In the ad quoted above, Saul proclaims, "You don't have to swallow injustice. Call me—Saul Goodman, today!") In contemporary American society, we know that Saul will be able to find a plethora of clients seeking to cash in by using—or, depending on one's perspective, abusing—the American legal system.

Contemporary American Legal Culture—a Society Run Rampant?

Legal scholars and other observers have discussed the myriad problems with the legal justice system in the United States. It is important to acknowledge that no legal system is perfect, and that some of the criticism of the US legal system arises because of problems resulting from the great degree of freedom that individuals in our society possess. Such freedom is one of our most cherished values, but it does have certain negative consequences (even if most would agree they are far outweighed by the benefits). Our open and free society includes an open and free legal system. It is quite easy to file a lawsuit, even if such suits are frivolous and without any merit whatsoever. (Our legal system does sometimes sanction lawyers from bringing such suits, but restrictions on members of the general public, without legal representation, are much fewer, aside from the sometimes prohibitive time and cost.) Critics have argued that Americans have become obsessed with filing lawsuits.

One may also argue that part of the lawsuit epidemic in the United States stems from tacky advertisements that encourage—and sometimes, as discussed above, effectively *demand*—that members of the general public contact a lawyer to obtain legal representation. Jimmy McGill has

had his fair share of clients with odd requests for legal rep-
resentation. It is noteworthy in the context of this discus-
sion that he receives these requests *immediately after* his
billboard advertisement publicity stunt. The series directly
ties such media exposure to additional work for Jimmy.

In "Alpine Shepherd Boy," Jimmy meets with three
potential clients following the billboard stunt. The requests
of these potential clients can serve as case studies for the
broad spectrum of legal advice and representation that
is sought after by members of the public. The first two
requests are humorous in their absurdity, and support the
notion that people often seek lawyers for a wide variety of
odd reasons. Jimmy will, as we know, one day represent
an odd bunch of characters—lowlifes that other attorneys
often seek to avoid. But these strange requests are a bit too
weird even for him, at least at this point in his life. It bears
mention that the restrictions on lawyer solicitation do not
apply to these situations because, per Rule 7.3(b) of the
New York Rules of Professional Conduct, solicitation does
not occur unless the lawyer (as opposed to the client) initi-
ates the communication.

The first potential client asks Jimmy to represent him in
seceding from the United States. Jimmy is all game—or at
least purports to be—once he hears about the large fee that
this person offers to pay. (Jimmy is seemingly unaware of,
and/or not troubled by, the fact that secession was deemed
unconstitutional in the 1869 United States Supreme Court
case *Texas v. White*).[44] Jimmy balks, however, once his
potential client takes the secession idea to a whole new
level: he is only willing to pay Jimmy in currency with his
own face on it. While this currency may hold some value in
the event the man's secession plot succeeds (incentivizing
Jimmy to advocate zealously on his client's behalf), Jimmy
will have none of it and declines the representation. (Jimmy

declines to comment on the possible illegality of printing/ using non-US tender in this scenario). Note also that the New York Rules of Professional Conduct prohibit Jimmy from taking on the representation. Rule 1.16(a)(2) provides that "A lawyer shall not accept employment on behalf of a person if the lawyer knows or reasonably should know that such person wishes to...present a claim or defense in a matter that is not warranted under existing law, unless it can be supported by a good faith argument for an extension, modification, or reversal of existing law." Because secession from the union is illegal, Jimmy is not permitted to take on this case unless he can conjure up a good-faith argument that existing law should be reversed. For good measure, Rule 16-116(A)(1) of the New Mexico Rules of Professional Conduct similarly provides that attorneys may not take on a representation if it "will result in violation of the rules of professional conduct or other law." And both bodies of rules prevent attorneys from bringing "frivolous" claims to court (New York Rule 3.1(a) and New Mexico Rule 16-301, respectively). Jimmy might also face sanctions under Rule 11 of the Federal Rules of Civil Procedure (or similar state rules) for bringing a claim that is deemed to be frivolous.

Jimmy's second potential client seeks Jimmy's representation in filing for patent protection for an invention. Jimmy lies to the client (violating some of the "catchall" provisions to be discussed later on, such as those that reflect poorly on an attorney's character and honesty set forth in certain sections of Rule 8.4 of the MRPC and analogous state bar association rules) by stating that he has worked on a number of patent cases. In addition to lying, Jimmy also might be violating ethical rules that require an attorney to be competent enough in a field to advocate responsibly for a client (e.g., Rule 1.1 [Competence] of the MRPC). Jimmy

also declares that he should "just specialize" in patent law, and thereby comes quite close to violating Rule 7.4(d) of the MRPC, which prohibits an attorney from claiming a specialization in a particular field unless so certified by a proper authority.[45] Patent law is a highly technical field and, depending on the nature of the legal representation, may even require an attorney to pass a separate bar exam in order to take on a particular representation. There is little question that Jimmy is ill-equipped to handle such a matter.

Jimmy ultimately declines the representation due to the nature of the invention itself: "Tony the toilet buddy," a talking toilet, which, the inventor (Roland Jaycocks) contends, is intended to serve as an aid in potty training for toddlers. He does not comment on the patentability (or lack thereof) of such an invention, and does not apply any legal analysis to determine whether or not the idea is protectable under United States patent law.[46] Jimmy declines the representation not because of his ineligibility but because the words spoken by the toilet come across as sexually suggestive (the inventor is apparently unaware of this).

Even though Jimmy declines the representation, he owes certain obligations to Mr. Jaycocks, who was a prospective client. Later on in the episode, Jimmy violates his confidentiality obligations by revealing the invention, and making fun of it, with Kim. New York Rule 1.18 ("Prospective Clients") states that attorneys "shall not use or reveal information learned in the consultation," even when said consultation does not result in an actual representation. Jimmy also violates the nondisclosure agreement he signed, even though his only purpose is to laugh about it with Kim. If the disclosure leads to someone copying and profiting off the idea, the direct and consequential damages that Jimmy might be responsible for could be substantial.

The third potential client is an elderly woman who

needs a will. She has very specific requests for bequeath-
ing certain figurines in her collection, which makes for a
tedious discussion with Jimmy. Jimmy performs well in this
meeting, taking careful notes, paying attention to his client,
demonstrating patience, and charging a reasonable fee (in
compliance with the requirement that fees charged must
be "reasonable," per New Mexico Rule 16-105). Jimmy
communicates the fee verbally, which perhaps is not best
practice. But because the fee is so small, it need not be in
writing under most bar association rules. New Mexico Rule
16-105(b) only provides that the fee "preferably" be stated
in writing.

⚖️

It is noteworthy that Saul's fast-food advertisement
violates a host of the ethical rules that we will discuss in
the next section: the inclusion of client testimonials (in this
case, an overweight client holding bags filled with money
and praising Saul), the promise of achieving a particular
result, referring to past results to imply that a particular
result will be attained in the future, the deceptive and mis-
leading nature of the ad, and more. (Saul's disclaimer in the
ad that the "size of the money bag may vary" does little to
dispel the notion that a particular result is being promised).

Let's turn to the question of whether and how these
advertisements violate certain ethical rules.

Rules on Attorney Advertising

Portions of many, if not all, of Saul's ads violate state
ethics rules on lawyer advertising. Although state bar associ-
ations (which regulate the conduct of lawyers in individual
states in the United States) each promulgate their own sets
of rules, they often rely on the American Bar Association's

MRPC as the basis for creating those rules. The MRPC was adopted in 1983 by the ABA House of Delegates. Given the influence of these rules, citations in this book will refer to the MRPC unless otherwise noted.

It bears mention that not every attempt at marketing qualifies as an attorney advertisement that is subject to the restrictions set forth in the applicable state bar rules. An advertisement, as defined in the New York Rule 1.0(a), for example, is defined as "any public or private communication made on or behalf of a lawyer or law firm about that lawyer or law firm's services, the primary purpose of which is for the retention of the lawyer or law firm." If marketing material falls within the applicable state's definition, then it is deemed an advertisement and is subject to the rules set forth for advertisements in that state.

Under New York Rule 7.1(f), materials that qualify as advertisements must include the words "Attorney Advertising" and must include the "name, principal law office address and telephone number of the lawyer." Notably, a New York ethics opinion permitted law firms to distribute branded merchandise to hospital patients and held that such materials do not constitute advertisements so long as the items do not contain taglines, slogans, or offers of legal services (including in combination with any "oral communication about the firm," since such a combination might implicate and/or violate the solicitation rules set forth in New York Rule 7.3).[47] Based on this holding, using only a name and logo on marketing material would not constitute an advertisement; therefore, attorneys licensed to practice in New York are free to include the name of their branded firm on a business card, with no other information, and such a business card would not be subject to the restrictions on advertising. Because, however, Jimmy and Saul typically use a flamboyant and creative marketing style (including the

use of tacky slogans on items such as bingo cards), most, if not all, of the marketing that our protagonist employs qualifies as an advertisement under the rules.

Rule 7.2 ("Advertising") provides, in relevant part, that "a lawyer may advertise services through written, recorded or electronic communication, including public media." But the MRPC includes certain restrictions on the nature, content, and scope of the advertisement.

As noted earlier, Jimmy McGill's use of the pseudonym Saul Goodman is intended to mislead potential clients. Rule 7.5(a) ("Firm Names and Letterheads) provides, in relevant part, that "A lawyer shall not use a firm name, letterhead or other professional designation that violates Rule 7.1." Rule 7.1 ("Communications Concerning a Lawyer's Services") provides, in relevant part, that "A lawyer shall not make a false or misleading communication about the lawyer or the lawyer's services. A communication is false or misleading if it contains a material misrepresentation of fact or law, or omits a fact necessary to make the statement considered as a whole not materially misleading." Use of "Saul Goodman" on the sign of Saul's law office likely constitutes a "false or misleading communication about the lawyer"—particularly because Jimmy's intent is to mislead potential clients into believing he is Jewish.[48]

In addition to the deceptive use of the name Saul Goodman, many of Saul's ads include "false or misleading communication about the…lawyer's services." Lawyers are required to be careful as to what promises they make in an advertisement. Quoting a specific price for services and providing a brief description of each service is permitted as a result of the *Bates v. State Bar of Arizona* case. But ads that make promises about achieving results (or create such an implication) are commonly prohibited by state ethics rules—and for good reason. Without consulting with a

client, it is impossible for a lawyer to know how the law applies to the facts of the case. And even if the facts of the case were known, it would be irresponsible and arrogant for any attorney to believe that he or she could *guarantee* a result in a specific case: there are so many factors involved in determining how a judge will rule that it is impossible to predict the outcome. The lawyer's role in representing a client is to zealously argue on the client's behalf; it is impossible to predict or guarantee at the outset of the representation (or, in the case of Saul Goodman's advertisements, *prior* to even establishing the relationship) whether a particular result can be attained. A lawyer's ability to devise an effective legal strategy is just one factor in determining the outcome of a case; Saul's ads create the perception that by calling on Saul, a specific result will be achieved. Truth and honesty are essential to building and maintaining a relationship with a client: if an attorney promises results or intentionally implies that a past result will be matched in the future, a well-informed client will know that the attorney cannot be trusted.[49]

Although not explicitly prohibited by the MRPC, one can strongly argue that a "misleading communication" includes promises about achieving a particular result. Many states do include this specific prohibition: as of January 1, 2011, twenty-seven states (not including New Mexico, the state in which Saul practices law) have "prohibitions on attorney communications that create false impressions or imply that a lawyer can achieve results by means that violate the rules of professional conduct or other law."[50] (As an example, the Florida rule states that "A lawyer shall not make or permit to be made a false, misleading or deceptive communication about the lawyer or the lawyer's services. A communication violates this rule if it promises results.") Some of Saul's prospective clients may retain Saul because

he has *promised* to solve their problems. For example, the ads in which Saul claims that he'll turn a prospective client's "affliction into a medical condition," that a "settlement will be profound," and that he knows a "guy who knows a guy who can fix that" are likely considered promises about achieving a particular result (although Saul can argue that they constitute mere puffery to promote his services). But puffery cannot be used to explain advertisements in which Saul directly and explicitly promises a specific result: Saul's website also includes a picture of a baby with the caption, "I can prove that baby's not yours!" Another ad reads "Incestuous love? I can make it legal!" And yet another reads "Cheating problems? I'll prove you're innocent on the witness stand (and help you find another one-night stand)." All of these ads likely fall into the common prohibition against using false, misleading or nonverifiable communications about a lawyer's services—to say nothing of the unprofessionalism displayed and the shame that they bring to the legal profession.

Florida and Louisiana restrict the use of images that are deceptive, misleading, or manipulative. Saul's "Liberty" ad seems to fall squarely into this category, as it evokes imagery intended to manipulate clients into believing that Saul's practice is focused on achieving justice; in fact, the true value of his services is measured by the degree to which he helps clients *evade* justice!

In addition, not all of Saul's ads include the word "Advertisement." Rule 7.3(c) ("Solicitation of Clients") requires that the words "Advertising Material" appear. Some states require other variations of these words, such as "Attorney Advertising." In addition, some states require advertisements to be filed with state grievance committees: these committees would likely be shocked to see some of Saul's appalling ads!

Rule 7.3(a), with certain limited exceptions, prohibits a lawyer from soliciting business "by inperson [*sic*], live telephone or real-time electronic contact…when a significant motive for the lawyer's doing so is the lawyer's pecuniary gain." Jimmy likely violates this rule by engaging in "inperson" contact with senior citizens. Not only does Jimmy hang around the senior center and host bingo games; in order to realize a financial gain, he also promotes his services verbally and by handing out bingo cards and Jell-O pudding cups with his brand and slogans. The bingo cards include a drawing of Jimmy's face, with the tacky tagline "Need a will? Call McGill!"

Jimmy also solicits business from senior citizens in Texas[51] as they sit aboard a bus in the season 2 episode "Amarillo." Jimmy's "client outreach" in this scene involves Jimmy paying the bus driver to pretend the bus has broken down, allowing Jimmy to jump onboard and directly solicit individual elderly clients to join the Sandpiper Crossing class action lawsuit. The plan works perfectly, as Jimmy gives his spiel and effectively relates to the individuals on a personal level. Jimmy tells the elderly individuals to think of him as their "nephew Steve," who would inform a restaurant manager of a mistake on a bill. He even recalls the Alpine Shepherd Boy figurine that he saw while doing a previous client's will. He demonstrates an uncanny ability to relate to the elderly. As we know, he also targets their daily TV show when timing his ad. After developing the close connection with the elderly individuals so quickly, Jimmy completes his pitch: like the nephew taking care of the issues with the bill, Jimmy promises that he will handle the "discrepancies" on the bills issued by Sandpiper.

It bears mention that, upon boarding the bus, Jimmy initially only asks to speak to one person there—an individual who had sent back the mailing that Davis & Main

had sent out as part of its client outreach efforts. If Jimmy had not devised the broken-down bus scheme and had only sought to speak to the individual who had responded to the mailing, such an action *may* not have resulted in a violation of Rule 7.3(a), since he could argue that he was simply engaging in a back-and-forth communication with a client who had responded to the mailing. However, even absent the bus scheme, consider whether Jimmy's overtures to the client *in front of the other passengers* in a loud manner constitute a violation of Rule 7.3(a). His clear intent is to sign up other clients, and he is eager to collect forms and answer questions from the other passengers. The halted bus scheme itself is intended to effectively *trap* the other passengers into hearing his conversation with the individual who responded to the mailing. It therefore seems likely that a bar disciplinary committee would find that Jimmy's actions regarding the other passengers violated the Rule 7.3(a) prohibition on "in person" contact "when a significant motive for the lawyer's doing so is the lawyer's pecuniary gain."[52] Jimmy's implementation of the bus scheme may also constitute "conduct that adversely reflects on his fitness to practice law," a violation of Rule 16-804(h) of the New Mexico Rules of Professional Conduct.

After Jimmy signs up so many new clients (on the bus in Texas), Chuck, suspecting foul play, challenges him about how he has done so. Jimmy denies engaging in any in-person solicitation, but Chuck raises the valid concern that the significant influx of new clients will raise eyebrows and likely create at least an appearance of impropriety. Chuck argues that the American Bar Association created the nonsolicitation rule in order to protect a vulnerable class like the elderly,[53] so a heightened degree of attention must attach to the way in which attorneys interact with older prospective clients. Jimmy stands by

his lie and insists that his hard work has led to word of the case getting around, and that he did not directly solicit the senior citizens in person.

In another episode ("Alpine Shepherd Boy"), Jimmy barely avoids implicating the nonsolicitation rules when he hands Mike (a somewhat elderly fellow) a business card, telling him:

> I'm doing elder law now. "Need a will, Call McGill!"
> So give me a call if you...uh...if...you happen to know any elders.

Here, Jimmy avoids soliciting Mike by changing course and asking for a referral. Such an interaction is permissible, and does not implicate lawyer referral rules unless Mike is paid for recommending potential clients to Jimmy.

Many states include a series of other prohibitions and restrictions on attorney advertisements. A number of states, for example, prohibit or restrict comparing or describing the quality of a lawyer's services. Fifteen states prohibit or restrict the use the use of dramatizations or simulations—both of which are common fixtures in many of Saul's ads. Many states prohibit the use of testimonials or endorsements. Saul's website is in direct contravention of this rule, as it includes a "testimonials" section, replete with glowing reviews from former clients. Several states prohibit making statements about past legal services that have been provided. Missouri prohibits advertisements for specific types of cases for which a lawyer lacks experience or competence. It is questionable as to whether Saul has experience in all of the types of legal services that he advertises. New York prohibits "depictions of fictionalized events or scenes"—the use of boxers in a ring and some of the other imagery in Saul's ads likely violate this rule.[54]

Finally, some of Saul's ads contain actual legal advice.[55] A portion of Saul's website is devoted to a "letters to mail" segment, in which he dispenses legal advice to potential clients who have written to him about their legal issues. By providing such advice in this interactive manner, Saul likely inadvertently creates an attorney-client relationship with the recipient of such advice, and this triggers certain obligations related to prospective clients under MRPC Rule 1.18.[56] If an attorney-client relationship is formed, related obligations such as those pertaining to maintenance of client information and prohibitions against conflicts of interest also apply.[57]

Now that Saul/Jimmy has our attention—since we have become thoroughly acquainted with his ads—let's take a look at the services that our favorite lawyer provides to his clients, along with the ethical dilemmas that he confronts and boundaries that he steps on in the process.

Notes

1. Query whether the AMC official Saul Goodman website can be accepted as canon, or whether it is intended as a joke only to draw potential viewers in through its comedic value. For purposes of this book, we will assume that it is intended as a true representation of Saul Goodman's business site.
2. See *The Simpsons* season 5 episode "Treehouse of Horror IV" (Episode 1F04, 1993), in which Lionel Hutz informs client Homer Simpson that he's prepared for trial by watching *Matlock* in a bar).
3. If bingo is considered a form of gambling under applicable law, Jimmy's advertisements may run afoul of prohibitions on advertising in connection with gambling.
4. For instance, when writing a demand letter on toilet paper in

the Sandpiper senior home, he tells opposing counsel, "Ignore the medium. Focus on the message."

5. Marshall McLuhan and Lewis H. Lapham, *Understanding Media: The Extensions of Man* (Cambridge: The MIT Press, reprint, 1994).

6. Not all lawyers are opposed to gimmicks. Some have even created ads intended to emulate the ones from "Better Call Saul." See Jacob Gershman, "Lawyer TV Ads Pay Homage to 'Better Call Saul,'" *The Wall Street Journal,* July 21, 2016, http://blogs.wsj.com/law/2016/07/21/lawyer-ads-pay-homage-to-better-call-saul/.

7. Jimmy plans to don one of the suits on a billboard image in an effort to mimic Howard Hamlin.

8. For a detailed examination of misappropriation and right of publicity claims (including a discussion of the elements of the causes of actions discussed above), please see "Using the Name or Likeness of Another," Digital Media Law Project, http://www.dmlp.org/legal-guide/using-name-or-likeness-another.

 Certain states have statutory rights for these sets of claims, while others rely on common law or do not recognize the causes of actions at all.

9. Incidentally, Patrick Fabian (the actor who portrays Howard Hamlin) informed me that he wears a great deal of blue clothing in real life!

10. The United States Supreme Court held that color may "sometimes" be the subject of a federal trademark or service mark registration "when that color has attained 'secondary meaning' and therefore identifies and distinguishes a particular brand (and thus indicates its 'source')." *Qualitex Co. v. Jacobson Prods. Co.*, 514 U.S. 159, 161, 163, 115 S. Ct. 1300, 131 L.Ed. 2d 248 (1995). See Susan Neuberger Weller, *When Can You Claim a Color as Your Trademark?*, *Mintz Levin*, September 14, 2012, https://www.mintz.com/newsletter/2012/Advisories/2243-0912-NAT-IP/index.html.

 Weller also notes that a federal trademark registration will be denied if the mark serves a utilitarian and/or aesthetic functional purpose. For example, if the exclusive right to use a particular color in connection with specific goods or services creates a barrier to entry of a market, or if it unfairly inhibits

competition, the color will be deemed functional and registration denied. Certain other requirements must be satisfied in order to receive a federal trademark or service mark registration. The mark must be used in at least two states in order to satisfy the "interstate commerce" requirement. An application must be filed with the United States Patent and Trademark Office specifying the date of first use of the mark, accompanied by a specimen showing the mark's use in a trademark context. The class(es) of goods/services for which registration is sought must also be identified on the application, and a description of same as it relates to the mark must be included.

11. Jimmy clearly does not copy HHM's logo for purposes of a parody or to engage in comparative advertising. See Baila Celedoria, "Statutory and Nominative Fair Use Under the Lanham Act, Intellectual Property Management," *IP Frontline*, December 7, 2006, http://ipfrontline.com/2006/12/statutory-and-nominative-fair-use-under-the-lanham-act-i/.

12. "Third Party Trademarks: Fair Use or Foul?" Fish & Richardson, November 6, 2013, http://www.fr.com/news/third-party-trademarks-fair-use-or-foul/.

13. While states set forth different tests and factors for determining whether a mark qualifies as a "nominative" fair use, the following factors, generally speaking, should be present in order to so qualify:

 - The use must accurately refer to the owner of the trademark or the goods or services sold under the trademark—it cannot be misleading or defamatory;
 - The use must not imply any endorsement or sponsorship by the trademark owner;
 - There should be no easier way to refer to the owner or its products; and
 - Only so much of the trademark can be used as is needed to identify the trademark owner and no more—this is often taken to mean that only words may be used but not logos.

Imagine for a moment that Jimmy's purpose had been to refer to HHM. In such a case, the contents of his ad would still not qualify as a "nominative" fair use because the use of the logo is misleading, and there are many easier ways for Jimmy to

refer to his business. The fact that it is a logo (as opposed to a word mark) is another knock against his usage.

14. *Bates v. State Bar of Arizona*, 433 U.S. 350 (1977).

15. Ibid.

16. Ibid.

17. In other contexts around the same time period as the *Bates* case (e.g., advertising prescription drug prices in *Virginia State Pharmacy Board v. Virginia Citizens Consumer Council*, 425 U.S. 748 [1976]), the court also rejected advertising bans (holding, in the aforementioned case, that the public's interest in comparing drug prices was a more significant concern than the desire to maintain the elitism of the pharmacy industry).

18. The phrase "shouting fire in a crowded theater" was included in Justice Oliver Wendell Holmes Jr.'s unanimous opinion in the *Schenck v. United States* case (249 U.S. 47, 1919). This case held that it was a "clear and present danger" to distribute draft opposition flyers during the World War I draft. While *Schenck* was overruled by *Brandenburg v. Ohio* (395 U.S. 444, 1969), the phrase has found a place over the years as a metaphor for the government's ability to limit free speech in certain contexts.

19. "Legal Advertising in the United States," http://en.wikipedia.org/wiki/Legal_advertising_in_the_United_States.

20. Jennifer Fulkerson, "When Lawyers Advertise," *American Demographics*, 17.6 (1995): 54–6.

21. Peyton Paxon, "Have You Been Injured? The Current State of Personal Injury Lawyers' Advertising," *Journal of Popular Culture* 36.2 (2002).

22. Kimberlianne Podlas, "The Funny Thing About Lawyers on *The Simpsons*," in *Lawyers in Your Living Room!: Law on TV*, ed. Michael Asimow (Chicago: American Bar Association, 2009), 370.

23. Michael Freedman, "New Techniques in Ambulance Chasing," *Forbes*, 168.12 (2001): 56–8.

24. Lester Brickman, "The Use of Litigation Screenings in Mass Torts: A Formula for Fraud?" *Southern Methodist University Law Review* 6 (2008). I conducted research for, and contributed to, this article.

25. Ibid.

26. As we know, Saul Goodman conflates the concepts of "business"

and "profession" in every conceivable way, and he is in no way a professional. On *Breaking Bad*, Saul exploits and endangers his own clients for personal monetary gain.

27. See Chicago Bar Association, http://www.chicagobar.org/AM/Template.cfm.

28. Ask yourself why Jimmy does not seek Cliff's permission before airing the advertisement. Jimmy is about to enter Cliff's office to ask permission, but then decides not to do so. We can speculate that perhaps Jimmy fears rejection, or that he wants to demonstrate (and create a precedent for) his own independence. Or perhaps he feels the strong need to prove that his methods work, and believes the only way to do so is to provide a demonstrable example. Perhaps Jimmy even anticipates a certain degree of anger by the partners over his insubordination, but he may (incorrectly) believe that such anger will be offset by the short-term pecuniary gains that result from the ad. In any event, Jimmy clearly miscalculates the partners' reaction.

29. Jaclyn Nicholson, "Infographic: Lawsuits in America," July 17, 2012, http://www.commongood.org/blog/entry/infographic-lawsuits-in-america.

30. *Seinfeld*, "The Maestro," 1995.

31. See Steven Keslowitz, *The World According to The Simpsons: What Our Favorite TV Family Says About Life, Love and the Pursuit of the Perfect Donut* (Naperville: Sourcebooks, 2006), for a discussion of the ways in which *The Simpsons* questions and subverts authority and carries on the tradition of Socrates's dictum that "the unexamined life is not worth living."

32. *Bates v. State Bar of Arizona*, 433 U.S. 350 (1977).

33. Justice Powell dissent, *Bates v. State Bar of Arizona*, 433 U.S. 350 (1977).

34. Episode 5F15, 1998.

35. Note that Jimmy, when trying to placate the Kettlemans, indicates that he does not seek to represent guilty clients: "Frankly, I don't go looking for guilty people to represent. Who needs that aggravation?" he asks in "Uno." Note that this is the opposite of what most attorneys feel: the hardest clients for a criminal defense lawyer to represent are those who are innocent, as a mistake by the attorney could ruin the life of an innocent person.

36. For further reading on the role of a criminal defense lawyer, see Alan Dershowitz, *The Best Defense: The Courtroom Confrontations of America's Most Outspoken Lawyer of Last Resort – the Lawyer Who Won the Claus von Bulow Appeal* (New York: Vintage Books, 1983).

37. The Wayfarer 515 plane crash is connected to Saul's client Walt. Walt had allowed an air traffic controller's daughter to die, leaving the controller distraught upon returning to work.

38. The exploitative sentiment is echoed in other Saul Goodman ads relating to the crash as well. One cynically asks, "Did any little piece [of the plane crash residue] fall on your property? I'm not looking for a whole wing, just a nut, bolt, a bag of peanuts, just as long as it caused you pain and suffering." See David Stubbs, *Better Call Saul: The World According to Saul Goodman* (New York: Harper Design, 2015), 119.

39. Some of Saul's ads are even more intimidating in nature: one employs a pair of fighters in a boxing ring, demanding that "You better call Saul—or else!"

40. Geraldine Sealey, "Obese Man Sues Fast-Food Chains," *ABC News*, July 26, 2015, http://abcnews.go.com/US/story?id=91427.

41. The media erroneously reported that defense attorneys in the Harvey Milk murder case had argued that the sugar in the defendant's system altered the defendant's mental state. While the defendant was ultimately convicted not of murder but of the lesser charge of manslaughter, the "Twinkie defense" (as such phrase was described by the media) was not the cause. Instead, part of the reason for the manslaughter conviction was due to the argument that the defendant's *choice* to consume sugar was evidence of longstanding untreated depression, as the defendant was normally a health conscious person. See "The Twinkie Defense", October 30, 1999, http://www.snopes.com/legal/twinkie.asp

42. See "Battered Women's Syndrome," FindLaw, http://family.findlaw.com/domestic-violence/battered-women-s-syndrome.html, for more information on battered women's syndrome.

43. For further discussion on the types of defenses used in the criminal context and an argument that these excuses abuse the

American legal system, see Alan Dershowitz, *The Abuse Excuse: And Other Cop-outs, Sob Stories, and Evasions of Responsibility* (Little Brown & Co., 1994).

44. *Texas v. White*, 74 U.S. 700 (1869).

45. Note that Jimmy violates this rule in "Bingo" when he informs the Kettlemans that he has changed his area of specialization.

46. Note that since Jimmy has not passed a separate Patent Bar exam, he is not permitted to prosecute the inventor's patent application.

47. New York State Bar Association, Committee on Professional Ethics, Opinion 937, *Promotional Gifts Branded with a Law Firm's Logo*, October 3, 2012. For further discussion, see Nicole Hyland, "Episode 5 (Alpine Shepherd Boy)—Part 2," The Legal Ethics of Better Call Saul, http://ethicsofbettercallsaul.tumblr. com/post/113992765906/episode-5-alpine-shepherd-boy-part-two

 Oral communication is not always a requisite component of a finding of a violation of NY Rule 7.3 prohibition on in-person solicitation. *Any* form of communication (likely even handing out physical advertisements on bingo cards and Jell-O cups) is prohibited under certain circumstances, including with respect to recipients with a "physical, emotional or mental state…that makes it unlikely that the recipient will be able to exercise reasonable judgment in retaining a lawyer." See *New York Rules of Professional Conduct* (as amended through January 2014), Rule 7.3(a)(2)(iv), New York State Bar Association, https://www. nysba.org/DownloadAsset.aspx?id=50671.

48. Even though "Better Call Saul" is used as a tagline and not the official name of Saul's law practice ("The Offices of Saul Goodman & Associates"), Saul uses the tagline so openly that it likely constitutes a "professional designation" covered by the rule.

49. And Saul knows better than to do so. When he is still Jimmy McGill, the Kettlemans try very hard to get him to promise that he will achieve a particular result. Jimmy is not optimistic about the possibility of Mr. Kettleman serving no jail time and his response to their request reflects this uncertainty. This is one of Jimmy's better, more honest moments. In some ads, he is a bit more cautious and attempts to disclaim the idea that he can promise a specific result. Some of the commercials posted

on his website include the disclaimer "results not guaranteed—for informational purposes only—legal cases unpredictable—your case may differ."

50. *Differences between State Advertising and Solicitation Rules and the ABA Model Rules of Professional Conduct*, American Bar Association, January 1, 2011, http://www.americanbar.org/content/dam/aba/migrated/cpr/professionalism/state_advertising.authcheckdam.pdf.

51. Note that even though Jimmy is soliciting potential clients in Texas, Jimmy is subject to the New Mexico Rules of Professional Conduct (and not the Texas rules), since he is licensed to practice law in New Mexico (not Texas). Separately, states vary as to their reciprocity rules when an attorney seeks to practice law in a state in which he or she is not licensed.

52. Note that in many of Saul's other initial meetings with prospective clients, the client initiated the contact and therefore Rule 7.3(a) is not implicated.

53. Rules in certain jurisdictions are in fact heightened for groups perceived to be more vulnerable to solicitation. New York Rule 7.3(a)(2)(iv) provides, for example, that that a lawyer may not engage in solicitation by "any form of communication" where "the age or the physical, emotional or mental state of the recipient makes it unlikely that the recipient will be able to exercise reasonable judgment in retaining a lawyer." See *New York Rules of Professional Conduct* (as amended through January 2014), Rule 7.3(a)(2)(iv), New York State Bar Association, https://www.nysba.org/DownloadAsset.aspx?id=50671.

54. See *New York Rules of Professional Conduct*, 7.1(c)(3), New York State Unified Court System, http://www.nycourts.gov/rules/jointappellate/ny-rules-prof-conduct-1200.pdf.

55. In one such ad, he gives direct instructions on how to make excuses for having an illegal tiger on one's property. A fact finder would need to determine whether or not the ad is sufficiently interactive with browsers to potentially create an attorney-client relationship. Interactions in a social media context are perhaps more likely to be held to create such a relationship.

56. Ibid., Christina Vassiliou Harvey, Mac R. McCoy, and Brook Sneath, "10 Tips for Avoiding Ethical Lapses When Using Social Media," *Business Law Today*, January 2014, http://www.americanbar.org/publications/blt/2014/01/03_harvey.html.

57. Ibid. See also *ABA Formal Opinion* 10-457, referenced in this article, which, as noted in the Harvey article, "recognized that by enabling communications between prospective clients and lawyers, websites may give rise to inadvertent lawyer-client relationships."

Harvey, McRoy, and Sneath note that the use of appropriate disclaimers may help avoid this: "Depending upon the ethics rules in the jurisdiction(s) where the communication takes place, use of appropriate disclaimers in a lawyer's or a law firm's social media profile or in connection with specific posts may help avoid inadvertently creating attorney-client relationships, so long as the lawyer's or law firm's online conduct is consistent with the disclaimer."

From Kettlemans to Cobblers: A Critical Analysis of the Legal and Ethical Issues on Better Call Saul

Only half of us [lawyers] are idiots. The other half are crooks. ~ Jimmy McGill, "Alpine Shepherd Boy"

As an attorney licensed to practice law in the state of New Mexico, Jimmy McGill (and later on Saul Goodman) is

subject to the Rules of Professional Conduct of the New Mexico Bar Association. The preamble to this set of rules includes a description of a lawyer's role in contemporary society, with a particular emphasis on the special function that lawyers have in connection with the pursuit of justice: "A lawyer is a representative of clients, an officer of the legal system and a public citizen having special responsibility for the quality of justice."

The preamble goes so far as to state that "Lawyers play a vital role in the preservation of society." It is within this landscape that we should consider Jimmy McGill and Saul Goodman's responsibilities and actions. Does this character, particularly in the role of Saul Goodman, contribute in any meaningful respect to the "preservation of society"? Or is he simply a self-interested, corrupt, morally bankrupt, vacuous individual, perhaps a function and consequence of the many excesses of a world obsessed with greed, fame, and accumulating personal accolades? Does our protagonist possess any immutable *values*?

While the Rules of Professional Conduct are intended to provide attorneys with direction and guidance upon encountering potentially complex and delicate situations in the course of their practice, the rules are imbued with a strong, palpable purpose that requires attorneys to seek to achieve justice in their practices, encouraging lawyers, in effect, to adhere to the biblical proclamation "Justice, justice, shalt thou pursue" (Deuteronomy 16:20). The preamble explains, at a high level, the kinds of obligations shared by members of the New Mexico Bar:

> As a representative of clients, a lawyer performs various functions. As advisor, a lawyer provides a client with an informed understanding of the client's legal rights and obligations and explains their

practical implications. As advocate, a lawyer zealously asserts the client's position under the rules of the adversary system. As negotiator, a lawyer seeks a result advantageous to the client but consistent with requirements of honest dealing with others. As intermediary between clients, a lawyer seeks to reconcile their divergent interests as an advisor and, to a limited extent, as a spokesperson for each client. A lawyer acts as evaluator by examining a client's legal affairs and reporting about them to the client or to others. In all professional functions a lawyer should be competent, prompt and diligent...A lawyer's conduct should conform to the requirements of the law, both in professional service to clients and in the lawyer's business and personal affairs. A lawyer should use the law's procedures only for legitimate purposes and not to harass or intimidate others. A lawyer should demonstrate respect for the legal system and for those who serve it, including judges, other lawyers, and public officials. While it is a lawyer's duty, when necessary, to challenge the rectitude of official action, it is also a lawyer's duty to uphold legal process...Many of a lawyer's professional responsibilities are prescribed in the Rules of Professional Conduct, as well as substantive and procedural law. However, a lawyer is also guided by personal conscience and the approbation of professional peers.[1]

We watch Jimmy McGill and, later on, Saul Goodman perform many of the roles described above. Jimmy wears a number of different hats—he is an advisor, an advocate, a negotiator, an intermediary between clients, and an evaluator. While Mr. McGill's moral compass does not always function

properly while he is performing in these different roles, it is when he becomes Saul Goodman that he truly loses the heart of what it means to pursue justice as an attorney. Saul refuses to be "guided by personal conscience," and he therefore ultimately fails his peers, clients, and society at large. Mr. Goodman's compass is irretrievably broken, even if he does occasionally earn some praise for adherence to a particular rule. Ultimately, Saul's heart is in the wrong place, and it is not surprising that many of his actions violate the ethical rules to which he is bound. Despite his comical television advertisements that claim otherwise, Saul does not believe that he is in the business of pursuing justice.

⚖️

Although *Better Call Saul* largely focuses on the behavior and transformation of its protagonist attorney, the series addresses, or at least touches upon, a host of thorny legal issues. These issues span a wide spectrum of legal areas, including Chuck's attempt to invoke a statute in order to prevent a doctor from having him temporarily committed to a psychiatric facility against his will ("Alpine Shepherd Boy"); Sandpiper Crossing's attempt to obtain a restraining order to prevent Jimmy from visiting clients at its facilities ("Pimento"); bribing a court employee with a Beanie Baby in order to receive a favorable court date ("Rebecca"); court arguments over access to medical records of elderly clients as part of a discovery process; the contractual implications of Chuck leaving HHM, potentially breaking up the partnership; overcharging clients for toilet paper in the Sandpiper Crossing case; executing wills for elderly clients without the proper and required testamentary formalities; cops forcing Chuck out of his home after accusing him of stealing a neighbor's newspaper ("Alpine Shepherd Boy");[2]

and cops attempting to convince Mike to talk after he requests the presence of legal counsel ("Five-O"). Many of these legal issues are (intentionally) mundane in nature, such as those dealing with certain banking regulations during season 2 (including a banking hearing in "Nailed" that is actually quite riveting), but they do raise some intriguing legal questions.

In addition, various scenes implicate, or at least potentially implicate, a number of ethical rules that govern the conduct of lawyers.[3] For example, Jimmy potentially violates rules relating to client solicitation (with respect to the elderly individuals that he encounters at the senior center and bus, as will be discussed in greater detail); confidentiality (revealing client confidences during negotiations in a public bathroom in "Nacho"); unethical billing practices (such as accepting a "retainer" from the Kettlemans that is, in effect, a bribe); and duties to prospective, current, and former clients (as will be discussed at greater length with respect to Craig Kettleman).

This chapter analyzes many of the legal issues presented on the series as well as the applicable rules governing an attorney's conduct when confronted with thorny ethical questions.

Client Documents and Confidentiality Considerations

Jimmy is not the only attorney on *Better Call Saul* who violates ethical rules and/or laws. For example, in "Bingo," the normally rule-abiding Chuck commits a security breach by opening a box of legal documents that Jimmy leaves at his house. In "Bingo," Kim violates her confidentiality obligations (pursuant to MRPC 1.9(c)(2))[4] to her former client Craig Kettleman by providing Jimmy with details about his actions.[5]

And in "RICO," we learn that Chuck not only opens the box of documents but actually works on the wills contained within the box. Chuck is not an associate at Jimmy's one-man law firm, and Jimmy's clients have no expectation that Chuck might gain access to their documents. Perhaps Jimmy can argue that Chuck is simply part of his staff or even a contractor for hire (notwithstanding the lack of pay), and clients may not need to consent to such outsourcing of work. Jimmy can also argue that consultation with Chuck is permitted under New York Rule 1.1(b), which provides that "A lawyer shall not handle a legal matter that the lawyer knows or should know that the lawyer is not competent to handle, without associating with a lawyer who is competent to handle it." A major issue with that argument, of course, is that Jimmy does not actively or overtly seek out Chuck's assistance, and we have no evidence that Jimmy is not "competent to handle" said work.[6] In addition, it is possible that Chuck's large firm, HHM, could be engaged by clients with interests adverse to the clients whose documents he accessed. Chuck could, conceivably, use information from documents contained in Jimmy's box against the clients who entrusted Jimmy with their legal representation. Chuck might argue that he does not violate the MRPC or New Mexico Rules of Professional Conduct by accessing the documents because the rules regarding confidentiality only apply to an attorney's representation of his or her clients; since Chuck is not in fact their attorney, he has not violated Rule 1.6 ("Confidentiality of Information") of the MRPC or the corresponding Rule 16-106 of the New Mexico Rules of Professional Conduct. But Chuck is not off the hook, as his actions may violate one or more of the aforementioned catchall rules in NY Rule 8.4.

Because Jimmy is the attorney of record for the elderly clients whose wills are contained in the box, he is subject

to the confidentiality rules of the New Mexico Bar Association. Jimmy peers through the window, sees Chuck open the box, and does not intervene. One could argue that Jimmy should be faulted for storing client documents in an unsecure location (especially if he has a reasonable expectation that Chuck might view the documents), resulting in a possible violation of Rule 1.6(c) of the MRPC: "A lawyer shall make reasonable efforts to prevent the inadvertent or unauthorized disclosure of, or unauthorized access to, information relating to the representation of a client." And Jimmy clearly acts wrongfully by failing to stop Chuck from reviewing the documents once he sees him do so. Absent such knowledge, however, ask whether keeping a box of documents in the home of one's brother, who is also an attorney, would violate the "reasonable effort" security requirement. It is also noteworthy that the New Mexico Rules of Professional Conduct do not include a requirement to prevent such unauthorized disclosure or access; the New Mexico Rules focus exclusively on duties not to (intentionally) *reveal* such information, except in limited circumstances. That being said, the disciplinary wing of the New Mexico Bar Association could argue that carelessness with client documents on the part of Jimmy perhaps violates Rule 16-804(h), a broad catchall that prohibits engaging "in any conduct that adversely reflects on his fitness to practice law."

Jimmy may have also violated MRPC Rule 8.3(a) and the corresponding New Mexico Rule 16.803 ("Reporting Professional Misconduct"), each of which provide that "A lawyer who knows that another lawyer has committed a violation of the Rules of Professional Conduct that raises a substantial question as to that lawyer's honesty, trustworthiness or fitness as a lawyer in other respects, shall inform the appropriate professional authority." Because Jimmy

actually watches Chuck access the documents, he certainly knows that there has been a violation. And, as noted above, the disciplinary wing of the New Mexico Bar Association could effectively argue that Chuck's action raises "a substantial question" as to his "honesty, trustworthiness or fitness as a lawyer," and that therefore Jimmy is required to report Chuck's violation.

The Legal Consequences of Jimmy's Freewheeling Style

Issues relating to attorney-client privilege, zealous advocacy, and competence to practice law are frequently addressed on the series. Even though Jimmy is not nearly as morally bankrupt as the vacuous Saul Goodman, Jimmy frequently violates MRPC Rule 8.4(c) and New Mexico Rule 16-804(C), each of which effectively serve as a catchall for many ethical violations: "It is professional misconduct for a lawyer to engage in conduct involving dishonesty, fraud, deceit or misrepresentation." Note that Rule 16-804 of the New Mexico Rules of Professional Conduct also includes broad catchall language for potentially different contexts, prohibiting lawyers from engaging in (b) "criminal acts" that reflect "adversely on the lawyer's honesty, trustworthiness or fitness as a lawyer in other respects," and (h) "any conduct that adversely reflects on his fitness to practice law." Many of Jimmy's actions fall within the categories set forth in sections (c) and (h).

A few quick examples: Jimmy's publicity stunt with the billboard likely qualifies, as does his immature act of dressing up like Howard Hamlin for his billboard photo. Perhaps Jimmy's use of the Saul Goodman name even constitutes a "misrepresentation," particularly since he admits that his intent is to dupe potential clients into believing he is Jewish. (Ask yourself whether the wearing a fancy suit

to convey an image that might not accurately represent an attorney's actual financial situation is different in nature or merely degree). Jimmy would be hard pressed to argue that the fake secretary voice he uses on his answering machine does not constitute "deceit." And, for good measure, Jimmy's impersonation of a federal agent in the desert scene (in "Mijo") to avoid being killed by Tuco (when he claims to be Special Agent Jeffrey Steele) violates these catchall rules, as there is no exception for saving life or limb—even though no reasonable person would expect Jimmy not to lie to save himself in this situation.

Jimmy also engages in conduct that is punishable under criminal law. Jimmy's forgery of Mesa Verde documents during season 2 is illegal, and he could be charged with laws against not only forgery but also fraud, falsifying evidence, and possibly breaking and entering (as Jimmy does not have the right to enter Chuck's home and direct Ernesto, who is caring for Chuck, to vacate the premises). While forgery would be reprehensible under any circumstances, we can admonish Jimmy even more harshly because doing so sets back the interests of another law firm's client. Jimmy forges the document to help Kim win her former client back from HHM and to embarrass Chuck in the process. He disregards the interests of Mesa Verde. Any attempt to justify the action by arguing that the client would benefit by having Kim as counsel fails: the action causes the client great harm because it results in a delay of approval from the banking commission. It also goes without saying that choice of counsel is solely a client's decision, and a client should not be unduly influenced in that regard by outside forces. Jimmy demonstrates a lack of integrity by engaging in such conduct. Because Jimmy's "criminal act" reflects "adversely" on his "honesty," the forgery also violates New Mexico Rule 16-804(b).

There are instances in which Jimmy would earn the praise of legal ethics committees. For example, he zealously advocates for the two skateboarding lackeys (although the question of whether they are his clients at that point is an interesting one, which will be discussed later on), and provides competent representation to clients in connection with the Sandpiper Crossing case. His competent representation to the Sandpiper Crossing clients complies with Rule 1.1 of the MRPC and the corresponding Rule 16-101 of the New Mexico Rules of Professional Conduct, each of which provides that "A lawyer shall provide competent representation to a client. Competent representation requires the legal knowledge, skill, thoroughness and preparation reasonably necessary for the representation." He also handles police interviews well. In the interrogation of Mike in "Five-O," for example, he is able to obtain important information from the detectives and shifts the power dynamic by having the detectives speak first.[7]

Jimmy often does, however, cross the line by violating rules when he acts *too* zealously for his clients. For example, in the police interrogation discussed above, Jimmy agrees (at his client Mike's request) to spill coffee on a detective so that Mike can steal a notebook potentially containing evidence against him. While Mike notes that spilling the coffee on the officer would not qualify as "assault,"[8] Jimmy states that this action constitutes "aiding and abetting."[9] Jimmy breaks several ethical rules (including New York Rule 3.4(a)(6) prohibiting attorneys from engaging in illegal conduct, as well as catchall rules 8.4(b), (c), and (d)), and he cannot effectively argue that doing so is permissible in order to adhere to other rules. Each rule must be interpreted in a manner that does not enable an attorney to violate any other rules. Bar association rules requiring attorneys to provide competent, diligent, and zealous representation do

not require Jimmy to perform actions that would violate any laws or rules.

Saul Goodman's Egregious Actions

On *Breaking Bad,* many of the legal issues are much darker in nature—and often involve serious malfeasance on the part of our favorite lawyer. We watch Saul Goodman provide advice to clients on issues such as money laundering techniques, drug dealing, and forging new identities so as to hide from the police. We see him bug Skyler's home (to the dismay of Walt) and propose murder as a means of resolving issues. Like all criminal defense attorneys, Saul seeks to negotiate the best deals for his clients with prosecutors so as to avoid jail time and other penalties. However, what differentiates Saul from most defense attorneys is that he frequently *advises* his clients to *commit* such actions, and he is involved in furthering his client's criminal objectives. Once such actions are performed, Saul will then devise creative (and deceitful) legal strategies to aid his clients' agenda and help them avoid punishment. As he says when attempting to convince Jesse Pinkman to launder money, "If you want to stay a criminal, and not become, say, a convict, then maybe you should grow up and listen to your lawyer."

Saul also plays a fundamental role in his clients' criminal objectives, the most prominent example being his close involvement with Walt and Jesse's drug dealing. Saul provides them with a connection to Gus Fring, which dramatically leads all of the characters (including Saul) down a dark path. He is so intimately involved with his clients' non-legal issues and schemes that he feels the need to remind Walt that Saul is not "Maury Povich,"[10] though Walt often does use Saul as a dark therapist of sorts, venting to him about his non-legal troubles. By becoming so intertwined with his criminal clients' goals and frequently con-

spiring with them in furtherance of their initiatives, Saul violates MRPC Rule 8.4(b) and the corresponding New Mexico Rules of Professional Conduct 16-804(b), each of which prohibits lawyers from committing "a criminal act that reflects adversely on the lawyer's honesty, trustworthiness or fitness as a lawyer in other respects." This rule was intended, in part, to maintain the dignity of the legal profession itself. Members of the bar must not commit crimes that reflect poorly on attributes that are particularly valued by the bar, such as honesty and trustworthiness. Saul also frequently violates MRPC Rule 1.2(d), which provides, in part, that "A lawyer shall not counsel a client to engage, or assist a client, in conduct that the lawyer knows is criminal or fraudulent."[11]

Saul is well aware of the dual nature of his agenda, misguided though it may be. He pointedly tells Walt in *Breaking Bad's* season 3 episode "Green Light" (2010) that, as Walt's lawyer, he wants Walt to commit crimes so that Saul's "billable hours" can be increased, but that as Walt's "business associate," he wants Walt to lay low so that they can deal drugs without being caught. Saul may not consider himself a therapist (based on his Maury Povich disclaimer), but in addition to being a lawyer, he does frequently act as a consultant and a businessman (declaring in season 3's "Caballo Sin Nombre" that he is "in the wrong business" upon hearing about someone else's monetary success). He is a primary point of contact and strategist for many of his clients' illicit endeavors, doling out practical legal and business advice that flies in the face of morality and the bounds of the law. In short, Saul is a critical part of the operations of his most despicable clients.

And there is no shortage of rules and laws that Saul Goodman violates on *Breaking Bad*. At various points, Saul engages in egregious actions unbecoming of an attorney

(or any responsible, law-abiding person for that matter). In season 2's "Better Call Saul" episode of *Breaking Bad* (2009), for example, he arranges for an imposter to be paid to go to jail in lieu of his client, Badger, for an $80,000 fee. Saul is the ultimate con artist, and it is comical when he attempts to invoke ethical rules in order to avoid performing certain actions. He tells Mike Ehrmantraut, in one scene during season 3's "Full Measure" (2010), that he does not want to divulge the location of client Jesse Pinkman because doing so would violate attorney-client privilege. "There's rules to this lawyer thing," Saul explains while somehow maintaining a straight face. In the *Breaking Bad* episode "Better Call Saul," Saul exclaims that he is "morally outraged" after refusing to accept a $10,000 bribe to act against the best interests of his client Badger (Walt asks him not to cut a deal with the DEA so as to avoid exposing Walt and Jesse). Saul typically loves bribes[12]—we even see him attempt to offer a Beanie Baby doll to a worker at the court desk in order to receive a favorable court date (in "Rebecca")—and he later admits to Walt and Jesse that "I don't take bribes from strangers. Better safe than sorry." Saul has no moral issues with taking the bribe, but he is nothing if not a survivalist, and he will exploit the rules to his personal advantage at the earliest opportunity. Often in life, it is the con artist who, when it suits his needs, seeks to invoke rules that he would never follow were the shoe on the other foot.

Saul's Client Conflicts

On *Breaking Bad*, Saul violates the rule regarding client conflicts when he represents clients who have divergent interests from one another. MRPC Rule 1.7(a) requires a lawyer not to represent a client if the representation involves a "concurrent conflict of interest," which exists if:

(1) the representation of one client will be directly adverse to another client; or

(2) there is a significant risk that the representation of one or more clients will be materially limited by the lawyer's responsibilities to another client, a former client or a third person or by a personal interest of the lawyer.

Initially, Walt's and Jesse's legal interests are aligned, but as the pair drifts apart, their motivations, goals, and legal concerns do as well. Saul should drop either Jesse or Walt as a client for this reason. While MRPC Rule 1.7(b) provides an exception if "the lawyer reasonably believes that the lawyer will be able to provide competent and diligent representation to each affected client," Saul would have a difficult, if not impossible time doing so. At times, Walt and Jesse are at each other's throats, and each seeks to gain the upper hand by employing Saul's services. Furthermore, each client would need to provide "informed consent in writing" before Saul is permitted to proceed with the respective representations. Note also that the New Mexico Rules of Professional Conduct Rule 16-107(A) requires the attorney to provide "consultation" to both clients, which "shall include explanation of the implications of the common representation and the advantages and risks involved" (which is quite similar to the "informed" requirement in the MRPC), and requires that each client "consent" to the representation before proceeding. Saul does not attempt to provide such consultation to either Walt or Jesse, nor does he seek their explicit consent. The requirements set forth above for the MRPC and New Mexico Rules are also invoked when a lawyer's personal interest may conflict with the representation; we witness this conflict quite frequently in the course of Saul's interactions with Walt and Jesse.

Saul faces a similar ethical issue in the season 5 premiere episode of *Breaking Bad* ("Live Free or Die," 2012) when he acknowledges the difficulty of representing both Walt and his wife, Skyler. Saul notes that the representation is "tricky" because of their potentially divergent interests. Walt harshly condemns Saul for giving $622,000—money that Walt earned through drug dealing—to Skyler to help with her deal with Ted Beneke's IRS situation. (Saul essentially steals the money that one client, Walt, earned and gives it to another client, Skyler.) Saul tells Walt that he tried his best to act "ethically," to which Walt replies, "Ethically? I'm sorry, I must be hearing things. Did you actually just use the word 'ethically' in a sentence?"

Because of the divergent interests of his clients, Saul cannot effectively represent both Walt and Skyler. By doing so, he violates the spirit of MRPC Rule 1.3, which demands that attorneys zealously advocate on behalf of their clients ("A lawyer must also act with commitment and dedication to the interests of the client and with zeal in advocacy upon the client's behalf," as stated in Comment 1 to the rule.) Representing clients with differing interests also makes it more likely that an attorney will violate the confidentiality and attorney-client privilege of one client in order to further the interests of another.

Saul's actions go way beyond the pale of all of these rules: not only does he frequently violate many rules that govern attorneys' conduct (including rules relating to maintaining client confidences, like MRPC Rule 1.6),[13] but he even proposes—in season 6's "Rabid Dog"—that one client (Walt) kill another client (Jesse). (He earlier proposed to both Walt and Jesse, in "Better Call Saul," that they murder one of his other clients [Badger]. He also once proposed to Walt that Walt kill DEA agent Hank Schrader.) Saul may attempt to feebly argue that his advice was intended

to further the interests of the client standing in front of him, but it goes without saying that such arguments would be universally rejected. It may be true that murder is the most effective way to further a client's interests (even at the expense of another client), but the MRPC's comments regarding zealous advocacy in MRPC Rule 1.3 require that an attorney act, and provide advice, within the bounds of the law. Walt is clearly spot on when he is flabbergasted by Saul's use of the word "ethically." As we know, however, the character that preceded Mr. Goodman was not nearly as morally challenged. Many of the ethical issues that Jimmy faces during the early seasons of *Better Call Saul* arise from tricky client representations, such as his interactions with Craig and Betsy Kettleman.

An Introduction to the Kettlemans

During season 1 of *Better Call Saul*, Jimmy desperately wants Craig Kettleman to retain Jimmy as his lawyer after Mr. Kettleman is accused of embezzling $1.5 million from the local county treasury. In order to achieve this goal, Jimmy plans to employ a complicated scam in which two lackeys pretend to get hit by Mrs. Kettleman's car while skateboarding, and Jimmy negotiates with the boys to allow Mrs. Kettleman off the hook without any liability. She will be so impressed by and indebted to Jimmy—so Jimmy's theory goes—that she will eagerly seek his services in connection with her husband's legal issues. The plan ultimately backfires quite badly, but there is little question that Jimmy's actions violate at least some, if not all, of the MRPC Rule 8.4 and New Mexico Rule 16-804 sections discussed previously. Note that neither MRPC Rule 8.4 nor New Mexico Rule 16-804 presupposes that an attorney is representing a client; the rule may be violated even if there is no client representation involved. It is also noteworthy

that with respect to Jimmy's interactions with the Kettlemans and the dangerous Nacho Varga, Jimmy engages in a delicate balancing act and at least sometimes attempts to act appropriately. Sometimes an attorney has the right intentions but still violates ethical rules because of difficult circumstances.

Those Crazy Kettlemans and Complications with Nefarious Nacho

The characters that Jimmy deals with during season 1 of *Better Call Saul* cause him a great deal of consternation. One such character, Nacho Varga, even causes Jimmy to fear for his life. In "Mijo," Nacho tracks Jimmy down in his nail salon office and informs Jimmy of his plan to steal the $1.5 million that Craig Kettleman embezzled. He offers to give Jimmy a cut of the proceeds—a "finder's fee"—if Jimmy provides assistance. Insisting that he is a lawyer and not a criminal, Jimmy resists the offer, but informs Nacho that he considers Nacho to be his client and that the conversation is confidential and protected by attorney-client privilege. Nacho leaves the office, but not before threatening Jimmy with death if the conversation is disclosed.

The exchange raises several questions. The ethical rules require attorneys to maintain the confidences of prospective, former, and current clients, except in certain limited contexts. The attorney-client privilege (and the associated confidentiality obligations that an attorney has with respect to current, former, and prospective clients) is an important part of providing a client with the best legal representation possible. A client should feel free to disclose to his or her attorney information related to a case in order to best position the attorney to zealously advocate on the client's behalf. As a general matter, the more information an attorney has, the better he or she will be able to rep-

resent the client—unless, as will be discussed later on, the attorney has knowledge that the client has introduced false testimony or evidence in a tribunal. Clients should view their attorney as their advocate, and an attorney needs certain information in order to advocate most effectively on their behalf. A legitimate system of justice requires that an attorney maintain confidences of a client unless a narrow exception applies.

First, we must decide whether Jimmy is in fact Nacho's attorney. This is a tricky question, given the unique circumstances of their encounter. Is there a meeting of the minds between the two on this point? On the one hand, we can argue that Nacho is not necessarily seeking an attorney for assistance in his plot; rather, he may be looking for a partner in crime. Under New York Rule 1.18(b) ("a lawyer who has learned information from a prospective client shall not use or reveal that information," except in limited situations),[14] Nacho would likely not obtain the confidentiality protections of a prospective client (since, as Nicole Hyland observes, Nacho did not "approach Saul to discuss "the possibility of forming a client-lawyer relationship," as the rule states, but to propose a "criminal enterprise").[15] On the other hand, it would be somewhat odd for Nacho to seek Jimmy's help outside of a legal context. He knows of Jimmy's title, and Nacho could have turned to a fellow henchman if he weren't in search of a partner to provide legal assistance. During the conversation, Jimmy explicitly informs Nacho that the conversation is protected by attorney-client privilege. That is a relatively clear promise to represent Nacho, and Nacho certainly does not object to the idea. But when the circumstances of the encounter are considered, Jimmy may reasonably argue that he felt threatened by Nacho, and that Jimmy only agreed to maintain the confidentiality of the conversations because he was under duress. A bar asso-

ciation disciplinary committee would certainly take into account the duress component when reviewing this case file.

Per the above analysis, determining whether Nacho is Jimmy's client is a difficult endeavor. If we determine that Jimmy is not Nacho's attorney (and that Nacho was not even a potential client), then Jimmy is likely neither prohibited nor required to report the plot to the police or to the Kettlemans or to anyone. If we determine that Nacho is in fact a client, however, we must consider the ethical rules that attach to the representation. In many contexts, attorneys are required to maintain the confidentiality of clients. In some jurisdictions, in certain limited situations, attorneys *must* disclose such information. New York Rule 1.6 *permits* an attorney to disclose confidential information either "to prevent reasonably certain death or substantial bodily harm" or "to prevent the client from committing a crime."[16] Under this rule, Jimmy is permitted (though not required) to report Nacho's plans to the police and/or the Kettlemans. (New York's prospective client rule, Rule 1.18, were it applicable, would also provide a permissive exception to the duty of confidentiality.)

Note that the rules promulgated by various state bar associations differ on the exceptions to an attorney's confidentiality obligations. As Nicole Hyland observes, "New Mexico *permits* disclosure of confidential information to prevent financial or property-related harm, [and] *mandates* disclosure 'to prevent the client from committing a criminal act that the lawyer believes is likely to result in imminent death or substantial bodily harm.'"[17] Jimmy's actions in a previous episode ("Mijo") may implicate this rule as well: while at the desert, he discloses the Kettleman embezzlement situation to Tuco and Nacho. The Kettlemans are likely not yet prospective clients, and any information

that Jimmy possesses is likely not confidential. But even if the confidentiality rules did apply here, Jimmy's disclosure complies with the New Mexico rule, as Jimmy reveals the information to save himself from death. Thankfully for lawyers, the rule does not seek to disvalue the life of the attorney of record.

In "Nacho," Jimmy visibly grapples with the disclosure issue. He wrestles with whether to tell Kim about Nacho's threat after the Kettlemans go missing. Jimmy calls Kim, hinting at possible danger for the Kettlemans, but then backtracks (and the following day claims that he was drunk). After hanging up with Kim, he mumbles "I'm no hero." Jimmy ultimately decides to anonymously call the Kettlemans from a payphone using a disguised voice. He warns the Kettlemans that they are "in danger."[18]

While Hyland correctly observes that Jimmy's decision to disclose to the Kettlemans in "Nacho" complies with the New Mexico standard (mandating disclosure in the event of a reasonable belief of imminent death or substantial bodily harm), she "takes issue with the manner of [Jimmy's] disclosure," pointing out that "the rule requires that the attorney 'reveal [confidential] information to the extent the lawyer reasonably believes necessary' to prevent the harm."[19] Hyland argues that Jimmy's anonymous late-night phone call to the Kettlemans (in which Jimmy initially uses a disguised, muffled voice before briefly using his own voice and hanging up) perhaps does not satisfy the "reasonable standard of the rule." Hyland points out that if in fact Jimmy is required to disclose the information to satisfy the rule, perhaps he "did not go far enough with his disclosure"[20] because there is no guarantee that the Kettlemans will take the warning seriously. The takeaway here is that if disclosure is deemed mandatory, then the means of such disclosure must meet a certain standard.

Jimmy's decision to call Nacho (because of Jimmy's concern about the safety of the Kettleman family) raises several ethical issues as well. Jimmy leaves Nacho several voicemail messages, offering assistance to "de-escalate the situation legally and otherwise." Jimmy is, in part, offering to provide legal services, which buttresses the argument that—at least in Jimmy's eyes—an attorney-client relationship with Nacho was perhaps already formed back at the nail salon.[21]

If Jimmy is Nacho's attorney at this point, he violates ethical rules by lying to Nacho: he explicitly tells Nacho that he has "spoken to no one" about Nacho's plan, even though he has in fact warned the Kettleman family of impending danger. Even if warning the Kettlemans is permitted (and perhaps required, as discussed above), Jimmy likely owes a duty to his other client, Nacho, to keep him apprised of this development—and of the fact that he may have a continuing duty to inform the Kettlemans of any other plans that Nacho might have in store for the family. Jimmy will not be able to provide effective representation to Nacho if he is committed to following the ethical rules that require him to disclose information to prevent death or bodily harm. While the ethical rules may require disclosure in this instance, they were not intended to be abused by taking on a case (or failing to bow out if the representation was already in place) with the *knowledge* that the information to be learned by counsel will be immediately disclosed to another party.

In addition, Jimmy has certain obligations to the Kettlemans because of their previous meeting with him. New York Rule 1.18(c) prohibits attorneys from representing a client with interests that are "materially adverse" to such prospective client "in the same or a substantially related matter" if the attorney "received information from the pro-

spective client that could be significantly harmful to the prospective client in the matter." One can reasonably argue that Nacho's interests are "materially adverse" to the interests of the Kettlemans, that the matters are "substantially related" (as they ultimately tie back to the alleged embezzlement), and that the information learned is "significantly harmful" to the couple.

Jimmy is working hard to toe a difficult line, but, for the reasons set forth above, the proper decision from a legal ethics perspective would likely be to decline Nacho's representation and drop out of the case. Note, of course, that this decision does not take into account the physical harm that might result to both Jimmy and/or the Kettlemans if Jimmy declines/abandons the Nacho representation and/or informs Nacho that Jimmy is separately communicating with the Kettlemans. While reasonable observers can debate the point in time in which Jimmy formed an attorney-client relationship with Nacho, it is clear that he is functioning as legal counsel when he shows up at Nacho's interrogation at the police station.

Kettleman Confidential

Both Jimmy and Kim attempt to get the other to violate (potential) confidentiality obligations. First, Jimmy asks Kim (who is representing Mr. Kettleman at this point), "How much exactly did Kettleman get away with?" Kim does not invoke her confidentiality obligations, but does not take the bait either. She simply demurs, telling Jimmy that her clients are "innocent until proven guilty." Jimmy absurdly argues that as a "taxpayer," he has the "right to know." Jimmy likely knows that this is a ridiculous argument, as we watch him struggle with potential client confidentiality issues related to his (possible) representation of Nacho.

During a conversation after the Kettlemans disappear,

Kim implores Jimmy to reveal any information that he may have regarding the whereabouts of the Kettlemans: "That family is in real danger. You don't have to stand behind attorney-client privilege." By this point, Jimmy has spoken to Nacho and does not believe that Nacho kidnapped the Kettlemans. He is confident that they kidnapped themselves, so he is not concerned about their safety. Still, Jimmy reveals to Kim that he had called the Kettlemans to warn them about Nacho's plan. The scene provides evidence that Jimmy likely believed that he had formed an attorney-client relationship at the time of their meeting in the nail salon; he explains to Kim that "It was lawyer to client, so there was confidentiality issues. But, I called the Kettlemans anonymously." Finally, Jimmy tells Kim that Nacho is a "bad guy" and that the cops may "find something" illegal about him if they continue to dig. Jimmy also reveals that he was worried that Nacho was going after the Kettlemans' money. If we determine that Nacho is Jimmy's client, it appears that these disclosures likely constitute a breach of Jimmy's confidentiality obligations. The New Mexico exceptions do not apply here, as disclosure to Kim is not necessary to prevent imminent death or substantial bodily harm, nor is it necessary to prevent substantial injury to the financial interest or property of another. On this last point, it is worth noting that it seems unlikely that Nacho, a smart, focused criminal, would be foolish enough to steal the money at this point, with the cops keeping their eyes on him.

Next, Jimmy asks Kim to relay to Howard Hamlin the theory about the Kettlemans running away from home, and then request that Hamlin inform the proper authorities. Kim responds by saying that Hamlin (as attorney of record for Mr. Kettleman) would never agree to report this information to the authorities because doing so would incrimi-

nate the family. Jimmy retorts: "Ya see, this is why people hate lawyers!" Jimmy's admonition notwithstanding, Kim's analysis is both practical and accurate. HHM owes a duty of confidentiality to the Kettlemans (or, at the very least, Mr. Kettleman, as it is not so clear that Mrs. Kettleman is being represented at this point, despite her close involvement with the discussions on the case). The New Mexico exceptions for disclosure do not apply here, as any crime that the Kettlemans may be committing by not cooperating with authorities does not rise to the level of an act that would permit or mandate disclosure by counsel. Finally, it bears mentioning that the information Kim learns from Jimmy is in fact covered by, and subject to, the confidentiality obligations in New Mexico. Under the New Mexico rules, confidential information is defined broadly as any information "relating to the representation," irrespective of the source of such information.

Kettleman Conundrums

After receiving inspiration from Mike—who correctly theorizes that the Kettlemans are still close to home after "kidnapping" themselves—Jimmy finds the family hiding in a tent in the local woods. They also have the money that Mr. Kettleman embezzled with them, prompting Jimmy to provide some advice: lie about their reason for leaving home. Jimmy is not their attorney at this point, but because of his previous conversation with the Kettlemans, Mr. Kettleman qualifies as a prospective client. Under MRPC Rule 1.18(b), Jimmy must not "use or reveal" information that he learns from Mr. Kettleman. Jimmy informs the Kettlemans that he has called Kim at HHM to make them aware of the family's whereabouts. Jimmy could argue that he found the couple without receiving any information from them, and therefore does not violate the rule by making the disclosure

to Kim. He does need to take great care, however, to not reveal any information to Kim that he learned directly from the Kettlemans. Also, even though Jimmy advises the Kettlemans to lie, he does not violate MRPC Rule 3.3(a), which requires candor to the tribunal in legal proceedings. Because Jimmy is not the attorney of record, it is not possible for him to engage in violations of MRPC Rule 3.3(a). Advising a prospective client to lie, however, may violate one or more of the catchall provisions of MRPC Rule 8.4.

Immediately after finding the Kettlemans, they offer him a bribe in exchange for not revealing their whereabouts to the authorities. Jimmy initially declines, but then accepts the money. He attempts to justify the money as a "retainer," but the Kettlemans make it very clear that they are not engaging him for purposes of legal representation. Later on, however, in "Bingo," they seek to hire Jimmy as their counsel, saying—in an attempt to bait him and argue that he is part of their plot—that they did in fact pay him a retainer (or alternatively, if he refuses to accept that idea, that his acceptance of a bribe was intertwined with their own crime). They explain that they fired HHM because they disagreed with their legal strategy. Jimmy excuses himself, and again calls Kim to advise her of their request. She demands that Jimmy convince them to return to HHM. Because the Kettlemans are still his prospective clients—in fact, with some renewed interest in a possible engagement—Jimmy needs to be quite careful in what he reveals to Kim (who is now obligated to comply with her obligations to a former client, pursuant to MRPC Rule 1.9). Even if Jimmy does not reveal any confidential information to Kim, it is not advisable to go behind a client's back and reveal anything about a client's proposed strategy or desires to anyone—even former counsel for said client. Jimmy also disrespects them behind their back, informing Kim that

"They're not really playing with a full deck, those Kettle-
mans."

Jimmy asks Kim to provide him with the details of the
deal that HHM obtained for Kettleman (which the Kettle-
mans refused to accept). Kim provides details of the deal,
potentially violating her obligations to former clients under
MRPC Rule 1.9(c)(2) because she "reveal[ed] information
relating to the representation" without their consent. Jimmy
briefly considers the merits of the deal, and then, believing
it is in the best interest of the Kettlemans, strongly advises
them to return to HHM and accept the deal.

Later on, Kim clearly violates MRPC Rule 1.9(c)(2) by
revealing to Jimmy details and evidence that HHM learned
during the course of the representation. She not only offers
opinions about her former client's guilt or innocence (saying
that Kettleman is "guilty as sin"), but also provides informa-
tion that could prove harmful to Jimmy's representation.
While lawyers often do want to have a lot of information
about a case in order to provide a good defense, having too
much information can backfire. As discussed previously, a
lawyer runs the risk of violating MRPC Rule 3.3(a) if he or
she fails to correct or otherwise remediate statements that
a client has presented in court he or she knows, in fact,
to be false. One might argue that Kim not only violates
her own obligations to a former client, but also places the
Kettlemans in a less favorable strategic position by provid-
ing Jimmy with information that they may not want him to
have, such as how they failed to cover their tracks during
the self-kidnapping fiasco or embezzlement scheme.

Cornering the Kettlemans

As discussed, both HHM and Jimmy strongly advise
Craig Kettleman to accept the deal that Kim has secured
from the district attorney (sixteen months' jail time, as

opposed to a possible thirty years if he loses at trial). MRPC Rule 1.2(a) allocates the authority between lawyer and client, and states that whether or not to accept a plea deal is the client's decision to make.[22] The Kettlemans seek to take full advantage of this ethical rule, as they (at the behest of Betsy Kettleman) not only forcefully decline the deal, but repeatedly demand that their attorney of record work to exonerate Craig at trial. They are opposed to accepting even a relatively favorable deal. And it is their prerogative to do so: MRPC Rule 1.2(a) provides that "a lawyer shall abide by a client's decisions concerning the objectives of representation." While a lawyer may take certain actions in furtherance of achieving a particular result (the "lawyer may take such action on behalf of the client as is impliedly authorized to carry out the representation," per MRPC Rule 1.2[a]), the attorney is required to consult with the client regarding the mechanics and strategy to achieve the objective (per MRPC Rule 1.4[a][2]).

A prudent client will decide whether or not to accept a plea deal after consultation with the attorney and take into account the attorney's breadth of experience in such matters. But ultimately it is the client's choice to make. It does not matter whether or not accepting the deal is, objectively, in the best interest of a client. Therefore, Craig Kettleman is absolutely entitled to roll the dice and not accept the deal if he so wishes. Kettleman resists the pressure from his current and former attorneys and refuses to accept the plea deal.

Jimmy is not willing to accept Kettleman's decision. Instead, Jimmy hires Mike to steal the money that Kettleman had previously embezzled, then returns the money to the district attorney. This effectively ties Kettleman's hands and forces him to take the deal. Jimmy's action (1) most likely violates Rule 1.2(a) (since his action takes the deci-

sion-making authority out of the hands of Kettleman); (2) betrays Kettleman's confidences; (3) violates a host of other rules that prohibit illegal conduct and/or engaging a third party (Mike) to commit a crime; and (4) does not further the interests of his client. Regarding this final point, it is noteworthy that he informs the Kettlemans that "criminals have no recourse."[23] Jimmy outsmarts Betsy Kettleman when she threatens to reveal that Jimmy previously accepted the bribe that they offered. Jimmy notes that at the current moment, only Craig faces jail time, but if the bribe is revealed, she, too, will be implicated in at least that portion of the scheme. Jimmy exerts significant energies in scheming against, and not acting in the best interests of, his clients. This is not the role that a responsible attorney should be playing.

Many of the aforementioned issues related to the Kettleman representation stem from their decision to switch legal representation. As we have seen, such movement, while permissible, raises a host of ethical issues that attorneys must address. From the client's perspective, remaining with counsel or switching lawyers is a strategic decision that may result in unintended consequences. The decision should involve careful deliberation of the various considerations at play. The Kettlemans are likely not aware, for example, that retaining Kim as counsel over Jimmy places them at a significant strategic advantage: NY Rule 3.3(a)(3) requires an attorney with actual knowledge that a client has lied in court to take "reasonable remedial measures," whereas mere belief (even if a strong belief or suspicion) of dishonesty does not implicate the rule. So if Craig Kettleman decides to lie in court, Jimmy will be required to "remediate" the issue (including, if necessary, informing the court of the lie), whereas Kim would not be so obligated (and might, in some jurisdictions, be prohibited from doing

so under advocacy rules). Armed with such information, a client such as Craig Kettleman may make different decisions with respect to his choice of counsel.

Attorneys are required to navigate through a complex web of issues that can, in fact, be made more difficult to juggle because of certain decisions made by clients. That is not to excuse any of the actions of Kim or Jimmy, but merely an acknowledgement that had the Kettlemans settled in with one attorney and acted more like a typical client, some of the issues discussed above would not have arisen at all. But watching the quirky Kettlemans made for great television.

Sandpiper *Crossing and RICO*

While drafting an elderly client's will, Jimmy learns that Sandpiper Crossing sends billing statements with significantly trumped up charges to its residents. In "RICO," Jimmy seeks to investigate the issue further at the assisted-living facility, but the receptionist bars him from entering. She claims that she is protecting the residents from unauthorized legal solicitation. The receptionist's solicitation argument likely fails in this context, even if the elderly residents qualify under the more stringent prohibitions attached to solicitation for certain groups of people.[24] Because Jimmy has clients in the residency and is following up on a discussion he had previously had with a client about the issue, he can argue that the MRPC Rule 7.3(a) prohibition on in-person solicitation that isn't initiated by the individual is inapplicable in this context. After he is denied entry, Jimmy observes others in the residency ominously shredding documents, presumably as a way to conceal any wrongdoing on the part of the facility.

At this point in time, Jimmy has not signed up any clients with respect to the Sandpiper case that he is just starting

to build. Jimmy might try to argue that his representation of some of the clients for will-writing services requires him to attempt to protect the assets described in the will, but that seems like a stretch. He is, however, within his rights to discuss his suspicions or any other issues with existing clients; it therefore is improper for Sandpiper to deny him access to the residents. In any event, it is not Sandpiper's responsibility to police or monitor violations of the rules regarding solicitation (although Sandpiper can argue that it is simply invoking policies intended to disrupt solicitation from both a security and harassment perspective).

Jimmy needs to act quickly in order to prevent the further destruction of potential evidence, also known as "spoliation."[25] He asks the receptionist to use the bathroom, and, once inside, frantically writes a demand letter—on toilet paper—informing Sandpiper of a pending claim against the residency. Jimmy's intent here is to provide Sandpiper with written notice that it is now required by law to preserve potential evidence that may relate to the claim. In that sense, the letter is akin to a "litigation hold" letter that requires the preservation of evidence. He shoves the letter in the receptionist's face and loudly demands that the employees stop shredding documents. The letter alleges several potential causes of action, including negligent infliction of emotional distress, breach of contract, elder abuse, and a clear pattern of fraudulent, deceptive and unfair trade practices. Note that the letter is valid despite the fact that it is written on toilet paper; it is just another example of Jimmy's focus on the message, as opposed to the medium through which the message is communicated.

Sandpiper disregards Jimmy's anti-spoliation pleas, and they kick him out of the facility. He returns at night and rummages through the dumpsters located outside of the facility. The bins are located in a public place and are not

locked. Jimmy finds the shredded documents in one of the bins. When Chuck later challenges Jimmy about the legitimacy of removing the shredded papers from the dumpster, Jimmy argues that the dumpster diving was a component of a permissible investigation. Jimmy retorts that "You can't say it's private if a hobo can use it as a wigwam!" arguing that Sandpiper has "no reasonable expectation of privacy" in garbage it voluntarily disposed. (Jimmy's argument is reminiscent of *The Simpsons'* attorney Lionel Hutz's declaration that "I'll have you know the contents of that dumpster are private! You stick your nose in, you'll be violating attorney-dumpster confidentiality."[26]) As a general rule, garbage placed in a dumpster is no longer considered private property. Courts have held that police officers do not need to obtain a warrant in order to search a trash can that a homeowner places outside the home in a publicly accessible area.[27] The act of throwing something in the garbage removes one's ownership interest in and to the property. For this reason, an attorney perusing a dumpster for evidence is likely permissible.[28] Consider whether an overly aggressive bar committee would argue that doing so, however, violates the dignity of the profession and places the attorney in a negative enough light to raise questions about his fitness as an attorney under MRPC Rule 8.4. A possible retort would be that, if searching for said evidence is permissible, perhaps doing so is actually required in order to comply with rules regarding zealous advocacy.

Jimmy falls asleep during the painstaking and seemingly impossible task of piecing together the documents, and Chuck ultimately takes over for him. Chuck's actions could present a couple of possible ethical issues. If we can reasonably determine that Jimmy has a right to access the shredded documents, is it necessary for Chuck to obtain Jimmy's consent prior to accessing the documents? Chuck is not an

associate or partner of Jimmy, and even if we determine that Jimmy does not need explicit consent from his clients from his existing elder law practice to investigate, perhaps Chuck needs to have the consent of Jimmy and/or the clients before engaging in any action. The documents are not the property of the clients, however, so they would be hard pressed to argue that Chuck's actions violate any of their rights.

Furthermore, questions can be raised as to whether Chuck's involvement in the case is prohibited by his partnership agreement with HHM. Because Chuck works in a large law firm, it is possible that the firm represents Sandpiper in a different matter, thereby potentially creating a conflict of interest. Once Chuck and Jimmy decide to bring the case to HHM, the firm (notwithstanding Kim's initial failure to do so)[29] presumably proceeds to conduct client conflict checks, which are intended to prevent conflicts between former, existing, and future clients. But during his initial involvement with the case (prior to HHM's involvement), Chuck risks potentially breaching his partnership arrangement as well as rules relating to conflicts of concurrent clients. MRPC Rule 1.7(a) provides, for example, that, except in certain circumstances:

> A lawyer shall not represent a client if the representation involves a concurrent conflict of interest. A concurrent conflict of interest exists if:
>
> (1) the representation of one client will be directly adverse to another client; or
> (2) there is a significant risk that the representation of one or more clients will be materially limited by the lawyer's responsibilities to another client, a former client or a third person or by a personal interest of the lawyer.[30]

The risk of Chuck violating the foregoing rule is probably not too high in this context. He might argue that even if HHM separately represents Sandpiper, and even if his representation of a particular, yet-to-be identified elderly client is "directly adverse" to Sandpiper, the representation "does not involve the assertion of a claim by one client against another client represented by the lawyer in the same litigation or other proceeding before a tribunal."[31] Still, attorneys working at large law firms need to be careful about taking on cases independent from their work at the firm.

Upon review of the pieced-together documents, Jimmy's Sandpiper Crossing case is quickly determined (by Chuck) to fall under the auspices of the federal Racketeer Influenced and Corrupt Organizations Act (RICO)[32] because the alleged criminal actions of Sandpiper crossed state lines. (The discovery that Sandpiper ordered syringes from Nebraska leads to this conclusion). RICO covers various types of criminal conduct, and the pattern of fraudulent charges engineered by Sandpiper Crossing easily qualifies, if the allegations prove true.

Pie, Anyone?

In "Cobbler," we watch Jimmy McGill do his very best Saul Goodman impression. Mike asks Jimmy to represent Daniel Wormald, an IT technician with access to pharmaceuticals. Wormald engaged Mike to serve as his bodyguard for protection during certain illicit drug sales, with Wormald comically out of his element during each transaction. Because of certain missteps—starting with Wormald's inexplicable call to the cops asking them to investigate the theft of baseball cards from his house—the cops suspect that he is dealing drugs. They have no hard evidence to back up their suspicions, however. They call Wormald into the

station for questioning, but he is accompanied by Jimmy. And Jimmy proceeds to concoct the story of a lifetime, leaving the detectives baffled, dazed, and confused.[33]

Jimmy tells the detectives that Wormald provides "art" in exchange for an individual's patronage. When pressed for more details, Jimmy explains that Wormald makes "squat cobbler" videos for the individual. Jimmy reveals that these are private videos of an artistic nature, and the "art" patron stole the videos and baseball cards. Jimmy describes the burglary as a "lover's spat." The detectives ask for further clarification, informing Jimmy that they have never heard of a "squat cobbler." Jimmy describes the details to the detectives ("when a man sits [fully clothed] in a pie, and wiggles around"), all the while feigning disbelief at their claim that they've never heard of such an arrangement (suggesting that perhaps the cops are more familiar with the terms "full moon," "moon pie," or "Boston cream splat" than they are with "Hoboken squat cobbler"). Upon leaving the police station, Jimmy orders Wormald to make such a video and keep it handy in the event that it is ever needed to back up Jimmy's story. Later that night, Jimmy celebrates with Kim by eating peach cobbler. Kim seems proud of Jimmy for making up such a creative story and lying to the cops, but she condemns him for fabricating "evidence."

Jimmy demonstrates his uncanny ability to lie with ease during this scene. He violates several ethical rules (including portions of NY Rule 8.4). If these lies were told in a court of law by a *defendant*—never mind by a lawyer—the rules would go even further, demanding that an attorney correct the defendant client. Here, *the attorney* (Jimmy) is the one who is lying and actually demands that his client follow the lie. Per the discussion below, it is not clear that Jimmy is fabricating evidence here, since Wormald has not yet been charged with a crime. But at a minimum, Jimmy is

interfering with an ongoing investigation, and this may lead to obstruction of justice or other similar charges.

Kim seems to make a distinction between (1) lying to the cops (which she apparently does not take issue with, even though it violates ethical standards governing Jimmy's conduct, and (2) telling a client to create a private video (which bothers her significantly). Perhaps Kim views fabricating a story as a legitimate articulation and implementation of advocacy, but views the creation of physical materials to potentially use as evidence as crossing a line. But Kim's analysis is misguided here, as Jimmy *already* violated the rules by lying to the detectives. The private video is not yet being shared with the cops, and, per the above analysis, may not constitute evidence. Furthermore, since Kim *knows* that Jimmy has violated one or more ethical rules by lying to the detectives, she may be required to report the violation (per MRPC 8.3[a]). By failing to so report, Kim violates this rule.

⚖️

Now that we have examined many of the legal ethical issues addressed on *Better Call Saul*, let's turn our attention to the (surprising) question of whether Jimmy and/or Saul can reasonably be considered "heroic" in some sense.

Notes

1. Legal Information Institute, "New Mexico Rules of Professional Conduct, Preamble: A Lawyer's Responsibilities," www.law.cornell.edu/ethics/nm/code/NM_CODE.htm.
2. Chuck argues that the cops do not have "probable cause" to do so. He had left the neighbor $5 before taking the paper, but she never consented to the "transaction." Chuck is clearly in

the wrong here, but the probable cause question is murkier. Courts have interpreted the Fourth Amendment prohibition on unreasonable searches and seizures as requiring that police satisfy a "probable cause" standard prior to conducting a search. Here, perhaps Chuck is correct that a neighbor's accusation, without any further evidentiary support, does not constitute sufficient cause to search, enter Chuck's home, or force Chuck out of his home.

3. Even though the attorneys on *Better Call Saul* are all presumably licensed to practice in New Mexico and are therefore subject to the rules promulgated by the New Mexico Bar, this chapter (unless otherwise noted) largely focuses on the MRPC (located at http://www.americanbar.org/groups/professional_respon- sibility/publications/model_rules_of_professional_conduct/ model_rules_of_professional_conduct_table_of_contents. html) to make the discussion applicable to a wider array of attorneys. Some portions of this book (including this chapter) briefly touch upon the Rules of Professional Conduct estab- lished by the New Mexico Bar Association, too. Most states promulgate their own rules based, at least to some degree, on the MRPC. It bears mention, though, that attorneys are only responsible for complying with the rules set forth in the juris- dictions in which they are licensed to practice law and are not responsible for compliance with rules set forth in other juris- dictions.

4. This rule prohibits an attorney from "revealing information relating to the representation" of a former client.

5. Kim predicts that Jimmy will lose if he brings the Kettle- man case to trial, and informs Jimmy that "Kettleman did a terrible job covering his tracks." She declares that "He's guilty as sin" after noting that Kettleman "is not my client anymore." Kim violates her obligations to Kettleman, a former client, by revealing information about him to Jimmy without his consent. Kim may argue that since Jimmy is the new attorney of record, perhaps she is not violating the spirit of the rule. While the rules do not include an exception for this scenario, perhaps a disciplinary committee would take it into account when reviewing the file and meting out punishment.

6. Nicole Hyland speculates that Jimmy wants Chuck to review the client files, presumably to form a working relationship

with him. She points to the fact that Jimmy peers through the window and watches Chuck open the boxes. Hyland argues that both Chuck and Jimmy thereby violate New York Rule 1.6, which requires an attorney to preserve confidential information of a client. Nicole Hyland, "Episode 7 (Bingo)," The Legal Ethics of Better Call Saul, http://ethicsofbettercallsaul. tumblr.com/post/114154553491/episode-7-bingo. I respectfully disagree. As discussed above, Jimmy likely violates this rule by not stopping Chuck before he opens the boxes. The failure to prevent a security breach in this regard and allow it to continue with Jimmy's knowledge likely constitutes a violation of the rule. Chuck may be guilty of violating laws, but it is impossible for him to violate New York Rule 1.6 because he is not an attorney of record for the client.

7. See Nicole Hyland's discussion of "Five-O." "Episode 6 (Five-O)," The Legal Ethics of Better Call Saul, http://ethicsofbettercallsaul.tumblr.com/post/114095618441/episode-6-five-o.

8. "Assault" is defined on a state-by-state basis, but generally it occurs "when someone threatens bodily harm to another in a convincing way." Assault is often accompanied by "battery," which is defined, generally, as unlawful physical contact. See "Elements of Assault" at http://injury.findlaw.com/torts-and-personal-injuries/elements-of-assault.html.

Intentionally spilling coffee on a person may well constitute battery in many jurisdictions—particularly if the coffee is hot, perhaps even without regard to the temperature.

9. Question whether Jimmy's action constitutes evidence tampering. Since Mike has not been charged with any crime, perhaps the notebook is not considered evidence. But it is clear that the intent is to obstruct the pursuit of justice.

10. *Breaking Bad*, season 2 ("Mandala," 2009).

11. Note that NY Rule 1.2(d) permits a lawyer to discuss "the legal consequences of any proposed course of conduct with a client." Saul complies with this rule when he offers his clients practical advice with respect to potential future actions. Saul sometimes toes a difficult line here, as he is permitted to discuss the consequences, but not recommend or further a criminal course of conduct. In his early days, we watch Jimmy (in "Hero") advise Nacho to clean up the blood in the car in the future. If pressed, Jimmy would argue that the recommendation does

not amount to evidence tampering since there is no crime at the time of the recommendation. Jimmy would also attempt to invoke this portion of NY Rule 1.2(d), arguing that he is simply advising a client not to run afoul of the law by cleaning up a mess in a particular way. An aggressive bar disciplinary committee might view the situation differently and, in an attempt to apply the former part of NY Rule 1.2(d), argue that Jimmy's advice equates to counseling a client in conduct that the attorney knows is fraudulent.

12. "Bribery" is frequently defined as "the offering, giving, receiving, or soliciting of something of value for the purpose of influencing the action of an official in the discharge of his or her public or legal duties." See the Free Dictionary, http://legal-dictionary.thefreedictionary.com/bribery.

Despite the low monetary value of the Beanie Baby, Jimmy's offer of the doll to a court official falls squarely within the foregoing definition. Jimmy's purpose is to exchange the doll for a favorable court date. The official's "public duty" is to assign dates and not be influenced in any way by the likes of Jimmy. Furthermore, Jimmy's action violates MRPC Rule 8.4, and Davis & Main would strongly disapprove of such action.

13. Saul Goodman violates the confidences of other current or former clients as well. In "Hazard Pay," from season 5 of *Breaking Bad* (2012), Saul betrays the confidences of insect exterminators (who are burglars) to Walt, Jesse, and Mike: he informs Walt and company that the exterminators are criminals. Saul would likely argue that those clients would be happy with the disclosure because it results in Walt and company engaging them to aid in their drug enterprise, but MRPC Rule 1.6 prohibits such disclosure unless Saul receives the prior consent of the exterminators. It is possible that Saul did so, in which case he would not be in violation of this particular rule.

14. *New York Rules of Professional Conduct* (as amended through January 2014), Rule 1.18(b), New York State Bar Association, https://www.nysba.org/DownloadAsset.aspx?id=50671.

15. Nicole Hyland, "Episodes 1 and 2 (Uno and Mijo)," The Legal Ethics of Better Call Saul, http://ethicsofbettercallsaul.tumblr.com/post/113961009951/episodes-1-and-2-uno-and-mijo.

16. See *New York Rules of Professional Conduct* (as amended

through January 2014), Rule 1.6, New York State Bar Association, https://www.nysba.org/DownloadAsset.aspx?id=50671.

17. Nicole Hyland, "Episode 3 (Nacho)," The Legal Ethics of Better Call Saul, http://ethicsofbettercallsaul.tumblr.com/post/113975579941/episode-3-nacho. Italics added for emphasis.

18. Note that the Kettlemans are not Jimmy's clients at this point, though they do receive the protections of the prospective client rule due to previous conversations with Jimmy. This fact is not relevant to the analysis of whether Jimmy may or must warn the Kettlemans of impending danger. While Jimmy would have an obligation to represent the Kettlemans zealously if they were his clients, the rules do not include special disclosure exceptions to prevent loss of life or limb to one's clients. That said, representing Nacho and the Kettlemans together later on in the series presents serious conflict-of-interest issues.

19. Nicole Hyland, "Episode 3 (Nacho)," The Legal Ethics of Better Call Saul, http://ethicsofbettercallsaul.tumblr.com/post/113975579941/episode-3-nacho.

20. Ibid.

21. Having said that, Jimmy appears to be legitimately surprised when the cops inform him that Nacho (upon being arrested) requests that they bring Jimmy in as his lawyer. "You sure he asked for me?" Jimmy asks the cops.

22. One can consider the skateboarding lackeys' objection to the "deal" that Jimmy procured from Tuco. Though far from a judicial setting, it is noteworthy that if the lackeys were his clients at that point in time (an interesting question), the ethical rules (if applicable, which they are most certainly not!) would require Jimmy to accede to their wishes and not negotiate the leg-breaking deal. That said, of course, no bar committee would ever seek to impose disciplinary action on an attorney "representing" clients in a situation that involves being alone in a desert with the crazed Tuco and his fellow gang members.

23. This is somewhat reminiscent of the *Breaking Bad* scene (season 3, "Caballo Sin Nombre," 2010) in which Saul negotiates a deep price discount on behalf of Jesse Pinkman, using the fact that the home previously housed a meth lab as leverage against Pinkman's parents, the sellers.

24. As noted earlier, New York Rule 7.3(a)(iv) provides that a

lawyer may not engage in solicitation by "any form of communication" where "the age or the physical, emotional or mental state of the recipient makes it unlikely that the recipient will be able to exercise reasonable judgment in retaining a lawyer." See *New York Rules of Professional Conduct* (as amended through January 2014), Rule 7.3(a)(iv), New York State Bar Association, https://www.nysba.org/DownloadAsset.aspx?id=50671.

25. As noted by attorney Nicole Hyland, Jimmy's reference to spoliation as a felony "is true in certain jurisdictions. But the more likely result of spoliation is that the court will give an adverse inference instruction; that is, the jury may infer from the intentional destruction of the evidence that it was damaging to the offending party." Nicole Hyland, "Episode 8 (RICO)," The Legal Ethics of Better Call Saul, http://ethicsofbettercallsaul.tumblr.com/.

26. "The Springfield Connection" (season 6, Episode 2F21, 1995).

27. See *United States v. Redmon*, No. 96-3361, 7th Cir. (1998); *California v. Greenwood*, 486 U.S. 35 (1988). The *Greenwood* case held that the individual who has thrown out the garbage no longer has any "reasonable expectation of privacy" in said garbage. The court determined that it was "common knowledge" that garbage sitting outside is "readily accessible to animals, children, scavengers, snoops, and other members of the public."

28. Nicole Hyland, "Episode 8 (RICO)," The Legal Ethics of Better Call Saul, http://ethicsofbettercallsaul.tumblr.com/.

29. In "RICO," Kim agrees to print cases from Westlaw without running a client conflict check. As Nicole Hyland notes, "Kim's failure to follow [HHM's institutionalized procedures] puts her firm at risk of an ethical violation if Sandpiper was to be a client." Hyland also notes that Jimmy "would be tainted by HHM's conflict and could be disqualified from representing the clients." The other issue presented by Jimmy's request to Kim is the fact that he gives her Chuck's Westlaw code to use for printing documents. That action is improper, as HHM resources are being used without the firm's knowledge or consent on a case for which they have not yet been retained. In addition, as Hyland points out, the task that Jimmy asks Kim to do is more substantive in nature than simply printing documents—he asks her to conduct legal research, which, had HHM pressed

the issue, perhaps could give them "the leverage to argue that they owned the Sandpiper case outright, leaving [Jimmy] in the cold." See Nicole Hyland, "Episode 8 (RICO)," The Legal Ethics of Better Call Saul, http://ethicsofbettercallsaul.tumblr.com/.

30. "Rule 1.7: Conflict of Interest: Current Clients," American Bar Association Center for Professional Responsibility, Rule 1.7, http://www.americanbar.org/groups/professional_responsi-bility/publications/model_rules_of_professional_conduct/rule_1_7_conflict_of_interest_current_clients.html.

31. Ibid., MRPC Rule 1.7(b)(3).

32. RICO was enacted by section 901(a) of the Organized Crime Control Act of 1970 (Pub.L. 91–452, 84 Stat. 922, enacted October 15, 1970), and is codified at 18 U.S.C. ch. 96 as 18 U.S.C. §§ 1961–1968. "Racketeer Influenced and Corrupt Organizations Act," Revolvy, http://www.revolvy.com/main/index.php?s=Racketeer%20Influenced%20and%20Corrupt%20Organizations%20Act&item_type=topic.

33. This is not the first time that Jimmy has lied to the cops, violating NY Rule 8.4(c) and other rules. For example, during "Bingo," Jimmy tells Detective Abassi that he found the detective's notebook on the ground. The truth: Jimmy helped Mike steal the notebook during the infamous coffee-spilling incident.

6

Jimmy McGill/Saul Goodman: American Hero?

Jimmy McGill—shyster, con artist, devoted brother and friend, lawyer, and...hero?[1] The controversial characterization of Jimmy as a "hero" depends much on one's definition of that term. As I write in my book *The Tao of Jack Bauer*:

> In modern American society, we have different perceptions of the ideal hero. Indeed, in our multifaceted, diverse society, we have a plethora of options when searching for our heroes. A hero can be defined by what he or she has done (such as Jackie Robinson) or what he represents (such as Martin Luther King, Jr.). Teenagers often look to rock stars or *American Idol* contestants. Students often look to

their parents. Children look to superheroes, such as Superman, Spiderman, and Batman. Those pursuing a particular career path often look to the leader in the field in which they wish to enter. Some of us look to fictional creations, such as Indiana Jones or Jack Bauer. And some of us look to real-world figures who save lives—presidents, doctors, research scientists, and the like.[2]

While lawyers are not included in the aforementioned categories of individuals "who save lives," there can be little doubt that an attorney representing clientele who are despised by many in society has the chance to be seen as *their* hero (possibly saving their lives in certain contexts) and also the chance to serve the aforementioned societal (and perhaps heroic) goal of ensuring that our legal justice system ensures fair representation to those accused of crimes.

Traditional views of a hero involve admiration of the individual for fighting for a particular cause, perhaps overcoming odds in the course of engaging in specific actions. One can, alternatively, take a more nihilistic view of the concept of a hero, focusing on the *process* by which an individual engages in a course of conduct while remaining agnostic about the *substantive content* and *desired results* of those actions. Most of us would not consider Saul to be a hero (at least in the traditional sense) once he transforms into the corrupt and morally inept Saul Goodman—although Saul's clients may beg to differ. If Saul has any chance of being considered a hero in our eyes, he will have to rely on the agnostic viewpoint, given the moral depravity of many of his actions. He often has his back to the wall, and overcomes significant challenges. Perhaps, under the nihilistic definition, that is sufficient for him to qualify.

But what about Jimmy? One can argue that Jimmy is, or at least has the potential to be, the "champion of the underdog,"[3] and perhaps even fits the mold of the traditional hero. He is akin to David from the biblical account of David versus Goliath. He acknowledges this, noting that he is like a "kiddie lemonade stand," whereas HHM, the prestigious mammoth law firm, is "Walmart." As stated on the *Better Call Saul* website, "Jimmy's buoyant optimism and quick wit make him a forceful champion for his down-market clients. Jimmy's a legitimate lawyer, an underdog fighting to make a name for himself, but his moral compass and his ambition are often at war with each other."[4] We wish for our hero to stick with and strengthen his moral compass, even though we know that he will not do so.

Jimmy's decision to put his own life in harm's way when negotiating with Tuco and Nacho to save the lives of the two boys fits squarely within Dean A. Miller's descriptive definition of a hero: "An individual is named the 'hero' of a particular incident, which means that he or she had intervened in some critical situation in an extraordinary fashion, acting outside, above, or in disregard to normal patterns of behavior, especially in putting his or her life at risk."[5] While Jimmy's proclamation to the boys that he is "the best lawyer ever" (based on his negotiating skills) is overstated, it is reasonable to assume that many lawyers would not have been as courageous or devoted to his clients as Jimmy was in this ominous situation.

In addition, Jimmy makes a phone call to the Kettlemans to warn them of impending danger after Nacho reveals his plan to Jimmy. Jimmy places his own life and limb on the line, possibly violating applicable client confidentiality rules and attorney-client privilege in the process (if Nacho is properly considered his client at this point, and if exceptions for commission of future crimes involving

bodily harm weren't be applicable), potentially leading to reprimand, sanctions, and/or disbarment.

Other than certain limited exceptions (such as the aforementioned bodily harm exception), the attorney-client privilege prevents an attorney from revealing confidential information disclosed to him or her by the client (to the extent such information is truly confidential and has not been otherwise disclosed by the client). In the role as friend of the accused in the criminal defense context, an attorney serves as a trusted advisor to the client. If such trust is breached, the attorney-client relationship will disintegrate and the representation of the client will be adversely affected. The stakes of revealing information are often high, but the law is quite clear on the parameters and scope of the privilege. There is no time limit, and the privilege does not disappear upon the death of a client.[6] In the United States Supreme Court case *Swidler & Berlin v. United States*,[7] the court affirmed that the privilege lasts in perpetuity and stated, as some of the main justifications for maintaining the privilege forever, that "Clients may be concerned about reputation, civil liability, or possible harm to friends or family. Posthumous disclosure of such communications may be as feared as disclosure during the client's lifetime."[8]

Criminal defense lawyers are often placed in uncomfortable positions upon learning information from their clients. For example, defendant Andrew Wilson admitted to his attorneys that he had committed the murder of a security guard at a McDonald's in Chicago in 1982.[9] Alton Logan was wrongfully convicted of this crime, and was imprisoned for twenty-six years. The attorneys were tormented over the fact that the bar required them to maintain the confidentiality of Wilson's admission. They also felt an obligation to their client. One of the attorneys, Dale Coventry, stated

that he was less concerned with disciplinary measures that he might face from revealing the information than he was concerned with his "responsibility" to his client, noting that he was "very concerned to protect him."[10]

> Well, the vast majority of the public apparently believes that [attorneys should be permitted to reveal the information], but if you check with attorneys or ethics committees or you know anybody who knows the rules of conduct for attorneys, it's very, very clear. It's not morally clear. But we're in a position where we have to maintain client confidentiality, just as a priest would or a doctor would. It's just a requirement of the law. The system wouldn't work without it.[11]

Coventry and his cocounsel, Jamie Kunz, ultimately convinced Wilson to waive the privilege upon death, and finally revealed the information after Wilson died. Logan was released from prison after having served much time for a crime that the defense attorneys knew he did not commit. Had Wilson not waived the privilege, the truth may have never been revealed to the general public. The account of Alton Logan is an example of the seriousness of the attorney-client privilege and its potentially negative societal consequences. Despite such unfortunate outcomes, the bar views the goal of maintaining confidentiality as a fundamental part of a society built on justice and the rule of law.

Perhaps many people would agree that the benefits of maintaining the privilege during a client's life outweigh the search for truth, even in murder cases that affect innocent people. But notwithstanding the arguments provided by the Supreme Court in *Swidler & Berlin*, far fewer people,

I surmise, would advocate for maintaining the privilege *after* the client's death. Had Wilson's attorneys not secured the waiver from Wilson, perhaps the best course of action would have been for the attorneys to reveal the information and take their chances dealing with any disciplinary actions from the state bar. A brave attorney—maybe even Jimmy McGill at his best—would quite possibly violate this rule in order to achieve the "greater good" of procuring the release of Mr. Logan. Would such disclosure be considered heroic? Are there times in which breaking the rules is justifiable? Note that even if a brave attorney were to do so, a court might hold the information to be inadmissible because the disclosure violated attorney-client privilege.

In both the Tuco negotiation and warning call to the Kettlemans, there is little question that Jimmy should be "named the 'hero' of the particular incident." Although both are prime examples of heroic action by Jimmy, one can argue that his desire to fight for the underdog—even if it does not involve his intervention "in some critical situation in an extraordinary fashion"—deserves our attention and praise. That being said, because Jimmy ultimately disappoints us, there is a strong argument to be made that he is a failed hero.

Our Failed Hero

In *Exploring the Function of Heroes and Heroines in Children's Literature from Around the World*, authors Manjari Singh and Mei-Yu Lu note that:

Heroes and heroines in good literature are portrayed as complex individuals, so it is necessary to analyze them in a holistic manner by paying special attention to the interplay of both positive and negative traits. Many main characters are strong role models

because they rise above their own negative traits or weaknesses and overcome personal challenges. We often find protagonists inspiring because they demonstrate the need for individuals to be resilient and to respond proactively to challenging circumstances.[12]

As discussed, Jimmy and Saul are complex characters. It is the "interplay of both positive and negative traits" that makes our protagonist so intriguing. On the one hand, he is a skilled negotiator and engages in zealous advocacy on behalf of his clients. Jimmy even puts his own life and limb in serious jeopardy when advocating for saving the lives and (most of) the limbs of his two lackey "associates" in the skateboarding scheme. He returns a bribe that he reluctantly accepted from the Kettlemans. And he expresses a sincere interest in fighting against the bad guys in an effort to secure justice. In "Pimento," he describes to Chuck what teaming up together in the RICO case would look like: "Imagine that, huh! The two McGill boys, side by side, storming the gates, righting wrongs, taking down the bad guys, and making a boatload of money to boot! That would have been great!"

On the other hand, his motivations and ultimate agenda are unclear and debatable.[13] As previously discussed, we know that Saul is both a corrupt businessman and a corrupt lawyer. There is ample evidence to support the notion that Saul's primary goal is to make a lot of money. In Saul's first appearance on *Breaking Bad* (during season 2's "Better Call Saul"), Saul immediately talks to his new client, Badger, about payment. Saul takes substantial risks to earn large payments (such as demanding $50,000 from Walt to conduct a scheme in which an imposter pretends to be "Heisenberg" and serves his jail time). In the same

episode (as noted earlier), he tells Walt that it's a shame Walt is dying because they could have made "real money" together dealing drugs.

But does this character, particularly in the role of Saul, actually care about his clients? There is some evidence to suggest that he does, but it is also possible that his motivation is more obscure. Neither Jimmy nor Saul care much about creating a legacy. Our protagonist couldn't care less about achieving honor for himself. Both characters are largely self-deprecating and generally do not pretend to be heroic under the traditional definition of a hero. It requires some searching on our part to tease out the potentially heroic elements of these characters. Looking at the morally inept Saul in the most flattering light possible, perhaps we can argue that he achieves some degree of satisfaction from helping his downtrodden clients survive in a world stacked against them. And perhaps part of that satisfaction stems from Saul's empathy toward them: if he views Chuck as part of the "system" intended to keep him down, Saul shares a lot in common with his clients. Together, they can fight the fight against those seeking to tie them down. They can take a heroic journey together and survive not only unscathed but come out in a better position than they were before working together. From this perspective, it is possible that Saul views himself as a conduit through which his clients' (and his own) frustrations about their circumstances, place in the world, and challenges can be channeled, released, exhausted, and finally exonerated. We need not agree with or respect the substance of what Saul does, but we can at least acknowledge the herculean tasks he often has in front of him in the course of representing those society frowns upon. In this light, we can properly consider him a heroic character even though we disagree with his agenda.

If we dig a bit deeper into the definition of "hero"

offered by Singh and Lu, we continue to see elements of Saul's character that fit, but also those that demonstrate that he is, in many ways, an "antihero." We know that Saul is the opposite of a "strong role model" and that he does not "rise above" his "negative traits or weaknesses." In fact, he ultimately embraces and succumbs to those traits and weaknesses, becoming defined by them. But Jimmy's transformation into Saul does represent, at some level, that he has "overcome" the "personal challenge" of seeking his brother's approval. His transformation is a reactive rather than "proactive" response to his "challenging circumstances." Jimmy ultimately reacts to the rejection by his brother by becoming his own person. Any new struggles that Saul endures will be of his own making. Although we do not admire the person that Saul becomes, the fact of the trans-formation itself—the *process* and *not the substance*—can be seen in an admirable light. But because the substance is so unfailingly and grossly immoral, he ultimately fails us. This complex character possesses several flaws that lead to his ultimate downfall.

The Two Separate Shakespearean Tragedies of Saul Goodman

Saul Goodman's life is a case study of tragedy. His meteoric rise from small-time, two-bit con artist to mailroom clerk to attorney is admirable and inspiring. He is able to overcome (at least for a limited period of time) poor habits and characteristics, and, in doing so, achieves a modicum of success. Were it not for certain bumps in the road and a series of unfortunate events (including his own poor decisions), we might be analyzing a character of modest beginnings who turned himself around and became a successful, wealthy, dignified partner at a white-shoe law firm. But fate will not be so kind to our protagonist—and,

for that reason, our study of our favorite lawyer is even more intriguing.

The rise and fall of Saul Goodman in many ways resembles a Shakespearean tragedy. Shakespeare's tragedies are typically characterized by the following four elements: (1) "a noble protagonist," (2) "who is flawed in some way," (3) who is "placed in a stressful heightened situation," and (4) whose story "ends with a fatal conclusion."[14] These elements are present in many of Shakespeare's works, including *Antony and Cleopatra, Coriolanus, Hamlet, Julius Caesar, King Lear, Macbeth, Othello, Romeo and Juliet, Timon of Athens,* and *Titus Andronicus.*[15] Let's analyze these elements in turn as they apply to Jimmy McGill and Saul Goodman.

"Noble Protagonist"

Our "noble protagonist," Jimmy, in the course of his transformation into Saul Goodman, is pushed over the ethical cliff by those around him, particularly his brother, Chuck, and his friend Marco. We might be skeptical upon hearing the notion that Jimmy is a "noble" character. "Nobility" may be defined as "having or showing fine personal qualities or high moral principles."[16] Even on his best behavior, it is difficult to argue that Jimmy possesses "high moral principles and ideals," despite certain laudable actions and causes that he undertakes. But if we define nobility a bit more loosely, we can argue that those laudable actions serve to buttress Jimmy's stature as a well-intentioned, hardworking champion of the underdog.

Just as Jimmy falls off the ethical cliff partially as a result of his interactions with others, we see the influence of external elements in Shakespearean tragedies as well. The significant pressure Lady Macbeth places on Macbeth in *Macbeth,* for example, leads to the protagonist's downfall. Like many protagonists in Shakespearean tragedies, Jimmy

McGill is generally not an evildoer—he is, arguably, our "noble protagonist." As briefly noted earlier with respect to both Walter White and Jimmy McGill, the tragedy of *Better Call Saul* and many of Shakespeare's works is that we can envision an alternate universe in which the protagonist chooses a different path and averts the tragic outcome. As writer Peter Gould states, "The more we got to know Jimmy, the more puzzling it became...the more it felt almost tragic, this guy who has such good intentions, who has a good heart, who is at his core a decent guy. How did he become Saul Goodman, who's rushing to advocate for murdering people and for building a drug empire? We realized as we went along that there was a much more convoluted, challenging journey than we had thought."[17]

"Flawed in Some Way"

We can pinpoint several flaws in Jimmy's character that lead to his descent into the nefarious Saul Goodman. While he overcomes his unhealthy obsession with winning the admiration of his brother, the fact that he *had* such an obsession and was *forced* to overcome it (in order to be successful) makes it one of the flaws that causes his downfall. If he had not cared about pleasing his brother, then he would not have had the motivation to become an entirely different person once he realized it was impossible. It is Jimmy's ambition to disassociate from his brother and still somehow achieve a modicum of success that ultimately leads him down a path to his demise.[18]

It is not clear to us whether Jimmy is incapable of fighting his internal demons and preventing his descent. While Marco and Chuck unquestionably have an impact on him, he demonstrates the ability, at least for a while, to combat the Slippin' Jimmy persona. And so it's possible that Jimmy's tragic fall was not caused by a flat inability

to overcome the negative aspects of his character. Instead, the transformation into Saul is a conscious decision made by a man who demonstrates the capacity to distinguish between right and wrong, moral and immoral, and honest and dishonest. As Ralph Waldo Emerson observed, "The only person you are destined to become is the person you decide to be."[19]

Saul's downfall on *Breaking Bad* can be dissected and analyzed from various perspectives. Viewed in the most favorable light, one may argue that his downfall is caused by his desire to help clients who are so broken that they are beyond repair. But Walter White is not broken beyond repair when he first encounters Saul. Walt comes to Saul for guidance before he falls into the abysses of greed, power, and wretchedness that ultimately consume him. In other words, Walt does not completely "break bad" until the series progresses and he becomes more involved with the drug empire and continues to follow Saul's misguided advice. Had Saul attempted to steer Walt in a different direction, perhaps the dual tragedy of Walt and Saul's downfalls could have been avoided (or at least mitigated). Instead, Saul's advice to Walt involves money laundering, meth-peddling, and even committing murder.

Saul's excessive pride and arrogance—"hubris," as it is known in Greek mythology—contributes to his downfall at the conclusion of *Breaking Bad*. He is enamored with the idea of providing advice of a criminal nature to Walt and Jesse. His decision to become involved in a high-stakes game of drug warfare leads to significant trouble. Saul takes on more than he can handle, and he pays the price by losing his career and ending up as a Cinnabon employee. His pride and arrogance push him to become involved with a debacle he should have stayed out of.

"Placed in a Stressful Heightened Situation"

In the course of his transformation into Saul Goodman, the "stressful heightened situation" is the falling out with his brother and his desire to make a reasonable living. He is also distraught by the death of his former partner-in-mischief, Marco. The dual losses of his brother (someone Jimmy previously respected) and his friend leaves Jimmy with an empty heart. He will ultimately fill that void and thereby combat the stresses of his life by becoming a much darker character.

Saul's involvement in the plight of Walter White and Jesse Pinkman is the "stressful heightened situation" that leads to his second downfall, as depicted on *Breaking Bad*. As Saul becomes further embroiled in the mess that he forms with these clients, his life is ultimately turned upside down. We get the sense that the scope of this situation is unlike anything that he has ever dealt with previously. As we know, the immense stress that he is under leads to a final downfall.

"Ends with a Fatal Conclusion"

Saul's story has two separate "fatal conclusions." His transformation from Jimmy to Saul is a tragedy of enormous proportions and the first fatal conclusion. His downfall from hotshot (if gimmicky) lawyer to Cinnabon employee is his final fatal conclusion.

Machiavellian, Utilitarian Jimmy

One may also argue that Jimmy (and Saul) exhibit Machiavellian traits in the sense that he believes that "the ends justify the means."[20] Saul is often willing to engage in despicable actions in order to achieve a particular end— noble or not. Jimmy, on the other hand, is somewhat more

reluctant to do so, and at least attempts not to cross ethical boundaries in order to achieve a particular result. Chuck calls Jimmy out for adhering to Machiavelli's canon. In "Gloves Off," for example, Chuck lectures Jimmy about Jimmy's production and airing of a television commercial without receiving approval from Davis & Main: "That's your problem, Jimmy, thinking the ends justifies the means." Jimmy defends the commercial based on potential short-term gains ("ends"), while Chuck is focused on the wrongful means employed in order to achieve such objectives.

In "Hero," Jimmy initially resists the Kettlemans' offer of a bribe in order to keep quiet about his knowledge of their misdeeds:

"I can't take a bribe."

Jimmy does have a Machiavellian moment, however, when he ultimately, albeit reluctantly, accepts the "bribe/retainer" from the Kettlemans just a moment later:

"But I can take a retainer."

Incidentally, Mrs. Kettleman turns down Jimmy's proposal, opining (quite ironically, given her actions) that Jimmy is "the kind of lawyer guilty people hire." Jimmy is hurt by this rejection, but ultimately ignores it and attempts to justify his acceptance of the money by associating the dollars with various aspects of his practice ("storage fees," "filing fees," "meals," etc.) as if he is representing them.

Note that Jimmy's attempts to justify the bribe as a legal fee would not pass muster if presented to a bar disciplinary committee. His actions, as noted by Nicole Hyland, likely constitute "illegal conduct that adversely reflect on" his honesty, and are arguably "prejudicial to the administration of justice," thereby violating Rules 8.4(b) and 8.4(d) in New York.[21] Even if we ignore the Kettlemans' explicit statement that they are not engaging Jimmy to serve as their legal counsel and attempt to justify the payment for

"legal services," Hyland correctly notes that the payment "violates [New York] Rule 1.5's prohibition against excessive, fraudulent or illegal fees and expenses."[22] Not only is Jimmy charging too much for his "services," but he simply invents the expenses, thereby engaging in fraud. Hyland notes that the fees and expenses, even if deemed reasonable, would still need to be communicated to the client—in New York, communication regarding these fees would need to be in writing.[23] Finally, Hyland observes that "attorneys may not accept fees from the fruits of illegal activities," and that "doing so risks fee forfeiture and possibly even criminal prosecution."[24]

The Machiavellian moment arrives when Jimmy, in the process of allocating portions of the money to his practice, says to himself: "Upon this rock, I will build my church." Jimmy attempts to justify his actions here by appealing to an end game: he will take this money and use it to build a successful, reputable legal process and thereby help countless clients in need for years to come. His practice will be the "church," and he can feel comfortable with accepting the dirty money (the "rock"), knowing that he will use it to build a solid foundation for the future.

Jimmy also appears to act out of a desire to achieve the "greater good," evoking the concept of utilitarianism promulgated by Jeremy Bentham and John Stuart Mill[25] by engaging in a questionable action in order to achieve the most beneficial result (as opposed to acting in accordance with a Kantian moral code that focuses on the *act*, not the *result*). Clearly, Jimmy's act would not be considered moral under a notion of morality set forth by Immanuel Kant, who considers an act to be morally justified only if one is willing to accept engaging in the act as a universal law.[26]

That is not to say, of course, that Jimmy's calculus to achieve what he considers to be the "greater good" is not

often thoroughly skewed and misguided. In "Nailed," for example, his sabotage of Chuck in order to win back Mesa Verde for Kim does not create overall goodness. Not only is Chuck harmed, but so is Mesa Verde. While Jimmy might acknowledge such harm if pressed, he does not see things quite this way. Upon winning back Mesa Verde, he tells Kim, "Sometimes the good guys win," and also opines that Kim "is meant for Mesa Verde and they are meant for [Kim]. So all is right with the world." Jimmy might be a lot of things, but he is not the person to be relied on for making things "right with the world."

Jimmy's Revenge

In "Fifi," Jimmy reaches his boiling point with Chuck. Upon learning that Chuck, by employing a very aggressive pitch, has convinced Kim's client Mesa Verde to stay with HHM (as opposed to following Kim to her new practice), Jimmy takes the gloves off. While Chuck is sleeping, Jimmy tells Ernesto (an HHM junior associate and Chuck's HHM-designated caregiver) that he is free to leave Chuck's home for the night.[27] After spotting boxes of Mesa Verde documents in Chuck's study, Jimmy pulls out a bunch of documents and heads to a twenty-four-hour copy shop. He carefully replaces the address of Mesa Verde on the documents through some cutting and pasting and rearranges the "1261" to read "1216." Jimmy knows that this minor yet important change will go unnoticed by Chuck, a man who prides himself not only on his knowledge of the law but his meticulous attention to detail (perhaps recalling Chuck's previous correction of Jimmy's 413/513 mix-up). Jimmy's plan works perfectly: at a hearing shown during "Nailed," the judges assigned to the file point out that Chuck filed the documents with the incorrect address. Chuck engages in some back-and-forth with the judges, and also angrily

refutes Mesa Verde's own claim about the address. Chuck embarrasses himself in his professional capacity, and that hurts him just as much as the physical harm that will soon come his way after hitting his head on a table in the afore-mentioned copy shop.

Jimmy's desire for revenge outweighs his desire to allow the client to fulfill its goals. Because of Jimmy's deception, Mesa Verde's operational plans will be delayed for at least six weeks. Jimmy violates a host of legal ethical issues by forging the documents (forgery, confidentiality obligations, etc.). A responsible attorney would never exact personal revenge at the expense of a friend's client. We continue to witness the birth and emergence of Saul Goodman, as Jimmy demonstrates that he is much more of a wolf than a sheep.

It is noteworthy that Chuck's aggressive pitch to Mesa Verde is what finally sets Jimmy off. Chuck has insulted Jimmy so many times, and yet Jimmy never seeks to cause serious harm to Chuck's reputation. Jimmy has demon-strated so much loyalty to Chuck by taking care of him, despite Chuck's lack of respect for Jimmy. But once Kim is adversely affected by Chuck's actions, Jimmy becomes unhinged. In Jimmy's eyes, Kim's happiness is far more important than his devotion to Chuck or to the needs of the innocent Mesa Verde.

Mistaken Heroism and Misguided Admiration

As we watch the awkward dynamic between Jimmy and Chuck unfold, we are shown a flashback scene in which they are sitting together in their mother's hospital room moments before she dies. Jimmy makes a quick run outside to buy food and misses his dying mother's last word: "Jimmy." Not "Chuck," but "Jimmy." Does this mean that Jimmy was her favorite son? The audience cannot know

for sure, but we do see Chuck's visceral reaction. Chuck then lies to Jimmy when he asks whether she said anything before she passed away.

Michael McKean believes that Mrs. McGill felt quite differently about Chuck and Jimmy. McKean posits that Chuck made her "proud," while Jimmy made her "laugh."[28] And, apparently, it was ultimately laughter that made her feel connected with Jimmy on a very personal level. Favoritism—especially with respect to one's child—is often misinterpreted by, and debated among, the children themselves. Chuck clearly believes that he deserved to be the favorite, and has difficulty believing that Jimmy in fact might be the one who earned this honor from their mom. Similarly, in *Breaking Bad*'s season 1 episode "Cancer Man" (2008), we meet Jesse Pinkman's younger brother, Jake—an honor student who claims that Jesse, the meth-peddling drug dealer—is their parents' favorite: "You're practically all they ever talk about!" he says in response to Jesse's comment that Jake is their favorite (probably due to Jake's success at such a young age). One can envision Jesse and Jake one day having the same type of relationship that Chuck and Jimmy have.

Other theories regarding Mrs. McGill's final word abound: perhaps she simply felt a stronger motherly need to take watch over Jimmy—more so than the stable Chuck. And perhaps she felt guilty about leaving the world before Jimmy found his proper place in it. But it is also possible that Mrs. McGill viewed Jimmy in a very favorable light, perhaps even admiring him more than Chuck. Is it a stretch to imagine that Mrs. McGill saw Jimmy as a heroic character, fighting against his base instincts and seeking to live a respectable life?[29]

If Jimmy's mom does in fact view Jimmy in such a favorable light, she would not be alone. Kim clearly feels

great affection toward Jimmy. In "Rebecca," we see that Chuck's wife, Rebecca, is charmed by Jimmy, not only because of the lawyer jokes he tells, but also his undeniably likeable personality. As noted by Peter Gould during a writers panel:[30] "Jimmy has that common touch [with Rebecca] that Chuck doesn't."[31] Jimmy's previous coworker Ernesto feels a sense of kinship with Jimmy stemming from their days working in the HHM mailroom together. But one could surmise that Ernesto might view Jimmy as a hero in some respects: starting in the mailroom and becoming an attorney is no small feat.[32] And Ernesto expresses such admiration for Jimmy (and disdain for the HHM partners) by telling Jimmy to represent the mailroom to the big shot partners. Despite Jimmy's moral ambiguities and flawed compass, one could not blame Ernesto for perhaps looking up to Jimmy as somewhat of a model. Theories abound,[33] but perhaps this is part of the reason that Ernesto corrects Chuck in "Klick" when Chuck (correctly) declares that Jimmy was near the copy shop before Chuck fell.[34] Perhaps Ernesto does not want his hero, Jimmy, to fall down, too.[35]

The media loves Jimmy, too. In "Hero," after he appears to save the man dangling from the billboard, the front page of a local newspaper reads, "Local lawyer, local hero"—with a picture of Jimmy to boot. Jimmy's mastery of the media is on full display, and he ultimately deceives the public into believing he had acted heroically.[36]

Lessons from Mike: Honorable Thievery and Half Measures

> "There's no honor among thieves—except for us, of course." ~ Saul Goodman, *Breaking Bad*

Saul's acquaintance/parking attendant client Mike Ehrmantraut is a complicated character study. He possesses

strong instincts, a great deal of experience with cops and criminals (both of which he's been at different points in his life), and a Jimmylike ability to set up creative schemes. In "Gloves Off," for example, he brilliantly devises and executes a plan to anger Tuco and have him arrested.

While Mike is relatively far removed from the person that the audience is introduced to on *Breaking Bad,* the most notable change is his willingness to expand his definition of what qualifies as a "last resort" murder that he can justify according to his own moral code. In that series he is a hired gun, a professional killer—a character that Walter White describes as a "grunting, dead-eyed cretin." His role is largely to protect one bad guy (Gustavo Fring) from other bad guys (such as Walter White and the Mexican drug cartel). Even during Mike's most reprehensible moments on *Breaking Bad,* he does not kill any truly good, moral, innocent people. During the first couple of seasons of *Better Call Saul,* we see Mike go out of his way *not* to be a killer-for-hire, though he is willing to kill if he deems it just or necessary. While it is fair to say that *Better Call Saul* is primarily focused on the transformation of Jimmy McGill into Saul Goodman, a significant portion of the series is devoted to Mike's own transformation/descent into America's badass.

Mike is a man of conviction, but he also engages in what he artfully refers to as "half measures."

In the appropriately titled "Half Measures," which takes place during season 3 of *Breaking Bad* (2010), Mike recounts to Walter White a story from his days as a member of the Philadelphia police force. He had threatened to kill a recidivist domestic abuser, placing a revolver in the perpetrator's mouth after the man savagely beat his wife yet again. The man pleaded for his release, swearing that he would not harm his wife again. Mike let the man go, and the abuser killed his wife two weeks later. "The moral of the story is, I

chose a half measure when I should have gone all the way," Mike says. "I'll never make that mistake again. No more half measures."

And during season 1 of *Better Call Saul*, we see that Mike is willing to play a major role in Jimmy's theft of the Kettlemans' money, but declines to rip off Jimmy when he has the chance. When Jimmy expresses amazement at Mike's decision not to do so, Mike responds that participation in the job that he was hired to do is "as far as it goes." Half measures, indeed.

Other examples abound. In the fourth season of *Breaking Bad*, Mike hogties a junkie who stole Jesse Pinkman's money, but he does not kill or even harm him. In another episode of *Breaking Bad*, he declines to kill Lydia Rodarte-Quayle even though she put a hit out on him. In *Breaking Bad's* season 5 episode "Live Free or Die" (2012), Mike expresses his opposition when he (mistakenly) believes that Walt is proposing to kill cops in order to destroy evidence contained on a laptop. In *Better Call Saul's* season 2 episode "Gloves Off" (2009), Mike considers a request from Nacho to kill Tuco. Mike asks questions about the crime, engages a gun dealer, and appears to be on his way to committing the murder in exchange for a $50,000 payment. Ultimately, Mike decides not to fulfill Nacho's murder plan; instead, he stages a scene to anger Tuco, provoking Tuco to punch Mike's face repeatedly after ensuring that the cops will arrive and catch him in the act. Tuco will be locked up, but because he remains alive, Nacho only pays Mike $25,000. Nacho is stunned and confused by Mike's decision to suffer the physical harm while giving up half of his pay. The audience is left to wonder whether Mike is simply afraid of getting caught for the murder or whether he refuses to kill because of his moral code. And then, in "Nailed," Nacho is similarly stunned that Mike hogties a driver without

harming him at all. Nacho declares that Mike is "the guy who won't pull the trigger." While we know that Mike has committed murder previously—as he killed his son's murderers—perhaps Mike's moral code demands that he spare those with whom he does not have a personal issue. Mike is a complex man, and his thoughts on morality merit examination.

Mike demonstrates empathy for undeserving victims of murder. In "Nailed," Mike learns that Hector shot and killed a good Samaritan who alerted Nacho and Hector about the man that Mike had tied up and stolen from at the beginning of the episode. Hector's only reason for killing the man is to tie up any loose ends and eliminate the possibility that a third party has any knowledge of Hector's criminal drug enterprise. Mike feels guilty for creating the circumstances that led to the murder of an innocent man and seeks to avenge the man's death. Mike is going to go after Hector hard. And during season 5 of *Breaking Bad* (2012), he is visibly angry at associate Todd for killing an innocent young child (and potential witness to their crimes) in cold bold. Mike demonstrates that he does not have too much of an issue with murder per se, but he believes only those who have acted wrongly should become victims of such a crime.

Mike also feels a strong sense of duty to fulfill obligations he has agreed to. For example, after convincing Hector Salamanca to pay him $50,000 to recant his story to the cops about Tuco's ownership of the gun, Mike gives $25,000 to Nacho (without even a request from Nacho) because Mike feels guilty about not keeping up his end of the bargain by ensuring that Tuco wouldn't be locked up for an extended period of time. Mike appears to place great value on keeping up his end of the bargain, irrespective of the nature of the deal itself.

It is from this perspective that we can consider Mike's

system of values in connection with the code employed by protagonist Dexter Morgan on the Showtime series *Dexter*. Dexter is a deeply disturbed individual who possesses an unquenchable thirst to kill people. His stepfather, Harry, ties this murderous desire to a specific code, namely the "Code of Harry." The Code of Harry demands that Dexter only kill those individuals who have killed others. While Dexter's murders are not morally justifiable in the eyes of Harry (or Dexter, for that matter), the Code of Harry at least protects the innocent from death at the hands of an otherwise unhinged Dexter. The series hints that Dexter would likely receive praise from some members of society—by eliminating the bad guys, he prevents them from committing future murders. The show asks its audience to consider whether killing a murderer can somehow be considered heroic—or at least morally justifiable, perhaps under a somewhat perverted form of utilitarianism—if it results in fewer lives lost in the long run. And the series further has us question whether Dexter himself is a hero, even if his motivation does not stem from protecting the innocent or avenging their deaths.

For Dexter, adherence to the Code of Harry is nearly sacrosanct, but not because he believes it imbues him with heroism. He follows the Code in order to act within a framework, not because he independently believes that it possesses any inherent moral value. In Dexter's view, following the Code is required for him to function as an individual in society. At best, it allows him to find some legitimacy in the murders, but Dexter would readily admit that such legitimacy is not within the parameters of any moral agenda. Dexter is still a serial killer; he considers himself to be a monster; and he typically does not heap praise upon the Code itself. It serves as his way of living and it is important to him, but he knows that the murders that he commits

are morally wrong. Mike might well consider Dexter to be a "good criminal" in that he strives not to deviate from a specific code, flawed though it may be. Mike follows a code that's similar in style when he follows Jimmy's plans to steal the Kettleman money (a morally questionable action) but is not willing to deviate from it for further personal again (i.e., stealing the money for personal use). Despite the murders that he commits, Dexter does have a sense of integrity: he places value in following the parameters of the code that his stepfather has established. Mike, too, demonstrates a sense of integrity as he follows a particular plan of action.

Irrespective of the substantive nature of his actions, Mike might praise Dexter for living a life with some boundaries: Dexter might kill a murderer, but he will not (knowingly) kill an innocent person. For this reason, Mike, if pressed, *might* consider Dexter's murders to be honorable, at least in some sense. Even though avenging the murders of innocent persons is not the main reason for his actions, such vengeance is the *result* of Dexter's actions. Perhaps the motivation behind the action is not as important as the end result. And perhaps Mike would even value the very process of following through with a plan, irrespective of the dark nature of said plan. One could imagine Mike telling Dexter to create a plan, follow through with it, and avoid distractions along the way. Such direction would not be so far from the Code of Harry, even though the Mike that we initially meet in *Better Call Saul* would not condone the murder of those with whom he does not have a personal vendetta.

Kaylee and Honesty

Mike appears to adhere to an imperfect moral code, and it is sometimes unclear where his priorities and motivations lie. Mike is very focused on earning money to support

his granddaughter, Kaylee. On *Breaking Bad*, we learn that he has deposited $2 million into an offshore bank account in Kaylee's name, [37] and it becomes apparent that Mike does not do the things he does for his own personal benefit. He is not concerned with his legacy or material possessions. He loves his granddaughter, and he feels responsible for the loss of her father (i.e., Mike's son). And he is willing to do some awful deeds in order to provide for her future.

In a promotional trailer preceding season 2, Jonathan Banks (the actor who portrays Mike) observed that "If Mike were to tell you about his moral code, he'd say it's pretty flawed."[38] Mike has opined (if indirectly and inadvertently) on the contours and parameters of certain elements that may comprise heroism. Mike distinguishes the concept of honor (or *time*, a fundamental part of the Greek conception of a hero) from criminality. He appears to value honesty above all else—with the possible exception of providing for Kaylee.

We learn, of course, that Mike frequently does not act honestly. *Better Call Saul* provides myriad examples. For example, he feigns drunkenness in order to lure two cops into believing that he is an easy target (before killing both of those cops), and after the murders, he tells detectives (in "Five-O") that he does not know anything about their deaths. He then directs Jimmy to spill coffee on those detectives, steals the detectives' notebook, and participates in the lie about the detectives dropping their notebook and Jimmy finding it in the parking lot. We also learn that Mike was a dirty cop, as he took money retrieved from drug dealers while he was an active member of the Philadelphia police force.

It is possible that Mike learned the value of honesty from his deceased son, Matty, as his son fought hard not to succumb to the pressures of becoming a dirty cop. Mike

is an emotional wreck when he retells Matty's story to his daughter-in-law. He accepts the blame for Matty's death, tearfully acknowledging to his son's widow, "I broke my boy." Once Matty learned about Mike's actions and realized that his own father could not withstand the pressures of a corrupt police department, he had no choice but to reluctantly succumb to the pressure himself, if only to be viewed as a team player. Mike actively convinced him to take the dirty money, and the dirty cops killed him anyway simply because they sensed his hesitation. On a broader level, Mike's emotional account foreshadows how the downfalls of both Walter White and Saul Goodman will affect others. Mike's misdeeds stained Matty, and led to Matty leaving a wife and a child behind. Walter White's misdeeds led to immense destruction and death among his family, friends, and others. And Saul's descent will lead not only to his own misery, but also, we would surmise, the misery of those that he built relationships with back in his Jimmy McGill days.

Mike may have learned lessons from his son, but his actions do not always match his words. Even so, Mike does seem to view (in word and sometimes in deed) keeping one's word as a fundamental component of one's character, or true, defining nature. He also views integrity as essential to one's character. In "Five-O," he forcefully and desperately conveys to Matty's widow that Matty was not a dirty cop. It is extremely important to Mike that Matty be remembered as a man of integrity.

Mike's most poignant discussion of criminality, honesty, and integrity comes in *Better Call Saul*'s "Pimento." He states:

I've known good criminals and bad cops, bad priests, honorable thieves. You can be on one side of the law

or the other, but if you make a deal with somebody, you keep your word. You can go home today with your money and never do this again, but you took something that wasn't yours and you sold it for a profit. You are now a criminal. Good one, bad one, that's up to you.

Interestingly, Mike views the specific act giving rise to criminality (such as theft) as having little to no effect on a person's *character*. One can be defined as a "criminal," but still retain honor by keeping one's word (although one committing criminal acts of fraud would find it quite difficult to retain honor under Mike's definition of the term). One will forever be defined as a "criminal" for performing the bad act, but Mike places much more value in the honesty of the individual. It is such honesty, in Mike's view, that builds character and demonstrates integrity—not the bad acts that the individual performs. Note that Mike also expresses this sentiment when Jimmy asks why Mike did not push to steal the Kettlemans' money: Jimmy had hired him to do a job (i.e., remove the money from the Kettleman home), and that he views the fulfillment of his job as an honorable act. Mike has no problem ignoring the *substance* of the act that he is hired to perform; rather, he is more focused on maintaining his *character*, which requires completion of the job that he has agreed to perform. Mike would not even consider deviating from the task at hand because his one mission is fulfilling the job that he has agreed to do— deplorable as it may be. Here, Mike might argue that his failure to steal the Kettlemans' money was not an example of a half measure; rather, it was total completion of the agreed-upon mission.

Reasonable observers can vigorously debate the methods behind Mike's madness. It is not clear why, in Mike's view,

building and maintaining one's character demands honesty and keeping promises but permits criminality. Still, Mike's words and (some of his) actions lead us to the following question: can it be the case that a criminal who keeps his word may be considered "heroic" if keeping his word is so inconvenient and difficult that it results in admiration from onlookers? If heroism is defined as engaging in actions that are deemed both difficult and praiseworthy, one can imagine a scenario in which a person is admired, despite engaging in nefarious actions, because the person makes (and keeps) a difficult promise. Mike may well view such an individual as possessing strong, even heroic, character. An honest lawyer who advocates for his clients despite performing reprehensible actions may be considered a hero in Mike's book. Now if only Saul could work on the honesty part…

Hero or Just an Angry Young Man?

Jimmy McGill/Saul Goodman is the type of character that we have encountered in the course of our popular culture, albeit in different contexts, in the past. American songwriters, for example, have provided commentary on those who have rebelled against the cultural and moral norms to which most of us seek adherence. Furthermore, we have witnessed many figures throughout history who have refused to accept (or respect) authority, ranging from Socrates's proclamation that "the unexamined life is not worth living" to *The Simpsons'* frequent subversion of authority by its critiques of elements of our societal institutions.[39] There is something intriguing about those who independently fight battles and wage war—in Saul's case, against the workings of the American criminal justice system—against authority. Police and prosecutors view Saul as a pest; the television audience views him as a crooked thief. But to his clients, Saul is a potential savior.

His fierce battles against officers who have overstepped
their boundaries in order to make arrests, for example,
are legendary and important for society at large. Even if
Saul's own motivations for performing these actions are
not noble, he is a hero to his clients.

In his song "Prelude/Angry Young Man" (from his 1976
Turnstiles album), Billy Joel sings of a man that, at least in
some respects, calls to mind our favorite attorney. Saul is
a champion of those clients that society has turned against
(often for good reason) and fervently declares that he will
not let those in positions of authority push him or his clients
around. In Saul's very first appearance on *Breaking Bad*,[40]
he walks into a room in a police station where a young
detective is questioning Badger, Saul's new client. He angrily
admonishes the detective for talking to Badger:

> What are you doing, Detective? What are you doing
> talking to my client without me being present? You
> sneaky Pete!... You—out—ten minutes ago! Go on.
> There are laws, Detective—have your kindergarten
> teacher read them to you!

Saul fights for the underdog. By kicking the detective
out of the room, he appears, at least from the perspective
of Badger, to shift the power dynamic in Badger's favor.[41]
Faced with the prospect of representing those that society
despises, Saul must show his anger and be as assertive and
aggressive as possible when standing up on their behalf. He
will not win every battle, but the lessons resulting from
those wounds and losses will help him represent other
alleged criminals in the future.

Saul is a man that, somewhat reminiscent of the indi-
vidual depicted in the words of Billy Joel, is backed up
against a wall and is unwilling to budge or beg for forgive-

ness, despite losing some fights. He likely has some degree of pride in fighting for the underdog, even if his agenda is less clear than the "angry young man" who serves as a crusader for particular causes.

As demonstrated by his breakdown in the bingo hall, Jimmy arguably becomes the "angry young man" that Billy Joel speaks of as a direct result of Chuck's betrayal.[42] As Peter Gould has stated, we know that Jimmy McGill has decent intentions: he wants to eke out a reasonable livelihood by representing clients who need him. Like Jimmy, Billy Joel's "angry young man" is often misunderstood and feels betrayed but possesses a warm heart.

The transformation of our arguably heroic Jimmy McGill—the lawyer who returns the money stolen by the Kettlemans (albeit by illegal means) and advocates to save the lives of young men in the dangerous run-in with Tuco and Nacho—into the meth-peddling, money laundering Saul Goodman is concurrent with Jimmy becoming more agnostic about his role in promoting the cause of justice. He is dismayed that he does the "right thing" by returning the Kettlemans' money only to have his brother treat him as though lawyer Jimmy is the old Slippin' Jimmy. If Jimmy is going to "do the right thing," he wants to at least receive some degree of admiration from those around him—let's call it a side benefit of promoting justice. Once Jimmy learns that he does not receive that admiration for engaging in the normal course of action, he shifts his focus to survival (by almost any means necessary). He has become a lost soul and the transformation into Saul is inevitable. And once he becomes Saul, we are unsurprised to hear him declare to his clients (in the "Better Call Saul" episode of *Breaking Bad*) that "Conscience gets expensive, doesn't it?" It seems that the cost of doing the right thing is too high considering the low return. Once he transforms into Saul, he no longer

cares about right versus wrong and is more interested in securing his own destiny. This is one angry young man.

Conclusion

Ultimately, whether we determine that our favorite lawyer possesses heroic and/or antiheroic traits and characteristics, the main takeaway is that he represents different things to different people. He can simultaneously be seen as a gimmicky charlatan by distinguished members of the legal profession (such as Chuck); a formidable opponent to his adversaries (such as Jesse's parents' real estate lawyer); an angry young man (to fans of classic Billy Joel songs); a sincere companion (and more) to others (such as Kim); and a zealous advocate to his clients and other associates (such as Walt, Jesse, and the skateboarding lackeys). From our perspective, he is quite simply our favorite lawyer—one from whom we can learn a great deal every time we pick up the phone and call Saul.

Notes

1. Note that the fourth episode of *Better Call Saul* is entitled "Hero."
2. Steven Keslowitz, *The Tao of Jack Bauer: What Our Favorite Terrorist Buster Says About Life, Love, Torture, and Saving the World 24 Times in 24 Hours With No Lunch Break* (Bloomington: iUniverse, 2009), 104–105.
3. See Kimberly Potts, "'Better Call Saul' Writer Talks Jimmy's Legal Skills, That Dumpster Scene, and What Caused Chuck's Illness," *Yahoo! TV*, March 24, 2015, https://www.yahoo.com/tv/better-call-saul-gordon-smith-interview-rico-114490318520.html.
4. "Better Call Saul"; "Cast and Crew"; "Jimmy McGill"; AMC, http://www.amctv.com/shows/better-call-saul/cast/jimmy-mcgill-saul-goodman.

5. Dean A. Miller, *The Epic Hero* (Baltimore: Johns Hopkins University Press, 2002), 1.

6. See Anne Klinefelter and Marc C. Laredo, "Is Confidentiality Really Forever: Even if the Client Dies or Ceases to Exist?" *Litigation* 40 (Spring 2014), Number 3, http://www.americanbar.org/publications/litigation_journal/2013-14/spring/is_confidentiality_really_forever_even_if_client_dies_or_ceases_exist.html.

7. Swidler & Berlin v. United States, 524 U.S. 399 (1998).

8. Ibid., 407.

9. Dan Slater, "60 Minutes Reports Legal Ethics Head-Scratcher," *The Wall Street Journal*, March 10, 2008, http://blogs.wsj.com/law/2008/03/10/60-minutes-reports-legal-ethics-head-scratcher/?mod=djemWLB&reflink=djemWLB.

 Wilson's attorneys stated that had Logan received a death sentence by a court, they would have broken the privilege so as to save his life. They would have relied on the applicable exception to the privilege that permits (and in some jurisdictions, mandates) disclosure in order to prevent bodily harm.

10. "26-Year Secret Kept Innocent Man in Prison: Lawyers Tell 60 Minutes They Were Legally Bound From Revealing Secret," *60 Minutes* report by correspondent Bob Simon, *CBS News*, March 9, 2008, http://www.cbsnews.com/news/26-year-secret-kept-innocent-man-in-prison/.

11. Ibid.

12. Manjari Singh and Mei-Yu Lu, *Exploring the Function of Heroes and Heroines in Children's Literature from Around the World* (*ERIC Publications*, 2003).

13. Even in *Better Call Saul*, we see that money is a motivating factor for Jimmy. In the very first episode ("Uno"), Chuck tells Jimmy (in regards to Jimmy's low-paying public defender work) that "The money is beside the point," to which Jimmy responds, "Money is not beside the point. Money *is* the point."

 And this greed only becomes more pronounced as Jimmy transitions into Saul Goodman. (Interestingly, Chuck argues that the public defender work will be a good experience for Jimmy but, as we come to learn, there is virtually nothing that Jimmy can do to impress Chuck).

 Still, Saul's agenda is much less clear than, say, that of Lionel Hutz on *The Simpsons*. Hutz absolutely did not join the

legal profession in order to help clients. His only care is his own reputation. Hutz declares to a client (Bart Simpson), for example, that "I'll be defending you on the charge of...murder 1! Wow! Even if I lose I'll be famous!" (Season 3, "Bart the Murderer," 8F03, 1991). In the season 4 episode "Marge Gets a Job," Hutz declares that Marge Simpson's "sexual harassment suit is exactly what I need to rebuild my shattered practice." (Episode 9F05, 1992.)

14. "Tragedies", Hudson Shakespeare Company. Hudsonshake-speare.org/Shakespeare%20Library/Ful%20Text/text%20tragedies/tragedies/htm.

15. Lee Jamieson, "Shakespeare Tragedies: Introducing the Shake-speare Tragedies," About Education, updated May 1, 2015, http://shakespeare.about.com/od/thetragedies/a/Shake-speare_Tragedies.htm.

16. Definition of "noble," *Oxford English Living Dictionary*, en.oxforddictionaries.com/definition/noble.

17. Kimberly Potts, "'Better Call Saul' Postmortem: Peter Gould Talks Where Jimmy Will Be in Season 2," *Yahoo! TV*, April 17, 2015, https://www.yahoo.com/tv/better-call-saul-producer-writer-talks-season-1-115773934500.html.

18. On the other hand, if Jimmy had never cared about pleasing Chuck, perhaps he would never have tried to turn his life around in the first place.

19. See "Quote by Ralph Waldo Emerson," Quotery, http://www.quotery.com/quotes/the-only-person-you-are-destined-to-become-is-the/.

20. Niccolò Machiavelli, *The Prince* (Signet edition, 2008; origi-nally published in 1532).

21. Nicole Hyland, "Episode 4 (Hero)," The Legal Ethics of Better Call Saul, http://ethicsofbettercallsaul.tumblr.com/post/113976861151/episode-4-hero.

22. Ibid.

23. Ibid.

24. Ibid.

25. For further discussion of Mill and Bentham's conceptions of this philosophical principle, see Garth Kemerling, Philosophy Pages, http://www.philosophypages.com/hy/5q.htm.

26. Immanuel Kant, *Grounding for the Metaphysics of Morals: with*

On a Supposed Right to Lie because of Philanthropic Concerns.
Cambridge: Hackett Publishing Company, Inc. 3rd edition,
1993, originally published in 1785.

27. Brandon K. Hampton (the actor who portrays Ernesto) told
me that believes that Ernesto knows what he is doing. "When
Chuck gives him explicit orders not to leave and Jimmy comes
and he leaves (knowing the dynamic between them), he knows
something. Some angle being played. I would have said 'Jimmy,
I understand, but he said not to leave so I'm here for both of
you'...But Ernesto had other plans."

 Brandon believes that Ernesto is "in a real position of
power" in that he knows the truth about what Jimmy did,
and also has intimate knowledge about what Chuck thinks of
Jimmy. Brandon believes that Chuck has "confided in Ernesto,"
and that sentiment is evidenced by Ernesto's declaration to
Jimmy in "Klick": "I don't know, man, your brother, the way
he's been talking about you lately, he's really out to get you."

28. Glenn Whipp, "Michael McKean knows the pain inside his
spiteful 'Saul' character," *Los Angeles Times*, June 14, 2016,
http://www.latimes.com/entertainment/envelope/la-en-st-
michael-mckean-better-call-saul-emmys-20160614-snap-story.
html.

29. We do not know what year Mrs. McGill died, or at what stage
of life Jimmy was in. But we do know that he was not locked
up at that moment for the Chicago sunroof incident!

30. Inside the Better Call Saul Writers Room panel, the Writers
Guild, Beverly Hills, California, May 26, 2016.

31. Rebecca's connection with Jimmy dismays Chuck, who feels
the need to thank Rebecca for spending an evening with his
younger brother. In other episodes, Chuck acknowledges
Jimmy's common touch, observing that Jimmy "certainly has a
way with people," and that many people feel affection toward
him. Chuck fears the consequences of such affection: when he
peers through his window and sees Ernesto talking to Jimmy,
he looks thoroughly frightened. And as he watches Kim and
Jimmy grow closer, he realizes that his warnings to Kim about
the potential deleterious effects of Jimmy's behavior have gone
unheeded.

32. As Brandon K. Hampton states, "When we first meet Ernesto

in the mailroom in season 1, we see his excitement for his friend becoming an attorney and moving up in life." May 2016, response to my interview questions.

33. When I asked Brandon K. Hampton his thoughts on the matter, he stated that Ernesto's action was "a power move" and that Ernesto was "cunning" and "positioning himself in a way now [in order] to reap benefits later. When we look into the *Better Call Saul* and even *Breaking Bad* world[s], we see characters wanting power. Everyone wants it in some capacity. I think et tu Ernesto. He is the only one who knows the absolute truth. Knows all the angles to Chuck and the angles to Jimmy…The power is playing the fool."

34. Chuck did not even ask Ernesto for confirmation. Rather, it was Ernesto's decision to speak up and contradict Chuck.

35. When Jimmy asks Ernesto why he lied, Ernie responds that Chuck is really out to "get" Jimmy, and that Jimmy is Ernie's "friend." Ernie sees and hears much more than we know, as he is around Chuck a great deal of time.

36. Chuck, of course, is not fooled, and is both angry and jealous about the undeserved adulation that Jimmy receives. Jimmy attempted to hide the paper from Chuck (knowing that Chuck would strongly disapprove), but failed to do so. Jimmy's attempt to allay Chuck's concerns upon seeing the newspaper ("Just showmanship, Chuck"), before sheepishly mumbling, "yeah, right" to himself, fails. In the following episode, Chuck is seen stepping on the newspaper with Jimmy's photo on the front page. For Chuck, the means of achieving success is important—not so, from Jimmy's perspective.

37. In "Blood Money," a season 5 episode of *Breaking Bad* (2012), Jesse Pinkman also attempts to give his $5 million to Kaylee, likely because he wants the "blood money" he made through drug dealing to be put to good use.

38. Katia Kleyman, "'Better Call Saul' Season 2 Preview Unseen Footage, Vince Gilligan and Bob Odenkirk Comment," *Design & Trend*, January 20, 2016, http://www.designntrend.com/articles/68675/20160120/better-call-saul-season-2-promo-video-new-clips-vince-gilligan-bob-odenkirk-commentary.htm.

39. For further discussion of Socrates's and the Simpsons' subversion of authority, please see my previous book, *The World*

According to *The Simpsons: What Our Favorite TV Family Says About Life, Love, and the Pursuit of the Perfect Donut,* (Naperville: Sourcebooks, 2006) 23.

40. *Breaking Bad,* season 2 ("Better Call Saul," 2009). We first learn of Saul Goodman's existence earlier in the episode. Jesse's meth-peddling lackey, Badger, is sitting on a bench covered with a "Better Call Saul" advertisement. Badger attempts to sell meth to an undercover cop and is promptly arrested. Later in the episode, we see one of Saul's tacky commercials. Badger hires Mr. Goodman for legal representation.

41. Detectives are required to allow arrested individuals to exercise their right to have an attorney present for any discussions. An arrested individual may waive this right, but if he or she requests legal representation, the conversation between the detective and individual must end until the lawyer arrives.

42. That is not to say that Jimmy did not engage in any fits of rage before he learns of Chuck's betrayal. We see him become quite frustrated as a result of "doing the right thing" by returning the Kettlemans' money. He knows that he will not be able to afford the rent for a spacious office to host his law practice and angrily kicks a metal garbage can, denting it in the process.

Law and Lawyers in Popular Culture: How Saul Goodman Breaks the Mold

BETTER CALL HUTZ!

For a host of reasons, lawyers are a popular target of critique, ridicule, and satire in popular culture. Sometimes lawyers are depicted in a positive light. Frequently, however, they are portrayed not as a conduit for obtaining justice and seeking the truth, but rather as an impediment, a road-block that stands in the way of achieving such noble goals. A criminal defense lawyer may be shown helping to obtain the freedom of a nefarious individual. A prosecutor may be depicted as overreaching, a person willing to engage in deceit in order to achieve a particular end. Each side may be portrayed as directly or indirectly lying and engaging in

improper behavior in order to further their careers—at the expense of clients, society, or both. Lawyers are routinely depicted in popular culture as sneaky, devious, dishonest, and otherwise unethical.[1] Such portrayals are anathema to the ideals that are promulgated by bar associations charged with regulating the actions and omissions of attorneys. The portrayals have engendered a deep-seated mistrust of lawyers in the eyes of both lawyers and society at large. Lawyers are commonly viewed as cunning, slick, and deceptive. And if an individual hires a lawyer for representation, he or she might be disappointed upon learning that her lawyer is one of the honest ones, perhaps not willing to violate ethical rules in order to beat the system or match the cunning of opposing counsel.

Most lawyers are not as unethical as these portrayals. But the perception that popular culture has engendered, through exaggerated depictions of the actions of a few fictional characters, persists. Portrayals of heroic lawyers are likely also overstated: there are probably no defense lawyers in the real world who have handled as many difficult cases as Ben Matlock and have an impeccable record of success (particularly while adhering so closely to strict ethical rules and principles).

Extreme depictions of law and lawyers can have a demonstrable influence on the way in which they are perceived by the public. Sometimes the law and the lawyers charged with analyzing and using such law are portrayed as fundamentally inadequate and out of touch with reality. In my study of the television series 24, a show which is focused on a federal super-agent determined to prevent terrorist attacks, I argue that the law is portrayed as weak and inflexible on the series:[2] it is wholly inadequate to deal with the show's specific high-stakes scenarios. Its protagonist and terrorist-buster, Jack Bauer, "is willing to break

the law in order to perform those actions that he believes are necessary to save the United States from harm."³ Bauer is "often unable (and unwilling) to conform his actions to the requirements of the law."⁴ Jack Bauer is rightfully (and nearly universally) perceived as a hero. And it may be argued that his willingness (sometimes, eagerness) to act outside of the parameters and constraints of the law contributes to this popular perception. His decision to break the law in order to achieve a "greater good" endears him to the viewing public. 24 may not go so far as promoting fundamental changes to our legal system, but it does hint at its inadequacy with respect to dealing with terrorism. In one episode, for example, a lawyer associated with the fictional Amnesty Global stops by the Counter Terrorist Unit (CTU) in order to prevent the torture of a suspected terrorist.⁵ The human rights lawyer is viewed by Jack Bauer (and much of the audience) as a nuisance, a mere pest standing in the way of our hero's quest to prevent a terrorist attack. We want Jack Bauer to solve a problem, and it is the pesky lawyer whose intervention threatens to bring the entire operation down. Still, the audience is reminded that lawyers have a job to do, and that there is merit in upholding the law and representing clients in a zealous manner.⁶

Saul Goodman takes this premise to its inevitable extreme. He is much more than a pest standing in the way of victory by the cops and the prosecution. He takes on those interests not to achieve the laudable objective of upholding the law and keeping the prosecution on its toes; rather, he wants to achieve victory at all costs so that his shtick can be enhanced by victories. Saul could likely not care less about any societal benefit resulting from his actions. While the public (sometimes begrudgingly) acknowledges that it is the role of certain lawyers to represent interests that most would deem abhorrent, the public also demands that such

advocacy and representation be performed in a scrupulous, ethical manner. This demand is at its firmest when lawyers are tasked with representing alleged terrorists, murderers, and evil corporations; as a practical matter, the public (though, we would hope, not the judiciary in a society based on the rule of law) oftentimes views the demand as perhaps less rigid when the prosecutor attempts to bend the law in order to achieve a laudable result. Because Saul invariably represents the lowest of the low, his ethical and moral bankruptcy is rightfully seen as particularly abhorrent. Saul is not attempting to make a political statement by zealously advocating for the scum of society. Instead, he lies, cheats, bends, and even breaks the law to achieve a winning result for his client. Saul cares not for upholding the law, and he is rightfully condemned by the audience.

As I wrote previously, "24's break from the strict constraints of the law in desperate situations serves as an equitable contrast to the constraints of existing law."[7] The point here is that the law may be the official rule of the land, but it may not hold all of the answers. The law may be respectfully disregarded by those we consider heroes (such as Jack Bauer) and manipulated by others (such as Saul Goodman) to achieve a particular end. Depending on one's role in society and individual perspective, the law can be seen and used as either a tool or an impediment. If we start from the premise that the law can be bent (perhaps, at times, justifiably so) in order to achieve a particular goal, we can take a more nuanced look at the actions of Saul Goodman.

Even when we consider all of the extreme depictions of lawyers, we conclude that it is rare for a television series to feature one who is as evil and ruthless as Saul Goodman. In Saul, we see some of the traits exhibited by other lawyers that have been portrayed in television and movies, but Mr. Goodman often seems like the amalgamation of some of

those characters on dangerous and powerful steroids. Saul violates many ethical rules in the course of his practice— telling clients how to commit crimes; betraying their trust; manipulating fees; engaging in deception, lying, and fraud; demonstrating incompetence; making up evidence; acting with too much zeal; and the list could go on.[8]

In my article "*The Simpsons, 24, and the Law: How Homer Simpson and Jack Bauer Influence Congressional Lawmaking and Judicial Reasoning,*"[9] I argue that that television shows and movies relating to and/or depicting law can be educational and influence our notions of law. I also posit that our popular culture has an impact on how law is made and interpreted in the United States. For instance, members of Congress have invoked the economic status of Homer Simpson and Mr. Burns in debates over tax laws, and the late Supreme Court justice Antonin Scalia made reference to Jack Bauer when debating the legal defensibility of torture with a group of judges in Canada. Viewers' perceptions of lawyers are likely influenced by elements of our popular culture as well.

Because most members of a viewing audience only have rudimentary, fleeting interactions with the legal system (perhaps serving on a jury at one point or another, or being a plaintiff or defendant in small claims court), it is likely that perceptions of the American legal system come directly from sources in popular culture, such as television and movies. Legal scholar Michael Asimow argues that "pop culture reflects what people actually believe...[and] serves as a powerful teacher, instructing millions of its consumers about what lawyers do and how legal institutions function."[10] He concludes that "Media *always* influences and affects those that consume it."[11] Elayne Rapping, another legal scholar, goes even further, arguing that "fictional programming actually has a much greater influence

than the news on how people view the legal system."[12] Legal scholar Charles B. Rosenberg observes such a close connection between legal TV shows and perceptions of the law in contemporary society that he "used to think the question at issue very much resembled the chicken-and-egg conundrum: are legal TV shows the chicken or the egg? In recent years, however, I have come to think that the best one can say is that the entire thing has become an inseparable chicken scramble."[13]

Building on these principles, popular culture and legal scholar Dr. Kimberlianne Podlas discusses "cultivation theory," which posits that "the overall pattern of television programming to which viewers are exposed cultivates in them common perceptions of reality."[14] Under cultivation theory, "[t]his 'reality' tends to mirror what viewers see on the TV screen. Therefore, people who watch a great deal of television will come both to perceive the real world to match the one on TV and adopt attitudes conforming to that visage."[15] This theory "divides the world into 'heavy' and 'light viewers,' and investigates the influence of media messages on society as a whole."[16] Podlas observes that "cultivation is not an incremental influence, but a presumed effect of significant viewing."[17] With a plethora of examples of lawyers in action, television and movies have a direct impact on how the audience perceives our legal system. Oftentimes, lawyers are portrayed in highly dramatic courtroom scenes (either real, such as intense moments on episodes of *Dateline* or *48 Hours*, or fictional, such as dramatic episodes of *Law & Order*). Because the majority of viewers' exposure to the legal system comes directly from popular culture, it is important to examine and understand the impact of such exposure on viewers' perception of lawyers in action.

Challenging Cultivation Theory

Saul Goodman challenges the validity of "cultivation theory." We might argue that TV audiences have at least *some* knowledge of how a typical lawyer operates, whether so informed by personal experience or popular culture. When lawyers are depicted in an extreme manner (à la Saul), such audiences may realistically conclude that such lawyers are outliers. Saul's actions are so outlandish that they should be identified as unrealistic by the audience. And, going further, if the audience is able to identify the glaring exaggeration and absurdity that is Saul Goodman, it might surmise that other depictions of lawyers in popular culture are also heavily distorted, or at least consider the possibility. Viewers may question their previously conceived notions of attorneys, thereby turning cultivation theory on its head. Instead of building on and reinforcing commonly held perceptions of lawyers, it is the extreme example that can lead to viewers' rejection of television as a medium from which they can view realistic lawyers in action. Astute viewers may react to Saul Goodman by overtly dismissing and rebelling against everything they may have thought they had learned about lawyers on TV and in movies. Watching Saul Goodman in action can be eye-opening, as viewers may come to realize that other pop culture elements likely depict lawyers in exaggerated ways for dramatic effect (not to mention higher ratings).

Ethical Rules Regarding Dishonesty, Incompetence, and Lack of Self-Interest

Real-life lawyers are subject to strict rules and regulations regarding their behavior as it relates to the practice of law. The legal profession has taken significant measures to reinforce this perception, requiring strict adherence to

a robust system of ethical rules regarding attorney honesty and integrity, and requiring law students to complete a legal ethics class while in school. Lawyers are required to provide competent representation to their clients and to advocate zealously on their behalf. Dishonesty, mixed motives, and acting out of one's self-interest are forbidden. Attorneys are required to uphold the dignity of the profession. As is too often the case in real life and in our popular culture, however, some attorneys fail to satisfy these basic requirements.

Temptation: Eating the Forbidden Fruit

Even when a lawyer intends to act honestly, he or she may be confronted with ethical challenges presented because of a client's strong desire to act dishonestly—and to engage the attorney as part of a nefarious scheme. While attorneys are obviously prohibited from participating in or furthering their clients' illegal schemes and plans, they are often presented with situations that test their ability to practice law in an ethical manner. Jimmy McGill is presented with this challenge several times during the first season of *Better Call Saul.* And these challenges lead Jimmy to question his approach to the practice of law. He blurs the line between Slippin' Jimmy and attorney Jimmy: while Jimmy attempts to use "attorney Jimmy" as a means to separate his improved self from his former persona, the immorality of his clients contributes to the lack of segregation and the reintroduction of immorality into his life. While attorney Jimmy is by no means an outstanding model of morality, there are lines that he would not consider crossing if not for mischievous clients. For example, the Kettleman couple places significant pressure on Jimmy to participate in their grand larceny plan and subsequent cover-up. While Jimmy ultimately does "the right thing," he teeters, and later laments that he

did not steal the money from them for his personal benefit when he had the opportunity to do so. Jimmy also acquiesces to Mike's request that Jimmy spill coffee on a police detective so as to cause a distraction and allow Mike to steal the detective's notebook. While Jimmy seeks to provide Mike with ethical representation, it is pressure from Mike that causes Jimmy to act in this manner. As we will see as Jimmy evolves into Saul, this character will embark on such unethical misadventures even without the pressure of clients.

Dishonest Lawyers

The movie *Liar Liar* (1997) depicts Jim Carrey's lawyer protagonist as so dishonest that he is unable to operate honestly. Placed in a position where he is physically unable to lie, the attorney cannot speak effectively in court or interact with his family and coworkers. It is no mistake that the movie's producers chose "attorney" as the protagonist's profession. On *The Simpsons*, we see quack attorney Lionel Hutz advise Bart Simpson to lie on the stand and wear a cast in order to greatly exaggerate injuries from a car accident in the season 2 episode "Bart Gets Hit by a Car."[18] While Saul's schemes are often more complex than telling a lie in a court of law, there is no question that he is not the first fictional attorney to act dishonestly.

Incompetent Lawyers

Sometimes lawyers are depicted as incompetent. In the film *My Cousin Vinny* (1992), for example, newly minted lawyer Vincent Gambini represents his defendant cousin in a murder case. Vinny has never tried a case. Although there is no express prohibition on members of the bar practicing a particular type of law (with certain limited exceptions, such as patent law)—irrespective of the stakes involved

in a specific case—no responsible lawyer would take on a murder trial as his or her first case. Although Vinny uses his significant street smarts to ultimately win, there is little question that he has violated the American Bar Association's Rule 1.1, which requires attorneys to provide competent representation to clients:

> A lawyer shall provide competent representation to a client. Competent representation requires the legal knowledge, skill, thoroughness and preparation reasonably necessary for the representation.[19]

This rule can serve as a catchall, given the absence of express prohibitions on practicing a particular type of law without possessing adequate experience or knowledge. During the film, Vinny demonstrates his lack of familiarity with evidentiary, discovery, procedural, and criminal rules and laws. Had he lost the case, his nephew would have had a very strong argument that he received "ineffective assistance of counsel."[20] His Sixth Amendment right to counsel in a criminal case would have been violated, and he would likely be able to receive a new trial.

On *The Simpsons'* season 5 episode "Treehouse of Horror IV," attorney Lionel Hutz attempts to assuage the fears of client Homer Simpson by declaring, "Mr. Simpson, don't you worry. I watched *Matlock* in a bar last night. The sound wasn't on, but I think I got the gist of it."[21] (Note also that Jimmy McGill also watches *Matlock* in order to mimic his style of clothing to attract elderly clients.)

Hutz's incompetency is further examined when, acting as a criminal defense attorney, he incorrectly states that "I rest my case." And his incompetency is on full display during an exchange with Judge Snyder in the season 4 episode "Marge in Chains":[22]

Judge: Do you know you're not wearing any pants?
Hutz: DAAA! I move for a bad court thingy.
Judge: You mean a mistrial?
Hutz: Right! That's why you're the judge and I'm the...law-talking-guy.

Kimberlianne Podlas[23] observes that Hutz is the only lawyer in Springfield who is shown as incompetent. He is the outlier, and therefore cultivation theory is inapplicable with respect to his actions.

It bears mention that notwithstanding Jimmy's considerable legal skills, it is possible that he, too, violates the competency rule, or at least comes close to doing so. As noted earlier, Jimmy would not be permitted to help inventor Roland Jaycocks prosecute his patent for Tony the Toilet Buddy because Jimmy has not passed a separate patent bar. But even if such a formal requirement did not exist, it is unlikely that Jimmy would be able to competently represent a client in such a complicated matter.

Like Vinny, Jimmy often applies his street smarts to his representation of clients. Jimmy practices different fields of law, and there is no prohibition on doing so (hence the prevalence of the general practice attorney in contemporary society) so long as he is able to provide effective representation in all such fields. And while Jimmy McGill generally appears relatively competent in his representation of clients, they should be wary that the Slippin' Jimmy persona will slip through and impact his ability to provide representation in a responsible manner.

Selfish Lawyers

Mr. Hutz has also been depicted as selfish. When representing a client in his role as court-appointed attorney in the season 3 episode "Bart the Murderer,"[24] he reads aloud

the summary of the case that he was hired to litigate: "I'll be defending you on the charge of…murder one! Wow! Even if I lose, I'll be famous!" Such a perspective is in sharp contrast to the letter and spirit of previously discussed ethical rules requiring an attorney to zealously represent a client and not act out of self-interest.

Lionel Hutz and Lack of Dignity

"I've argued in front of every judge in the state—often as a lawyer!" ~ Lionel Hutz, *The Simpsons*[25]

In an interview regarding the depth of Saul Goodman's character, Peter Gould stated, "If you just read the words on the [script] page, [Jimmy/Saul] could be a *Simpsons* character…I think the real difference is that, even when he's Saul Goodman, there was a little vulnerability there."[26] In contrast to *Simpsons* attorney Lionel Hutz, Jimmy McGill is a multidimensional character. When he transforms into Saul Goodman, the similarities between Hutz and Goodman are hard to miss.

In my conversation with *Better Call Saul* writer Genn Hutchison,[27] she noted that she and other *Better Call Saul* writers often discuss *The Simpsons* in the writers' room and are quite familiar with Lionel Hutz. Perhaps no fictional lawyer has as much in common with Saul Goodman as Lionel Hutz—particularly as it relates to the characters' lack of dignity. Both lawyers engage in tacky advertising and operate multiple businesses. Both have placed casts on their clients in order to exaggerate injuries. Hutz drinks alcohol in the morning and his briefcase is full of crackers. He has offered to sell a customer half of his orange Julius drink, and he performs shoe repairs in order to keep his law practice afloat. Hutz often combines product promotions with the procurement of legal services as a package

inducement to potential clients, noting to Homer, "You'll be getting more than just a lawyer, Mr. Simpson. You'll also be getting this exquisite faux pearl necklace, a $99 value, as our gift to you."[28] This enticement sounds much like one of Saul Goodman's law-related infomercials, as does Hutz's ad: "FREE smoking money to first-time enrollers!"[29] Per *The World According to Saul Goodman,* Saul sells (or is at least affiliated with the sale of) bright-colored suits on the side.[30] Both attorneys view law as a commodity, and the tie-in to product promotion (particularly with respect to Hutz) flows naturally from that premise. A dignified lawyer would not engage in these activities. In fact, in an attempt to maintain the dignity of the legal profession, many state bar associations ban lawyers from providing clients with bonus offers for seeking legal services.

But those similarities are just the tip of the iceberg. Hutz and Goodman both have wide-ranging legal practices, as opposed to focusing or even specializing in a particular field. Both are likely not competent in all of the fields in which they practice and would be subject to rebuke from bar associations for this failure. Both come from schools of little or no prestige: Hutz attended the Knight School of Law, Goodman attended the University of American Samoa. Hutz and Goodman both have tacky names for their law practices—"I Can't Believe it's a Law Firm," and "Better Call Saul," respectively. Hutz's office is located in a shopping mall, Goodman's in a strip mall. Both also make frequent use of the pay phone in order to avoid their calls being traced back to their respective offices.[31] At times, both feign prestige and class: Jimmy takes calls in a disguised female voice to fool callers into believing that he has a secretary, and Hutz asks his secretary Della to interrupt a meeting to (falsely) alert him that "The Supreme Court called again. They need your help in some freedom thing."[32]

Lionel Hutz's tacky advertisements illustrate another similarity. Hutz's ads could be swapped with Saul's and one would not be able to discern the difference.

A few noteworthy examples:

- "Why wait? Sue 'em today! Calling us could be like winning the *state lottery*!"[33]
- "Cases won in thirty minutes or your pizza's free."[34]
- "LIE convincingly, WRITHE in agony!, and MOAN with discomfort."[35]

The first two examples demonstrate how Hutz (like Saul) views law as a commodity rather than a service that merits deep thought, reflection, and care. The ads do not demonstrate a passion for achieving justice, but focus on the speed of achieving a particular commoditized result. The second ad may also be construed as promising a result, which is forbidden by legal ethics rules.

Like Goodman, Hutz is not concerned with the lack of dignity of the medium through which he presents his practice, as highlighted by his use of a unique business card: "Lionel Hutz, attorney at law. Here's my card. It turns into a sponge when you put it in water." (The sponge reads, "Clogging our courts since 1974.")[36]

The tacky promotional item calls to mind Jimmy McGill's ads on Jell-O cups and bingo boards at the senior citizen center.[37]

Not all portrayals of lawyers in pop culture are negative. Let's briefly turn to a few counterexamples.

Positive Portrayals

Prosecutors on legal dramas such as *Law & Order* (1990–2010) are routinely depicted in a positive light as they seek justice for victims of crimes. Positive portrayals of criminal defense lawyers exist too, such as Ben Matlock

on *Matlock* (1986–1995) and Perry Mason on *Perry Mason* (1957–1966), each of whom heroically defend the rights of their clients while adhering to both the letter and spirit of the law. And still other television shows and movies depict the law as a function of good and justice in society (e.g., *LA Law*, which ran from 1986 through 1994), and some even examine the complex and arduous process of seeking and obtaining justice (e.g., *12 Angry Men*, released in 1957, which depicts careful deliberation by certain jurors).

Kimberlianne Podlas observes that "the status of lawyers in society is schizophrenic. On the one hand, they are revered as intelligent individuals who fight for our rights and protect us from wrongs. On the other hand, they are vilified as 'hired guns' or 'shysters' who are just interested in money and file unnecessary lawsuits."[38] We see this dichotomy on *Better Call Saul.*

The law practices of Jimmy McGill and HHM are a prime example of the dichotomy. HHM is a distinguished law firm, whereas Jimmy/Saul represents a different type of clientele and engages in tactics that would be seen as unbecoming of a large law firm. A large law firm would never create tacky TV commercials encouraging potential clients to file frivolous lawsuits, for example. HHM is portrayed as a respectable, legitimate firm that will use its prestige to fight hard for a client's rights. Jimmy, the one-man shop of less-than-lawyerly stature, is portrayed as much more desperate—for money, clients, and fame. As his ads suggest, he will likely file frivolous lawsuits. As Saul Goodman, we know that he will act in reprehensible ways in order to achieve a particular result. HHM is portrayed in a more trusting light than Jimmy. Recall that the Kettlemans initially decide to retain HHM over Jimmy because Jimmy is "the type of lawyer that guilty people hire."

We also see the dichotomy within Jimmy McGill

himself. Jimmy advocates effectively on behalf of his clients, but he also acts as a "shyster" even before his full transformation into Saul. In the scene where he negotiates with Tuco and Nacho, Jimmy exclaims to the pair, "I'm a lawyer. I passed the bar!" Jimmy is reminding the audience of this fact, too, because his scheming ways and lack of lawyerly stature and demeanor may lead us to forget that he needs to be held to the same standards as, say, Chuck (who barely considers Jimmy to be a lawyer).

We also admire Jimmy because he does not back down from a challenge. He happily represents the downtrodden, and does not appear to be intimidated by the HHMs of the world. In this way (and perhaps only this way), we can perceive a distinction between Jimmy/Saul and Lionel Hutz. On the *Simpsons* season 4 episode "Marge Gets a Job,"[39] Lionel Hutz runs out of Mr. Burns's office screaming upon seeing Burns's "ten high-priced lawyers" emerge from behind a wall. Whereas the message from *The Simpsons* is that legal battles are often won by those with the most money, *Better Call Saul* demonstrates that the low-income folks have a fighter's chance as long as they retain Saul Goodman.

Notes

1. Legal scholar Michael Asimow observes, "Very few movies and television shows concern dysfunctional grandmothers, rabbis, or algebra teachers, but a great many show dysfunctional lawyers—which, unfortunately, is exactly the way most people view lawyers these days." *Lawyers in Your Living Room!: Law on Television* (Chicago: American Bar Association, 2009), XX.
2. Steven Keslowitz, "*The Simpsons*, 24, and the Law: How Homer Simpson and Jack Bauer Influence Congressional Lawmaking and Judicial Reasoning," 29 *Cardozo Law Review* 29 (May 2008) 2787, 2795.

3. Ibid.

4. Ibid.

5. 24, Day 4, 12:00 AM–1:00 AM (Fox television broadcast Apr. 18, 2005).

6. When interrogated at a hearing held by the United States Senate Committee, Jack Bauer acknowledges that he is "not above the law," and that he is happy to have the American public judge his actions, but that he is not willing to have his decisions second-guessed by the Senate. (See season 7 of *24*; also Steven Keslowitz, "The Trial of Jack Bauer: The Televised Trial of America's Favorite Fictional Hero and Its Influence on the Current Debate on Torture, Symposium, *Cardozo Law Review* 31 (2010): 1125.

7. Keslowitz, "*The Simpsons, 24*, and the Law," 2787, 2795.

8. For a broad list of ethical issues typically presented on TV, Carrie Menkel-Meadow, "Is there an Honest Lawyer in the Box? Legal Ethics on TV," in *Lawyers in Your Living Room!: Law on TV*, ed. Michael Asimow (Chicago, American Bar Association, 2009), 40.

9. Steven Keslowitz, *The Simpsons, 24*, and the Law," 2787.

10. Asimow, *Lawyers in Your Living Room!*, XXI. Note, however, that not all scholars agree on the extent to which inaccurate portrayals of the legal system on television influence viewers' perception of the legal system. In "27 Years as a Television Legal Adviser and Counting," Charles B. Rosenberg (despite analogizing the connection between legal TV shows and perceptions of the law to the classic chicken-and-egg conundrum) observes that:

> Many lawyers and judges worry about the negative consequences that portraying law on TV in such a shorthand and sometimes inaccurate manner might have on the public's understanding of law and its regard for lawyers and the justice system in general. I would concede that the shows must have *some* influence, but it's hard to say just how much. After all, there are multitudinous influences on people's perception of law and lawyers besides fictional TV. (Ibid., 22.)

11. Ibid.

12. Ibid, XXX.
13. Ibid, 23.
14. Kimberlianne Podlas, "'The CSI Effect': Exposing the Media Myth," *Fordham Intellectual Property Media & Entertainment Law Journal* 16 (2006): 429, 447.
15. Ibid., 447–448.
16. Ibid., 447–448.
17. Ibid., 447–448. See also Keslowitz, *The Simpsons*, 24, and the Law," 2787, 2799. ("Cultivation theory hypothesizes that viewers' perceptions of reality are cultivated in a manner consistent with the programming to which they are exposed.")
18. Episode 7F10, 1991.
19. Model Rules of Professional Conduct, Rule 1.1, http://www.americanbar.org/groups/professional_responsibility/publications/model_rules_of_professional_conduct/rule_1_1_competence.html.
20. See *Strickland v. Washington*, 466 U.S. 668 (1984), setting forth the standard for an attorney's inadequate performances. The vast majority of claims alleging ineffective assistance of counsel are ultimately denied.
21. Episode 1F04, 1993.
22. Episode 9F20, 1993.
23. Podlas, "The Funny Thing About Lawyers on *The Simpsons*," 374.
24. Episode 8F03, 1991.
25. Season 5, "Burns' Heir," episode 1F16, 1994.
26. Kimberly Potts, "'Better Call Saul' Creators Vince Gilligan and Peter Gould on Why We Haven't Seen Saul Yet," *Yahoo! TV*, November 15, 2016, http://www.yahoo.com/tv/better-call-saul-saul-creators-vince-gilligan-and-peter-gould-on-why-we-havent-seen- saul-yet-210635453.
27. Conversation during Inside the Better Call Saul Writers Room, the Writers Guild, Beverly Hills, CA, May 26, 2016.
28. Season 2, "Bart Gets Hit by a Car," episode 7F10, 1991.
29. As seen on *The Simpsons* season 4 episode "Marge in Chains," episode 9F20, 1993.
30. David Stubbs, *Better Call Saul: The World According to Saul Goodman* (New York: Harper Design, 2015), 27.
31. Note that the cover art for season 1 of *Better Call Saul* shows

Jimmy at a pay phone. This highlights the fact that McGill, like Hutz, sometimes prefers to use lowbrow street resources to operate his legal practice.

32. Season 2, "Bart Gets Hit by a Car." Episode 7F10, 1991.

33. Podlas, "The Funny Thing About Lawyers on *The Simpsons*," 367.

34. Season 5, "Treehouse of Horror IV." Episode 1F04, 1993.

35. Podlas, "The Funny Thing About Lawyers on *The Simpsons*," 370. The ad is for "$$$$ Lionel Hutz's COLLEGE OF LITIGATION $$$$," which trains individuals on how to become effective (and dishonest) plaintiffs. The ad is markedly similar to Saul Goodman's instructive website (http://www.amc.com/saul-goodman-esq). Hutz's college includes seminars on "The Art of the Limp," and, in a course particularly reminiscent of Slippin' Jimmy, "How to slip and fall on cue." Both Goodman and Hutz also make extensive use of customer testimonials in their promotional and instructional materials.

36. Homer's response: "Ooh, classy." (While Hutz's ad is the complete opposite of class, it demonstrates that Homer, as a potential client, wants a classy lawyer. He just has a difficult time identifying "class.") Season 2, "Bart Gets Hit By a Car," episode 7F10, 1991.

37. Other examples from Lionel Hutz abound, and call to mind Saul Goodman's distinctive style:
 - Hutz misleads about fees: He revises his ad to say "Works on contingency basis? No, money down!" Bart had read it as it was previously written—"Works on contingency basis! No money down!" Season 7, "The Day the Violence Died," Episode 3F16, 1996.
 - Hutz promises results while acknowledging that he is not permitted to do so: "The state bar forbids me from promising you a big cash settlement. But just between you and me, I promise you a big cash settlement." Season 2, "Bart Gets Hit By a Car," Episode 7F10, 1991. In the same episode, Hutz advises his clients (the Simpson family) that they can "ching, ching, ching, cash in on this tragedy!"
 - Hutz ad: "We put the 'fortune' in your misfortune."

(This ad is reminiscent of Saul Goodman's Wayfarer 515 ad). Podlas, "The Funny Thing About Lawyers on *The Simpsons*," 367.
38. Ibid, page 365.
39. Episode 9F05, 1992.

Conclusion: Why You Better Call Saul (and Say Hello to Jimmy)

We all have our secrets, don't we? And who among us is without sin? ~ Jimmy McGill, *Better Call Saul*

Bali Ha'i

In the *Better Call Saul* season 2 episode "Bali Ha'i," Jimmy leaves Kim a voicemail in which he serenades her with a portion of "Bali Ha'i" from the musical *South Pacific* (1949). The name of the song refers to a fictional island that is "visible on the horizon but not reachable."[1] The song speaks of the yearnings of individuals (who live on their

own islands that are lost at sea) to reach a different, special island.[2] Jimmy can be seen as one of the individuals who longs to reach this mystical island where an individual's unique hopes and dreams blossom and shine.[3]

What is perhaps most intriguing about this special island is that, at an opportune moment, the island that is seemingly not within reach will reveal itself and embark upon a call of action, inviting lonely dreamers to come and find it.[4]

Enter Jimmy McGill. As we watch Jimmy endlessly search for direction in life—a mystical island in which he can operate uninhibited by the pressures of the world—we know the ultimate result. He does not reach this special place, where perhaps he could have built a successful, admirable life. Instead, Jimmy reaches for a mask and transforms into the wicked Saul Goodman.

Masks

In the song "Reflection,"[5] Christina Aguilera sings of an individual who pretends to be someone she is not. She speaks of using a mask to allow her to play a particular role, and in doing so, is able to trick others about her true identity. But the individual is not satisfied with the deception, as she notes that her heart and mind cannot be so deceived. Living with knowledge of the underlying truth is a burden that she will carry with her.

At a fundamental level, *Better Call Saul* shows us that we often wear masks to conceal facts about our true identities from the world. And while peeling off the layers of the masks can be revealing, it also often leads to more questions related to one's identity. While we might know that a particular person is wearing a mask, it is often much more challenging to determine what elements of that person's character are tied to the mask and what elements reflect one's true nature.

Often, over time, the mask becomes so intertwined with the person that a clear segregation is not possible. And since the development of a complicated character like Saul Goodman is the focus of an entire television series, it is not surprising that clearly deciphering where the mask begins and ends is not an easy task. In short, the Saul Goodman character that we meet in *Breaking Bad* is both a reflection and result of Jimmy McGill's unique life experiences.

Jimmy achieves his happiest state and, with it, some degree of commercial success, when he takes his "lawyerly-play-by-the-book," straitlaced mask off. He is a nonconformist, a "square peg" trying to fit into a round hole, and it makes perfect sense for him to put up his own shingle rather than attempt (and fail) to fit in with the culture at a large law firm such as Davis & Main. The freedom he enjoys when he is not wearing a mask is essential to Jimmy's ability to function, whether at work or at home. As noted, while working at Davis & Main, he cannot even fall asleep in the luxury apartment that the firm purchases for him and has to drive to the nail salon in the middle of the night just so he can sleep in his small foldaway bed. We come to understand that wearing a new mask—as Gene, the Cinnabon manager—is an ironic punishment. After fighting so long and hard to attempt to hide his Slippin' Jimmy persona, then removing the straitlaced face paint when he transforms into Saul (who more closely emulates Slippin' Jimmy), being forced to wear the Gene mask is perhaps the cruelest fate he could meet.

Better Call Saul examines the complicated relationship between one's mask and true nature. Would young Jimmy transform naturally into Slippin' Jimmy without the intervention of the con man at Mr. McGill's store? Would Jimmy ever have become Saul Goodman were it not for his rocky relationship with Chuck? Was the Saul Goodman persona

stewing inside of Jimmy McGill forever, simply waiting for an opportunity to emerge? Or, as Rhea Seehorn asked, "Is Saul a mask [that Jimmy] puts on when he needs to?"[6] While we have discussed Jimmy's transformation into Saul Goodman at length, is it possible that he never transforms much at all, and simply puts on a clever disguise intended to hide the Jimmy McGill persona?

Ms. Seehorn's statement was echoed by Bob Odenkirk, who explains that "Saul is just who [Jimmy's] pretending to be to get back at the world."[7] Even upon extensive examination of the character development in *Better Call Saul* and *Breaking Bad*, it is not possible to answer these questions or confirm these statements with any degree of certainty. While we know that Jimmy wears a mask when attempting to impress Chuck, there is a blurry line between where the mask begins and ends. It is not clear whether even Jimmy could identify what elements of Saul Goodman are a façade and which are simply an expression of Jimmy's true, underlying, unhinged nature.

The difficulty in identifying one's underlying nature upon removing layers of a mask has been examined throughout our popular culture. On *Dexter*, Dexter Morgan—a serial killer who conceals the underlying monster within—refers to himself as a "master of disguise."[8] Like Dexter, we watch Jimmy McGill attempt to fit within a world that subsists on values that are antithetical to his underlying nature. Dexter acknowledges that he forgets where the fraud ends and his true self starts:

> Everyone hides who they are at least some of the time. Sometimes you bury that part of yourself so deeply that you have to be reminded it's there at all. And sometimes you just want to forget who you are altogether.[9]

On the ABC series *The Family*, pedophile Hank Asher echoes this sentiment, poignantly noting:

> We all wear a mask. Buyer beware. The longer you wear it, the harder it is to take off. It changes who you are. It embeds in your skin, until it's impossible to tell what's really underneath.[10]

And in the popular Billy Joel song "The Stranger," Billy sings about masks, pointing out that everyone hides his or her true identity and reveals the face underlying the mask only when alone.

While *Better Call Saul* is, of course, focused on what inspires Jimmy to transform into Saul Goodman—and whether such transformation entails taking off a mask or putting one on—we cannot say for certainty that we understand the way in which Jimmy is inspired. There are so many factors that lead to the development of Slippin' Jimmy and later Saul Goodman.

It is also noteworthy that Jimmy demonstrates love and support for others, and that the transformation into Saul largely results from manifestations of such love and support. We know that Jimmy is not evil by nature, and, as discussed previously, Peter Gould pointedly observed that the path to Saul's transformation is "paved with good intentions"—for instance, admitting his forgery to Chuck because he feels guilty about Chuck abandoning his career as a result of Jimmy's actions.[11] Like the figure depicted in the Billy Joel song, Jimmy ultimately "gives in" to his base "desires," and becomes the tragic Saul Goodman.

Jimmy's brother, Chuck, simply cannot understand why everyone doesn't clearly see through Jimmy's mask. He does not see the complexity that others see in Jimmy; instead, Chuck views Jimmy as entirely one-dimensional—

and entirely undeserving of anyone's admiration or praise. Jimmy does not see himself this way, but it may well be that Chuck is in a better position to see through Jimmy's masks than is Jimmy himself.

In the *Twilight Zone* episode "The Masks,"[12] a wealthy man named Jason Foster invites his greedy heirs to a Mardi Gras party in New Orleans. He designs a mask for each heir, customized in a way that is designed to match some negative aspect of the individual's personality. Ultimately, the masks become permanently stuck on each person's face so that his or her outward appearance serves as an accurate reflection of his or her personality. One could argue that Mr. Foster would have designed a wolf or sheepdog mask for Jimmy. The wolf or sheepdog is arguably embedded within him, and like the heirs, he is unable to remove this element of his personality, as it has become enshrined within him. Just like the heirs, Jimmy is not able to hide behind a friendly face; in the long run, his true nature cannot be hidden by a mask. Quite paradoxically, Saul's freedom enables him to wear a mask—his shtick—but he loves it, and he is at his most content when it is on full display for the world to see.

While it is clear that Jimmy, Saul, and Gene each wear a mask, a deeper dive into *Better Call Saul* reveals that other characters wear masks as well. In particular, we learn a great deal about Kim Wexler when she is with Jimmy. She is arguably at her happiest, acting with an uncharacteristic zest for life, when she serves as an active participant in Jimmy's scams. Her career as a lawyer is her mask, and when she removes it, her true nature is perhaps closer to Jimmy's than we may have otherwise guessed. Rhea Seehorn, the actress who portrays Kim, noted that "There's attraction and repulsion in taking off your masks with each other and getting to know that, and what you can accept and what can't you accept."[13] The quote is informative because it indicates that

it is not only the audience who is learning what lies beneath Kim's mask; it is Kim herself who comes to certain realizations about her underlying nature.

Choices

In "Identity" [14], poet Julio Noboa Polanco speaks of flowers for which proper care is provided, but notes that such flowers are still "harnessed" to a pot filled with dirt. By comparison, the author states that he would prefer to be an "ugly weed", living perilously above "high, jagged rocks." Christina Aguilera's "Reflection" argues that individuals should be free to soar, and simultaneously asks why thoughts, concerns and emotions need to be hidden away. [15]

As we watch the ethically *questionable* Jimmy McGill transform gradually, yet methodically, into the ethically *bankrupt* Saul Goodman, we learn a number of lessons not only about the journey of this particular character, but also about life in general. Jimmy's path rarely follows a straight line. Like many of us, he tries on several different hats in search of an identity that is more perfectly suited to him. He does not seek fame or excessive fortune, and does not set out to intentionally hurt others. While Jimmy is willing, at times, to cause harm to others, it is clear that he possesses some form of a moral compass, and it is this compass that leads to a degree of measured introspection and reflection regarding his actions. But as the circumstances in Jimmy's life change more and more dramatically as time goes by, he too changes in a more significant manner. And if we look at Saul's backstory from this perspective, perhaps he becomes a more relatable character.

At some point, Jimmy decides that the delicate moral balancing act that he tries desperately to maintain is too difficult for him to endure. By holding himself back, he is missing out on a life replete with potential rewards—

some that might be personally gratifying, others that would actually help those in desperate need of effective legal counsel.[16] As Saul, he is free to become unhinged, cater to the appetites and base instincts that he tried to cover up with a Band-Aid or evade altogether, and be his own man. Ralph Waldo Emerson observed that "To be yourself in a world that is constantly trying to make you something else is the greatest accomplishment."[17] Jimmy attempted to so transform earlier on: in "Switch," he uses an alias, checks into a hotel, and tells Kim, "I'm not acting like anything. I just finally decided to be me."

We can question, of course, whether Jimmy's transformation results in him being true to himself or whether Saul himself is masking another hidden identity. In any event, the "switch" turns out to be more of a gradual process for Jimmy. It takes a number of additional life experiences for him to move on. He realizes that receiving a reward for good behavior is not guaranteed, and even if it were, it might not be worth the wait. Jimmy embodies the principles contained within the lyrics of the seminal Billy Joel song "Only the Good Die Young," exhibiting a belief that enjoying the potential fruits of heaven is not worth the wait, and that sinning on earth is more enjoyable. He can live happily for the moment, and he need not wail on the sidelines with the good-doers. Because Jimmy realizes, as do many of us, that life is unfair, he does not want to take the chance of living a life that is untrue to his nature and never experiencing what it can be if he simply takes some chances and uses his street smarts to survive. He ultimately does not thrive as Saul Goodman, but at least he cannot say that he lived an unfulfilling, unadventurous life replete with regret: by becoming Saul Goodman, he lived a life in which he did not feel tied down by society. Perhaps Jimmy's greatest fear is engaging in good behavior, only to die young.

And speaking of a man faced with the prospect of dying too young (from cancer), it is noteworthy that Walter White lets loose and becomes unhinged once he believes that his chances at survival are slim. Walt speaks eloquently of his desire to make his own decisions, and about the inherent value of living life independently, unrestrained and unbeholden to the orders of doctors or the effects of the medicine that they will undoubtedly prescribe. "What I want—what I need—is a choice," he says in the *Breaking Bad* season 1 episode "Gray Matter" (2008). "Sometimes I feel like I never actually make any of my own choices...My entire life—it just seems I never, you know, had a real say about any of it. With this last one, cancer, all I have left is how I choose to approach this." And in the season 4 episode "Hermanos" (2011), Walt advises a fellow cancer patient to "Never give up control. Live life on your own terms." He tells the patient that until Walt receives "bad news," he will be "in charge." Later on in the series, Walt's son, Walt Jr., speaks ill of Skyler due to his false belief that she is treating Walt poorly because of his (made-up) gambling addiction. Walt pushes back, partially defending Skyler, and notes that the situation has resulted from choices that Walt made—choices he stands by. In the film *Steve Jobs* (2015), Jobs similarly extols the importance of having control, opining that "As long as you have control—I don't understand people who give it up." Walt's and Steve Jobs's yearning for the ability to make their own choices is reminiscent of Jimmy McGill's desire to set up his own shingle, practice law in a "colorful" way, and simultaneously break free from the restraints and outside influences (such as Chuck) that are holding him back. Jimmy ultimately follows the advice that he receives from Howard Hamlin in "Uno": "You know, Jimmy, in our line of work, you can get so caught up in the idea of winning that you forget to listen to your heart."

Living is about making choices, and if we do not possess the freedom to make those choices independently and listen to our own hearts, then we may ultimately question the quality and value of life itself.

Walt's ability to live freely,[18] without fear of consequence, is galvanized by his grim medical prognosis. In season 2's "Better Call Saul," (2009), he tells Hank Schrader that he has lived his whole life in fear of potentially bad things that could happen, recounting that he would awaken at night from such fear. He notes that after being diagnosed with cancer, he sleeps "just fine." He concludes, "Fear—that's the worst of it. That's the real enemy." And once Jimmy McGill is able to break free from his obsessive desire to please his brother, he also overcomes a significant force that was holding him back. As Saul, he does not feel burdened by a requirement to please others. He becomes more true to himself—even if the Goodman character, at least in some respects, represents a mask of sorts. Complicated characters, indeed.

The stories of both Walter White and Saul Goodman are accounts of survival in a world that is often quite cutthroat in nature. Each character's decisions are guided by their individual desires to thrive despite unappealing circumstances. And both characters, in their separate quests for survival, embody Muhammad Ali's declaration: "I know where I'm going and I know the truth, and I don't have to be what you want me to be. I'm free to be what I want."[19] We watch each character pave a path that we abhor. Yet we acknowledge that it is our free will, and the choices that emanate from such freedom, that makes all of us human. While we rightfully criticize (and certainly do not excuse) the deplorable behavior of both Walt and Saul, we do not disavow the belief that every human being should be free to create his or her own direction, charting his or her

unique course in life. We may not relate to each charac-
ter's behavior, but we do find the circumstances that lead
these characters to their decisions understandable—illness
in the case of Walt[20] and family issues in the case of Saul.
We can learn a lot about how human beings exercise their
free will, and the consequences that may result therefrom,
by watching and studying Walt and Jimmy. This is the gift
that they offer to the television audience.

Beginnings and Endings

> "Do not go where the path may lead, go instead where
> there is no path and leave a trail."
>
> ~ Ralph Waldo Emerson[21]

The opening sequence of the first episode of *Better
Call Saul* depicts Gene at home, recharging after a long
day working at the local Cinnabon. He pours a drink and
closes the blinds of his home in order to hide his viewing
of old Better Call Saul commercials from the world. The
song "Address Unknown"[22], which describes an individual's
lengthy and fruitless quest for a home and place in the
world that ultimately results in a solitary life of anonym-
ity, plays in the background. We know that there is much
more to Gene than his current lifestyle indicates. We also
know that Gene cannot erase the past. Hiding away in a
pastry shop does not remove the stains that he has left in
his wake: as Slippin' Jimmy, attorney Jimmy McGill, and
most colorfully and painfully, as Saul Goodman. As Kerry
Campbell states during season 2 of the television series
Wayward Pines, "The past: you carry it with you wherever
you go. No matter what you do—you can't run from it. You
can't control it. I'll always be me."[23]

Tears stream down this man's face as he drinks the

cocktail, and watches an old VHS tape of his tacky "Better Call Saul" advertisements. It is a poignant scene, intended to clearly show that Gene laments what he has lost during the course of his life. He may never become the distinguished attorney that he seems capable of becoming. He may have allowed outside influences to affect him far too greatly. He has made some poor decisions, and he has no choice but to own those choices and live with the consequences resulting therefrom.

Perhaps Gene is contemplating the lyrics of Gnarls Barkley's "Who's Gonna Save My Soul,"[24] as he realizes that his life story may never be revealed in its entirety, and that, nonetheless, his soul may not be saved because of his past actions. He is not able to reap the fleeting rewards of an immoral life and yet is punished for his past deeds.

Life certainly has gone awry for this character, and he likely regrets ever meeting Walt and Jesse back at his strip mall office in New Mexico. But, to borrow from an old adage, it is better to have fully lived and lost than never to have truly lived at all. And while Saul Goodman is undoubtedly a tragic character, he has lived a full life, replete with experiences. He has experienced love, adventure, happiness, and victory while also enduring pain, heartbreak, sorrow, and loss. He has survived, and at times thrived. He has acted heroically, but has also caused wreckage and destruction. In short, the man we know best as Saul Goodman has left his mark on the world. And yet, after all has been said and done, he still has us *calling* for more.

Notes

1. Oscar Hammerstein II and Richard Rodgers, "Bali Ha'i," (*South Pacific*, 1949).
2. Ibid.
3. Ibid.
4. Ibid.
5. Single version performed by Christina Aguilera, lyrics by David Zippel (1998).
6. Paul Schrodt, "'Better Call Saul' star Rhea Seehorn talks about the 'surprising' sex scene in the season 2 premiere," *Business Insider*, February 15, 2016, http://www.businessinsider.com/better-call-saul-kim-rhea-seehorn-interview-2016-2.
7. Tim Appelo, "'Better Call Saul' Star Bob Odenkirk Teases Season 3: 'Innocence Gets Torn Away,'" *The Wrap*, August 17, 2016, http://www.thewrap.com/better-call-saul-star-bob-odenkirk-teases-season-3-innocence-gets-torn-away-video/.
8. *Dexter*, season 1 ("Let's Give the Boy a Hand," October 22, 2006).
9. Ibid.
10. *The Family*, season 1 (2016), "Sweet Jane."
11. Kimberly Potts, "'Better Call Saul' Postmortem: Peter Gould Talks Where Jimmy Will Be in Season 2," *Yahoo! TV*, April 17, 2015, https://www.yahoo.com/tv/better-call-saul-producer-writer-talks-season-1-115773934500.html.
12. *The Twilight Zone*, Episode 145, "The Masks" (1964).
13. Paul Schrodt, "'Better Call Saul' star Rhea Seehorn talks about the 'surprising' sex scene in the Season 2 premiere."
14. Julio Noboa Polanco, *Identity*. See http://breadloafpoetryexchange.pbworks.com/w/page/39725748/Identity%20by%20Julio%20Noboa%20Polanco.
15. Single version sung by Christina Aguilera, lyrics by David Zippel (1998).
16. Saul Goodman has no misconceptions about his stature in society, but he does correctly observe that he is a qualified attorney. In the season 5 episode of *Breaking Bad*, "To'hajiilee" (2012), he greets Skyler by saying, "Clearly [Walt's] taste in

women is the same as his taste in lawyers: only the very best with just the right amount of dirty."

17. Ralph Waldo Emerson. *Self-Reliance, Essays: First Series* (1841), math.dartmouth.edu/~doyle/docs/self/self.pdf.

18. Consider, however, whether Walter White truly did live freely. He initially acts because he feels obligated to provide for his family, and he later engages in a series of actions designed to survive, thwart Gus, and become a drug lord (the latter in large part due to his excessive ego).

19. "Muhammed Ali Quotes," BrainyQuote, http://www.brainyquote.com/quotes/quotes/m/muhammadal167372.html.

20. Walt's initial motivation is providing for his family (as a result of fear of death from cancer), but he then becomes obsessed with money. Then the act of building an empire becomes the motivating factor; he tells Jesse Pinkman that it is neither the meth nor the money that drives him. During season 5, Walt acknowledges that he is proud to be the very best at something—even if that *something* is cooking a dangerous drug.

21. Ralph Waldo Emerson. *Self-Reliance, Essays: First Series* (1841), math.dartmouth.edu/~doyle/docs/self/self.pdf.

22. *The Ink Spots*, 1960.

23. *Wayward Pines*, season 2 ("Walcott Prep," 2016).

24. Gnarls Barkley, "Who's Gonna Save My Soul" (*The Odd Couple*, 2008). This song is played at the conclusion of the first season of *Breaking Bad* ("A No Rough-Stuff-Type Deal," 2008).

Index

You Better Know Saul:
The Quiz

Squat Cobbler

Ah, look at those sleazy readers out there! How sleazy, pray tell? Well, let's see here. How similar are you to the master—Saul Goodman—your favorite (not to mention the world's best) lawyer? Take this ten-question quiz to get some complimentary feedback and nuggets of wisdom. Uh, that's complimentary as in free. Not as in *master lawyer* Saul Goodman, Esq., giving *you*, lowly grasshopper, any praise. It's probably not warranted. No goofing around, either—he doesn't grade these quizzes for fun, you know. This is to be used strictly for educational purposes. And perhaps a few of you fine, more gifted, beautiful individuals actually emulate Saul in some small way. For the rest of you peeps,

don't worry; the world would be like heaven on Earth if everyone could be just like Saul Goodman. Not everything comes up peach cobbler and cream—he'll be the first to tell you that. It's just not in the cards. No need to be a nervous Nellie here if your score is low—Uncle Saul will take good care of you in exchange for a (cough) substantial (cough) retainer fee/(cough, cough) bribe. Well, good luck, you fine folks—it's showtime!

The Quiz: Add one point for each question to which your response is "yes." Add zero points for each question to which your response is "no."

1. Are you an attorney?
2. Have you staged slip-and-fall incidents in an attempt to scam unsuspecting victims?
3. Have you ever changed your name?
4. Have you ever undergone any major life changes or transformations that affect your identity?
5. Have you become more morally bankrupt as you've aged?
6. Do you have any issues with a sibling?
7. Do you use your invented name as part of a catchy, yet tacky, tagline for a business that you frequently advertise?
8. Have you ever managed a Cinnabon or similar shop?
9. Are you involved in a fairly complicated romantic relationship?
10. Do you enjoy any of the following activities: scheming, lying, breaking the law, wearing colorful suits, participating in drug rings, betraying your clients, and/or telling your dates that you are Kevin Costner? (Score 1 total point if you chose one or more. No double-counting, you cheating Charlie, you!)

Scoring Legend

o points: Sorry, folks! You lose! Heh heh heh. Time for you to face *some harsh realities* here. Zero points is pretty darn shameful. Not to get overly political here (as Saul is an impartial member of the bar), but zero is even lower than Barack Obama's reported bowling score of 37! Uncle Saul can only coddle you so much. Sorry to burst your bubble, but you have about as much in common with Saul as Mike Ehrmantraut has with one of those Disney princesses that my daughter likes. Y'know, the one with the ice and freezing power. Eh, whatever. Just *let it go*, you are not a *good man*, compadre. And quit your bellyaching about those last two pop culture puns—it's your fault that you're reading this section, as it's reserved for losers: you should have scored higher!

1–3 points: Don't get too excited here, dear friend. You may have cheated your way to scoring a point or two, and may not have even honestly earned a spot at this less-than-prestigious level. If you did cheat, though, good for you! At least you have the makings of someone who is corruptible! Perhaps you'd like some more lessons about how to live your life, y'know, some motivational sessions. Take a class taught by Mr. Goodman— payment up front, no refunds, that sort of thing. Nothing cheesy: the classes are full of class, panache, and useful tidbits of information. No warranties, no promises, though. You're all friends here, right? Heh heh heh. The last thing Mr. Goodman needs is lawsuits against him.

4–6 points: Okay, stop jumping up and down for joy over there—for those of you more hefty individuals, the jiggling is becoming a little hypnotic. And those hypnotists—don't get me started on them! Boy oh boy, now *that's* a business! Convincing people to do whatever you say

without having to make up stories about men sitting on top of peach cobblers to please their lovers—oh, the things Saul does for his clients! I don't care how "colorful" it gets, it's still a thankless job, he'll tell ya! Okay, but back to your mediocre score here. You may have taken a dive to earn a few bucks, but can you honestly say that others admire you for your quick wit and uncanny ability to deceive others? If you do "honestly" answer that question either way, deduct 2 points right now—you're just a sad disappointment. If you love the truth so much, why don't you go ahead and marry it? Heck, Saul will officiate the wedding—even actual weddings between two people! Just provide some advance notice so that he can extricate himself from whatever he's tangled up in, and so that he has enough time to print up a phony marriage license. The great news is that you can then call Saul once you're ready to file for divorce. It's the circle of life, Saul Goodman-style!

7–9 points: Keep this up and Saul will let you audition to be his Rolex scheme partner. I have to ask: did you steal the answer key before taking the quiz? You sneaky Pete! But Saul would be proud—even more proud if you did steal the answers! So let's talk long-term here: we all know that the Rolex scheme is only good for *beer money*. Take your pick: you can be a mailroom clerk, attorney, or Cinnabon manager. Seems like your sibling hates you. Welcome to Saul's world! Take it from him, you don't need him or her! And don't let that fair-weather romantic steer you "right." Stay just the way you are. It would be a shame if you looked both ways before crossing the street. And be sure to remember: if you team up with Saul, he'll have your back—at least until someone better comes along.

10 points: Ah, young apprentice! You *chimp with a machine gun*, you! You have made your favorite attorney very proud. We'll all be watching to catch a glimpse of

your slips and falls—and you better send Saul a cut of your profits. It's the least he deserves for all of the free training he provided to you. But let's get down to *brass tacks* here: it's pretty awesome to be Saul Goodman. The sheep come to you, you dispense your spiel, and you *make bank*—just like Marco said you would! Just one word of advice: be careful who you get into bed with. Saul made some, er, errors in judgment by agreeing to represent those two *anal polyp* clients who you may know better as Walt and Jesse. Boy, those two! But I digress. This is about your perfect score. Congrats are in order! There is nothing stopping you now. And if someone ever tries to get in your way, you know who to call. (Hint, you genius, you—I didn't mean Ghost-busters). Anyway, 's'all good man.

One last request for all you quirky quiz takers out there: now that you've learned all of Saul's tricks from this book, why don't you go ahead and send the author some royalties, huh? This magic sauce ain't free, y'know, especially if you're using it to marinate those juicy Omaha Steaks of yours!

Better Call Saul
Episode List

Episode Name	Original Air Date
Season 1	**2015**
Uno	February 8, 2015
Mijo	February 9, 2015
Nacho	February 16, 2015
Hero	February 23, 2015
Alpine Shepherd Boy	March 2, 2015
Five-O	March 9, 2015
Bingo	March 16, 2015
RICO	March 23, 2015

Episode Name	Original Air Date
Pimento	March 30, 2015
Marco	April 6, 2015
Season 2[1]	**2016**
Switch	February 15, 2016
Cobbler	February 22, 2016
Amarillo	February 29, 2016
Gloves Off	March 7, 2016
Rebecca	March 14, 2016
Bali Ha'i	March 21, 2016
Inflatable	March 28, 2016
Fifi	April 4, 2016
Nailed	April 11, 2016
Klick	April 18, 2016

Notes

1. Some fans rearranged the first letter of each season 2 episode title and discovered the anagram "Fring's back"—a tease for the future reemergence of *Breaking Bad's* notorious kingpin. Joanna Robinson, "Better Call Saul Creators Didn't Expect You to Solve Their Gus Fring Puzzle," *Vanity Fair*, April 19, 2016, http://www.vanityfair.com/hollywood/2016/04/better-call-saul-gus-frings-back-title-anagram-finale.

Bibliography

Journal Articles

Brickman, Lester. "The Use of Litigation Screenings in Mass Torts: A Formula for Fraud?" *Southern Methodist University Law Review* 6 (2008).

Fulkerson, Jennifer. "When Lawyers Advertise. *American Demographics* 17.6 (1995): 54–6.

Keslowitz, Steven. "*The Simpsons*, 24, and the Law: How Homer Simpson and Jack Bauer Influence Congressional Lawmaking and Judicial Reasoning." 29 *Cardozo Law Review* 2787 (May 2008).

———. "The Trial of Jack Bauer: The Televised Trial of America's Favorite Fictional Hero and Its Influence on the Current Debate on Torture." Symposium, 31 *Cardozo Law Review* 1125 (2010).

Klinefelter, Anne, and Marc C. Laredo. "Is Confidentiality Really Forever: Even if the Client Dies or Ceases to Exist?" *The Journal of the Section of Litigation* 40, no. 3 (2014). http://www.americanbar.org/publications/litigation_journal/2013-14/spring/is_confidentiality_really_forever_even_if_client_dies_or_ceases_exist.html.

Paxon, Peyton. "Have You Been Injured? The Current State of Personal Injury Lawyers' Advertising. Journal of Popular Culture 36.2 (2002).

Podlas, Kimberlianne. "The CSI Effect: Exposing the Media Myth." *16 Fordham Intellectual Property Media & Entertainment Law Journal* 429, 447 (2006).

Singh, Manjari, and Mei-Yu Lu. "Exploring the Function of Heroes and Heroines in Children's Literature from Around the World." *ERIC Publications* (2003).

Books

Asimow, Michael, et. al *Lawyers in Your Living Room!: Law on Television* (Chicago: American Bar Association), 2009.

Bentham, Jeremy. *An Introduction to the Principles of Morals and Legislation.* Mineola: Dover Philosophical Classics, 2007. Originally published in 1781.

Brooks, David. On Paradise Drive: How We Live Now (And Always Have) in the Future Tense. New York: Simon & Schuster, 2004.

Cranston, Bryan. *A Life in Parts.* New York: Simon & Schuster, 2016.

Dershowitz, Alan. *The Abuse Excuse: And Other Cop-outs, Sob Stories, and Evasions of Responsibility.* Little Brown & Co., 1994.

———. *The Best Defense: The Courtroom Confrontations of America's Most Outspoken Lawyer Of Last Resort – the*

Lawyer Who Won the Claus von Bulow Appeal. New York: Vintage Books, 1983.

Dickens, Charles, *The Old Curiosity Shop.* Penguin Classics, 2001; originally published in 1841.

Du Maurier, George. *Trilby.* New York: Oxford University Press, 2009; originally published in 1895.

Emerson, Ralph Waldo. *Self-Reliance, Essays: First Series* (1841), math.dartmouth.edu/~doyle/docs/self/self.pdf.

Grossman, David, and Loren W. Christensen. *On Combat: The Psychology and Physiology of Deadly Conflict in War and in Peace.* PPCT Research Publications, 2004.

Kant, Immanuel. *Grounding for the Metaphysics of Morals: with On a Supposed Right to Lie because of Philanthropic Concerns.* Cambridge: Hackett Publishing Company, Inc. 3rd edition, 1993, originally published in 1785.

Keslowitz, Steven. *The Tao of Jack Bauer: What Our Favorite Terrorist Buster Says About Life, Love, Torture, and Saving the World 24 Times in 24 Hours With No Lunch Break.* Bloomington: iUniverse, 2009.

———. *The World According to The Simpsons: What Our Favorite TV Family Says About Life, Love, and the Pursuit of the Perfect Donut.* Naperville: Sourcebooks, 2006.

Machiavelli, Niccolò. *The Prince* (Signet edition, 2008; originally published in 1532).

McLuhan, Marshall, and Lewis H. Lapham. *Understanding Media: The Extensions of Man.* Cambridge: The MIT Press, reprint, 1994.

Miller, Dean A. *The Epic Hero.* Baltimore: Johns Hopkins University Press, 2002.

Stubbs, David. *Better Call Saul: The World According to Saul Goodman.* New York: Harper Design, 2015.

Legal Cases, Opinions, and Statutes

ABA Formal Opinion 10-457 New York State Bar Association, Committee on Professional Ethics, Opinion 937, *Promotional Gifts branded with a law firm's logo*, October 3, 2012.

Bates v. State Bar of Arizona, 433 U.S. 350 (1977).

Brandenburg v. Ohio, 395 U.S. 444 (1969).

California v. Greenwood, 486 U.S. 35 (1988)

Qualitex Co. v. Jacobson Prods. Co., 514 U.S. 159 (1995).

RICO Statute: Section 901(a) of the Organized Crime Control Act of 1970 (Pub.L. 91–452, 84 Stat. 922, enacted October 15, 1970), codified at 18 U.S.C. ch. 96 as 18 U.S.C. §§ 19611968.

Schenck v. United States, 249 U.S. 47 (1919).

Strickland v. Washington, 466 U.S. 668 (1984).

Swidler & Berlin v. United States, 524 U.S. 399 (1998).

Texas v. White, 74 U.S. 700 (1869).

United States v. Redmon, No. 96-3361, 7th Cir. (1998).

Virginia State Pharmacy Board v. Virginia Citizens Consumer Council, 425 U.S. 748 (1976).

Articles and Posts

Appelo, Tim. "'Better Call Saul' Star Bob Odenkirk Teases Season 3: 'Innocence Gets Torn Away.'" *The Wrap*, August 17, 2016. http://www.thewrap.com/better-call-saul-star-bob-odenkirk-teases-season-3-innocence-gets-torn-away-video/.

"Are You Fit to Be a Lawyer?" New York State Lawyer Assistance Trust. http://www.nylat.org/publications/brochures/documents/characterandfitnessbrochure09.pdf.

Baker, Trent. "Trump: If Someone Hits Me, I Have to Hit Them Back Harder—'That's what we want to lead.'" Breitbart, April 3, 2016. http://www.breitbart.com/

video/2016/04/03/trump-if-someone-hits-me-i-have-to-hit-them-back-harder-thats-what-we-want-to-lead/.

Benner, Jeff A. *Ancient Hebrew Research Center: Biblical Hebrew E-Magazine*, Issue 041, February 2008. http://www.ancient-hebrew.org/emagazine/041.doc.

"Better Call Saul: Bob Odenkirk, Michael McKean and Jonathan Banks." February 5, 2015. http://www.92yondemand.org/better-call-saul-bob-oden-kirk-michael-mckean-jonathan-banks.

"Better Call Saul Creators Didn't Expect You to Solve Their Gus Fring Puzzle." *Vanity Fair*, April 19, 2016, at http://www.vanityfair.com/hollywood/2016/04/better-call-saul-gus-frings-back-title-anagram-finale.

"Better Call Saul Q&A—Thomas Schnauz (Writer, Director and Executive Producer)." http://www.amc.com/shows/better-call-saul/talk/2016/04/better-call-saul-qa-thomas-schnauz-writer-director-executive-pro-ducer.

Bowman, Donna. "The Lutheran Tragedy of Better Call Saul." Think Christian, March 15, 2015. https://think-christian.reframemedia.com/the-lutheran-tragedy-of-better-call-saul.

Butler, Karen. "UPI Spotlight: From 'Laverne & Shirley' to 'Better Call Saul,' Michael McKean 'never had a plan.' *UPI*, April 7, 2016. http://www.upi.com/Entertainment_News/TV/2016/04/07/UPI-Spot-light-From-Laverne-Shirley-to-Better-Call-Saul-Mi-chael-McKean-never-had-a-plan/9051459954569/.

Celedoria, Baila. "Statutory and Nominative Fair Use Under the Lanham Act, Intellectual Property Man-agement." *IP Frontline*, December 7, 2006.http://ipfrontline.com/2006/12/statutory-and-nominative-fair-use-under-the-lanham-act-i/.

Couch, Aaron. "'Better Call Saul': Bob Odenkirk on Finale's Saul Tease, Season Two Surprises." *The Hollywood Reporter*, April 6, 2015. http://www.hollywoodreporter.com/live-feed/better-call-saul-bob-odenkirk-786587.

———. "'Better Call Saul's Producer on Jimmy's Tragic Betrayal, 'Epic' Finale. *The Hollywood Reporter*, March 30, 2015. https://www.yahoo.com/movies/better-call-saul-producer-jimmys-tragic-betrayal-epic-040000469.html

Cummings, Michael, and Eric Cummings. "The Surprising History of American Sniper's "Wolves, Sheep, and Sheepdogs' Speech," *Slate*, January 21, 2015. http://www.slate.com/blogs/browbeat/2015/01/21/american_sniper_s_wolves_sheep_and_sheepdogs_speech_has_a_surprising_history.html.

Dibdin, Emma. "Why 'Better Call Saul' is One of the Most Feminist Shows on Television." IndieWire, March 17, 2016. http://www.indiewire.com/2016/03/why-better-call-saul-is-one-of-the-most-feminist-shows-on-television-57980/.

Dicker, Ron. "Howard Stern Uses Sheep-and-Wolf Analogy to Denounce Gun Control." *The Huffington Post*, June 16, 2016. http://www.huffingtonpost.com/entry/howard-stern-gun-control_us_5762c1b0e4b0df4d586f6733.

"Differences between State Advertising and Solicitation Rules and the ABA Model Rules of Professional Conduct (January 1, 2011)." http://www.americanbar.org/content/dam/aba/migrated/cpr/professionalism/state_advertising.authcheckdam.pdf.

"Electromagnetic fields and public health: Electromagnetic hypersensitivity." World Health Organization, December 2005. http://www.who.int/peh-emf/publications/facts/fs296/en/.

"Elements of Assault." http://injury.findlaw.com/torts-and-personal-injuries/elements-of-assault.html.

Fienberg, Daniel. "'Better Call Saul' Writer-Director on Surprise 'Breaking Bad' Return and What's Next." *The Hollywood Reporter*, February 15, 2016. http://www.hollywoodreporter.com/fien-print/better-call-saul-season-two-864735.

Fish & Richardson. "Third Party Trademarks: Fair Use or Foul?" November 6, 2013. http://www.fr.com/news/third-party-trademarks-fair-use-or-foul/.

Freedman, Michael. "New Techniques in Ambulance Chasing." *Forbes*, 168.12 (2001), 56–8.

Friedman, Megan. "Exclusive: Saul Goodman Takes the Road Less Traveled in New Better Call Saul Teaser." *Esquire*, January 21, 2016. esquire.com/entertinament/tv/news/a41378/better-call-saul-season-two-teaser/.

Gershman, Jacob. "Lawyer TV Ads Pay Homage to 'Better Call Saul.'" *The Wall Street Journal*, July 21, 2016. http://blogs.wsj.com/law/2016/07/21/lawyer-ads-pay-homage-to-better-call-saul/.

Gunn, Anna. "I Have a Character Issue." *The New York Times*, August 23, 2013, at http://www.nytimes.com/2013/08/24/opinion/i-have-a-character-issue.html?_r=0.

Harvey, Christina Vassiliou, Mac R. McCoy, and Brook Sneath. "10 Tips for Avoiding Ethical Lapses When Using Social Media." *Business Law Today*, January 2014. http://www.americanbar.org/publications/blt/2014/01/03_harvey.html.

Hayden, Erik. "'Breaking Bad's' Anna Gun Writes NY Times Column in Response to Fan Hate, The Hollywood Reporter, August 24, 2013. http://www.hollywoodreporter.com/live-feed/breaking-bads-anna-gunn-writes-613913.

Hocking, Courtney. "It's Showtime, Folks: Inside the Better Call Saul Writers' Room with Vince Gilligan." *Junkee*, September 23, 2016. http://www.junkee.com/show-time-folks-inside-better-call-saul-writers-room-vince-gilligan/85973.

Hyland, Nicole. "Episodes 1 and 2 (Uno and Mijo)." The Legal Ethics of Better Call Saul. http://ethicsofbetter-callsaul.tumblr.com/post/113961009951/episodes-1-and-2-uno-and-mijo Bold and italics added for emphasis.

———. "Episode 3 (Nacho)." The Legal Ethics of Better Call Saul. http://ethicsofbettercallsaul.tumblr.com/post/113975579941/episode-3-nacho.

———. "Episode 4 (Hero)." The Legal Ethics of Better Call Saul. http://ethicsofbettercallsaul.tumblr.com/post/113976861151/episode-4-hero.

———. "Episode 5 (Alpine Shepherd Boy)—Part 2." The Legal Ethics of Better Call Saul. http://ethicsofbetter-callsaul.tumblr.com/post/113992765906/episode-5-al-pine-shepherd-boy-part-two

———. "Episode 6 (Five-O)." The Legal Ethics of Better Call Saul. http://ethicsofbettercallsaul.tumblr.com/post/114095618441/episode-6-five-o.

———. " Episode 7 (Bingo)." The Legal Ethics of Better Call Saul. http://ethicsofbettercallsaul.tumblr.com/post/114154553491/episode-7-bingo.

———. "Episode 8 (RICO)." The Legal Ethics of Better Call Saul. http://ethicsofbettercallsaul.tumblr.com/.

"Inside the Writers Room with Better Call Saul." The Writers Guild Foundation, May 26, 2016. https://www.wgfoundation.org/screenwriting-events/inside-writers-room-better-call-saul.

Jackson, Gita. "Better Call Saul and the fine line between tragedy and comedy." *Paste Magazine*, April 29, 2015. http://www.pastemagazine.com/articles/2015/04/

better-call-saul-and-the-fine-line-between-tragedy.
html.

Jamieson, Lee. "Shakespeare Tragedies: Introducing the Shakespeare Tragedies." About Education, updated May 1, 2015. http://shakespeare.about.com/od/thetragedies/a/Shakespeare_Tragedies.htm.

Jancelewicz, Chris. "'Better Call Saul' Season 2 finale: Michael Mando on what's to come." *Global News*, April 18, 2016. http://globalnews.ca/news/2644553/better-call-saul-season-2-finale-michael-mando-on-whats-to-come/.

Kaminker, Mendy. "What Is the Significance of a Rainbow in Judaism?" Chabad. http://www.chabad.org/library/article_cdo/aid/2770455/jewish/What-Is-the-Significance-of-a-Rainbow-in-Judaism.htm. (Kaminker also cites Genesis 8:21, 9:8-16).

Keane, Allison. "TV Performer of the Week: Rhea Seehorn, 'Better Call Saul.'" *Collider*, April 8, 2016. http://www.collider.com/rhea-seehorn-better-call-saul-tv-performer-of-the-week/.

Kemerling, Garth. The Philosophy Pages. http://www.philosophypages.com/hy/5q.htm.

Khosla, Proma. "'Better Call Saul' Season 2 poster is full of 'Breaking Bad' goodies." Mashable, January 5, 2016. http://www.mashable.com/2016/01/05/better-call-saul-s2-poster/#aEUWxSlw48qu.

Kleyman, Katia. "'Better Call Saul Season 2 Preview Unseen Footage, Vince Gilligan and Bob Odenkirk Comment." *Design and Trend*, January 20, 2016. http://www.designntrend.com/articles/68675/20160120/better-call-saul-season-2-promo-video-new-clips-vince-gilligan-bob-odenkirk-commentary.htm.

Moye, Clarence. "Rhea Seehorn's Quiet, Emmy-worthy Strength in 'Saul.'" *Awards Daily*, May 14, 2016. http://www.awardsdaily.com/tv/interview-rhea-seehorn/).

Nicholson, Jaclyn. "Infographic: Lawsuits in America," *Common Good*, July 17, 2012, http://www.common-good.org/blog/entry/infographic-lawsuits-in-america.

Polanco, Julio Noboa. "Identity." http://breadloafpoetryexchange.pbworks.com/w/page/39725748/Identity%20by%20Julio%20Noboa%20Polanco.

Potts, Kimberly. "'Better Call Saul' Creators Vince Gilligan and Peter Gould on Why We Haven't Seen Saul Yet." Yahoo! TV, November 15, 2016. http://www.yahoo.com/tv/better-call-saul-saul-creators-vince-gilligan-and-peter-gould-on-why-we-havent-seen-saul-yet-210635453.

———. "'Better Call Saul' Postmortem: Peter Gould Talks Where Jimmy Will Be in Season 2." Yahoo! TV, April 7, 2015. https://www.yahoo.com/tv/better-call-saul-producer-writer-talks-season-1-115773934500.html.

———. "'Better Call Saul' Postmortem: Writer Tom Schnauz Talks Jimmy's Heartbreak, Mike's New Job, and the Easter Egg Title." Yahoo! TV, March 31, 2015. https://www.yahoo.com/tv/better-call-saul-pimento-postmortem-115128743980.html.

———. "'Better Call Saul' Writer Talks Jimmy's Legal Skills, That Dumpster Scene, and What Caused Chuck's Illness." Yahoo! TV, March 24, 2015. https://www.yahoo.com/tv/better-call-saul-gordon-smith-interview-rico-114490318520.html

Power, Ed. "Better Call Saul: Marco, episode 10, review: 'a dark conclusion,'" *The Telegraph*, April 7, 2015. http://www.telegraph.co.uk/culture/tvandradio/tv-and-radio-reviews/11517977/Better-Call-Saul-Marco-episode-10-review-a-dark-conclusion.html.

Reif, Donald M. Facebook post, April 21, 2016, on the Better Call Saul fan group page.

Rowles, Dustin. "Kim Wexler's Connection to Omaha Is

Now Even Stronger, and Other Details You May Have Missed From 'Better Call Saul.'" Uproxx, March 30, 2016. http://uproxx.com/tv/better-call-saul-kim-wexler-omaha/.

Schrodt, Paul. "'Better Call Saul' star Rhea Seehorn talks about the 'surprising' sex scene in the Season 2 premiere." *Business Insider*, February 15, 2016. http://www.businessinsider.com/better-call-saul-kim-rhea-seehorn-interview-2016-2.

Sealey, Geraldine. "Obese Man Sues Fast-Food Chains." *ABC News*, July 26, 2015. http://abcnews.go.com/US/story?id=91427.

Seemayer, Zach. "'Better Call Saul' Series Debut Breaks Cable Ratings Records." *Entertainment Tonight*, February 9, 2015. http://www.etonline.com/tv/159488_better_call_saul_series_debut_breaks_cable_ratings_records/.

Simon, Bob. "26-Year Secret Kept Innocent Man in Prison: Lawyers Tell 60 *Minutes* They Were Legally Bound From Revealing Secret." Originally broadcast on *CBS News*, March 9, 2008. http://www.cbsnews.com/news/26-year-secret-kept-innocent-man-in-prison/.

Slater, Dan. "60 Minutes Reports Legal Ethics Head-Scratcher." *The Wall Street Journal* Law Blog, March 10, 2008. http://blogs.wsj.com/law/2008/03/10/60-minutes-reports-legal-ethics-head-scratcher/?mod=djemWLB&reflink=djemWLB.

St. John, Allen. "The Top 10 Television Shows of 2015: No. 1 'Better Call Saul.'" *Forbes*, December 22, 2015. http://www.forbes.com/sites/allenstjohn/2015/12/22/best-of-2015-top-10-shows-on-television-1-better-call-saul-breaking-badder/.

"The Twinkie Defense", October 30, 1999, http://www.snopes.com/legal/twinkie.asp

"Tragedies", Hudson Shakespeare Company. Hudsonshake-

speare.org/Shakespeare%20Library/Ful%20Text/
text%20tragedies/tragedies/htm

"Using the Name or Likeness of Another." Digital Media
Law Project. http://www.dmlp.org/legal-guide/using-
name-or-likeness-another.

Venefica, Aviva. "Symbolic Meaning of Rainbows." http://
www.whats-your-sign.com/symbolic-meaning-of-rain-
bows.html.

Weller, Susan Neuberger. "When Can You Claim a Color
as Your Trademark?" Mintz Levin, September 14,
2012. https://www.mintz.com/newsletter/2012/
Advisories/2243-0912-NAT-IP/index.html.

Whipp, Glenn. "Michael McKean knows the pain inside
his spiteful 'Saul' character. *Los Angeles Times*, June
14, 2016. http://www.latimes.com/entertainment/
envelope/la-en-st-michael-mckean-better-call-saul-
emmys-20160614-snap-story.html.

Websites

1stdibs, Rare Cocobolo Wood desk Don Shoemaker,
https://www.1stdibs.com/furniture/tables/desks-
writing tables/rare-cocobolo-wood-desk-don-shoe-
maker/id-f_935216/

AMC; "Better Call Saul"; "Talk." http://www.amc.com/
shows/better-call-saul/talk/page/2.

AMC; "Profile of Jimmy McGill." http://www.amctv.
com/shows/better-call-saul/cast/jimmy-mcgill-saul-
goodman.

AMC; Saul Goodman's official website. http://www.amc.
com/saul-goodman-esq.

"Battered Women's Syndrome." http://family.findlaw.
com/domestic-violence/battered-women-s-syndrome.
html.

"Breaking Bad Tour." http://www.wikitravel.org/en/Breaking_Bad_Tour.

"Better Call Saul, Full Cast and Crew." http://www.imdb.com/title/tt3032476/fullcredits/

Chicago Bar Association. http://www.chicagobar.org/AM/Template.cfm.

Legal Information Institute; "New Mexico Rules of Professional Conduct" https://www.law.cornell.edu/ethics/nm/code/NM_CODE.htm

"Model Rules of Professional Conduct." http://www.americanbar.org/groups/professional_responsibility/publications/model_rules_of_professional_conduct/

"New York Rules of Professional Conduct" (as amended through January 2014). www.nysba.org/DownloadAsset.aspx?id=50671

"Oprah's Life Class", http://www.oprah.com/oprahs-life-class/when-people-show-you-who-they-are-believe-them-video

Oxford English Living Dictionary, definition of "noble". en.oxforddictionaries.com/definition/noble

"Racketeer Influenced and Corrupt Organizations Act", www.revolvy.com/main/index.php?s=Racketeer%20Influenced%20and%20Corrupt%20Organizations%20Act&item_type=topic

"Reddit" post, http://www.reddit.com/r/bettercallsaul/comments/4hm154/no_spoilers_this_ones_a_long_shot_but_this_shot/.

Rotten Tomatoes; "Better Call Saul: Critics Consensus". http://www.rottentomatoes.com/tv/better-call-saul/s01/.

The Elements of Greek Tragedy. amundsenhs.org/ourpages/.../The%20Elements%20of%20Greek%20Tragedy%20PP.ppt.

Acknowledgments

I am extremely grateful to have the support of my amazing family.

Lital, you are a wonderful wife and mom, and we are very lucky for everything you do for us. Thank you for reviewing drafts of the manuscript, and for introducing me to *Breaking Bad*. We love you so much.

Layla, you are our first miracle. You were born just as I was starting to write this book. Your mom and I love you more than you will ever know. We are so proud of you, and it is an honor to be your dad.

Eliana, you are our second miracle. You were born just as I was finishing this book. Your mom and I cannot wait to get to know you, and we are so excited to have you in our lives. We love you more than you will ever know.

I could not ask for a better father (Alan), mom (Helene), or brother (Justin). I feel very lucky that we are all so close. Thank you for everything, and for always being there for us.

Over the years, I have received a great deal of encouragement and support from writers, directors, artists, and actors within the film and television industries. I would like to thank everyone I have spoken with about *Better Call*

Saul and the other television shows that I have written about (namely *The Simpsons* and *24*). I would like to give a shout-out to the incredible *Better Call Saul* writing team and the wonderful cast of the show. I had the opportunity to meet Bob Odenkirk, Rhea Seehorn, Michael McKean, and the entire writing team, including cocreators Peter Gould and Vince Gilligan. And thank you to my friends Patrick Fabian, who spoke so highly of the manuscript, and Brandon K. Hampton, for agreeing to an interview for this project. Thank you all for your support for this book.

Thank you to my literary agent, Stacey Glick, of Dystel, Goderich & Bourret Literary Management, for your encouragement. Thank you to the entire QuillPop team, including Sam Henrie, Lori Conser, and Mindy Burnett for your painstaking efforts and excitement about this project.

About the Author

Steven Keslowitz is a practicing attorney and serves as Senior Director and Counsel of Intellectual Property and Technology at AXA Equitable Life Insurance Company. He previously practiced law at the international law firm Debevoise and Plimpton. He is a *magna cum laude* graduate of the Benjamin N. Cardozo School of Law, where he served as Executive Editor of the *Cardozo Law Review* and was named a Dean's Distinguished Scholar.

Steven is the author of three other books, The Tao of Jack Bauer: What Our Favorite Terrorist Buster Says About Life, Love, Torture, and Saving the World 24 Times in 24 Hours With No Lunch Break (2009), From Poland to Brooklyn: The Lives of My Grandparents; Two Holocaust Survivors (2008), and The World According to The

Simpsons: What Our Favorite TV Family Says About Life, Love, and the Pursuit of the Perfect Donut (2006). He is the author of several academic articles about pop culture and legal issues, including "*The Simpsons, 24* and the Law: How Homer Simpson and Jack Bauer Influence Congressional Lawmaking and Judicial Reasoning" (Cardozo Law Review, 2008); "The Trial of Jack Bauer: The Televised Trial of America's Favorite Fictional Hero and Its Influence on the Current Debate on Torture" (Cardozo Law Review, 2009); and "The Transformative Nature of Blogs and Their Effects on Legal Scholarship" (Cardozo De Novo, 2009). The World According to The Simpsons was translated into Portuguese (A Sabedoria Dos Simpsons). He published a weekly Simpsons column for his college newspaper, The Excelsior.

Steven was deemed a "Simpsons expert" by *FOX 5 News*, NY, and has spoken about *The Simpsons* on *The Today Show*, CUNY TV, *FOX 5 News*, and Swedish National Television. He has given dozens of radio interviews about pop culture issues across several continents, including on NPR and ABC Radio. He was also a guest speaker on *The Simpsons Show* podcast. His views on the political and social significance of *The Simpsons* and *24* have been cited in numerous academic articles, and his views on *The Simpsons* have been featured in more than five hundred newspapers and other media outlets across four continents, including the *Washington Post, New York Daily News, Miami Herald, CNN. com, Toronto Star, Yahoo! Asia,* and *MSNBC.com. The World According to The Simpsons* has been required reading in sociology, English, writing, and Simpsons courses at Tufts, Carnegie Mellon, Drury, Montana State University, and the University of Colorado at Denver, among others. He has lectured about *The Simpsons* at universities, law firms, bookstores, and book festivals.

Contact the Author

Please check out my website:

www.stevenkeslowitz.com

The site includes a new blog devoted to *Better Call Saul* (starting with Season 3). The site also contains information about my other books: *The World According to The Simpsons*, *The Tao of Jack Bauer*, and *From Poland to Brooklyn*.

Email: If you would like to drop me a line, please email me at:

steven.keslowitz@gmail.com

Social Media: Please also check out my author page on Facebook. You can also follow me on Twitter and Instagram.

CPSIA information can be obtained
at www.ICGtesting.com
Printed in the USA
LVOW07s1809010717
540052LV00001B/9/P